FOREWORD

Kids want answers to everything. Why is the sky blue? How many fish are in the sea? Why doesn't Bruce Wayne donate his millions to hire more policemen, rather than prancing around in a cape pretending to be a bat?

But as we get older, that begins to change. Often we find out the answer. Blue light waves are shorter and more easily scattered by dust particles. Sometimes there *is* no answer. The number of fish in the sea changes every second. Usually, we get lazy and just stop caring. Wolverine is way cooler than Batman anyway.

But the really big questions never go away. Is there a point to life? What will happen when the universe ends? Do we have free will or is everything predetermined? Do our spirits live on after we die?

Many people look to religion to provide those answers, but religion is about faith, not enquiry. Others have turned to science, but that's become almost as unsatisfactory. As the great physicist Richard Feynman once said, 'If you think you understand Quantum Mechanics, you don't understand Quantum Mechanics.' Eh? I don't even understand how to change a tyre.

Faced with those kinds of barriers, lots of folk just give up asking. But an intrepid few take that as their cue to return to old-fashioned methods. They get off the couch, put together some equipment and go out looking for themselves.

That's what Rob Kirkup did. He wanted to know if ghosts were real. So he and his friends went searching for them in locations that had fearsome reputations for being haunted. Then he wrote a story about what happened.

Most books about supernatural beings are just big lists. Worse than that, they're big lists that start with the phrase 'according to legend': 'According to legend, Headless Bill Nasty, the infamous parrot strangler was once seen on the number 24 bus to Shadwell.'
Really? So, exactly who spotted him and how drunk were they? After all, according to legend, Santa brings you presents at Christmas. And I know he doesn't because I set traps for him every year.

This book is different. It's the first-hand account of four ghost hunters trying to discover the truth about the creepy places they visited. As a writer, I know the human element is the most important thing in any story, and this book is not just about spirits. It's about real people getting off their backsides and doing something exciting. Because they were curious. Because they weren't satisfied with second-hand explanations. Because they wanted an adventure. And you can come along without having to get cold or wet or chased through a graveyard by a demon with glowing red eyes. Actually, I may have made that last bit up.

So … Did they actually make contact with the spirit world? Good question. But you'll have to read on to find out. I'm not going to spoil it for you.

Jan-Andrew Henderson

ACKNOWLEDGEMENTS

A huge thank you goes to my fellow ghost hunters: Tom Kirkup, John Crozier and Richard Stokoe. I'm sure you'll agree we endured some truly terrifying moments in Edinburgh, and created some memories that will last a lifetime. You guys made it a blast from start to finish, and I hope you'll enjoy reliving our adventure through these pages for years to come.

My family have been brilliant throughout the creation of *Ghosts of Edinburgh*; in particular, my wife Jo for all her support. Thanks to my parents, Tom and Emily, for all their encouragement. I would also like to express my gratitude to my in-laws, Patricia and Michael, my brother-in-law, James, and Norman, Jo's grandad.

I was thrilled when Jan-Andrew Henderson agreed to write my foreword. I own many books on the ghosts of Edinburgh, but the books I turn to time and time again are his *The Town Below the Ground: Edinburgh's Legendary Underground City*, *Edinburgh: City of the Dead* and my personal favourite *The Ghost That Haunted Itself*. Thanks so much Jan.

Thanks to Darren from Elite Paranormal Investigators (www.theeliteparanormalinvestigators.co.uk) for sharing his local knowledge with me, and suggesting we check out the Cammo Estate.

The owners and staff of the locations we investigated in this book could not possibly have been more helpful, and I'd like to thank everyone at the Real Mary King's Close, Mercat Tours, Blackhart Entertainment, Dalhousie Castle Hotel, Bedlam Theatre (especially Fiona, Julien, and Carolyn) and Edinburgh Dungeon (in particular, Helen and Jenny). Our appreciation goes out to John at Mysteria Paranormal Events (www.mysteriaparanormalevents.co.uk), who was kind enough to accommodate us on an organised public ghost hunt at Mary King's Close.

Thanks to the generosity of the guys at Haggerston Castle for allowing us to stay in one of their luxurious caravans on the evening of one of our investigations. We are indebted to Vie Amhor Edinburgh Apartments (www.vieamhor.com) for sorting us out with some fantastic apartments right in the heart of Edinburgh.

The kind people at www.roofbox.co.uk were brilliant in providing me with the ghost-hunting case I use throughout this book. Don the Gizmo Guru was kind enough to send me a Ghost Touch device (www.gurupaintball.com) and Al from www.moditronic.com kitted me out with the Paracorder 667. Thanks to Apex Radio (www.apexradio.co.uk) for loaning us two-way radios to use on our investigations in Edinburgh. The laser grid and motion sensors used at Mary King's Close in chapter seven were courtesy of the Ghost Hunter Store (www.theghosthunterstore.com). The public liability insurance we held for the investigation at the Vaults was through Insurelink (East Anglia) Limited.

Last, but certainly not least, I would like to say a big thank you to everyone at Amberley Publishing, Joe Pettican in particular, for giving me this opportunity, and their support and guidance from day one.

INTRODUCTION
IN THE BEGINNING

Let me tell you why you're here. You're here because you know something. What you know you can't explain, but you feel it. You've felt it your entire life, that there's something wrong with the world. You don't know what it is, but it's there, like a splinter in your mind, driving you mad. It is this feeling that has brought you to me.

Not my words, but profound words first uttered all the way back in 1999 by Morpheus in the smash-hit movie *The Matrix*. These words really struck a chord with me. There are some things in this world of ours we simply can't explain, and it's my own curiosity about one of those things, ghosts, that led me on this adventure in search of evidence to support proof of the existence of such things. Indeed, I believe it's your shared intrigue that has led to pick up a copy of this book.

In *The Matrix*, Neo's thirst for the truth was overpowering, and now it's your turn to 'take the red pill' and accompany me on a year-long investigation into haunted Edinburgh, with the aim of finding my own personal evidence for the existence of ghosts.

I would be joined on this quest by my brother, Tom, and two close friends, Rich Stokoe and John Crozier, names that will already be familiar to you if you've read our spiritual precursor, *Ghosts of York*. We're four everyday blokes from Newcastle-upon-Tyne, we all hold down 9–5 jobs, and have typical family lives. However, once darkness falls we share a common goal: seeking out the ghosts and ghouls rumoured to dwell at some of the UK's scariest locations.

Over the last decade, I've investigated some of the most haunted locations in the North of England, and having opted for Edinburgh for the focus of this book, none of us could wait to strap on our proton packs and head over the border to the capital of bonnie Scotland.

The reason I chose Edinburgh as our focus was simple. It's a stunning city, one of the most beautiful in Europe, set against a backdrop of rocky crags and extinct volcanoes, with the ancient fortress of Edinburgh Castle dominating the skyline, looking out over the city and towards the Firth of Forth and the North Sea beyond. Edinburgh city centre is dissected by atmospheric cobbled streets, overlooked by some of the most famous landmarks in the world. The incredible, awe-inspiring architecture and vistas around every corner simply blow you away.

Oh yeah, and then there's the ghosts.

From the eerie Covenanters Prison in a quiet, seemingly unassuming corner of Greyfriars Kirkyard, where countless visitors claim to have been attacked by the terrifying Mackenzie Poltergeist, to the spectres that haunt Mary King's Close, the subterranean underworld of the Old Town, where a once thriving community lived and died, is now little more than a ghost town. Edinburgh has a rich history steeped in bloodshed and misery, torture and death, and it's this dark past that has led to Edinburgh being considered one of the most haunted cities in Britain, possibly even the world.

Where better to continue our search for the answer to a question asked daily the world over since the dawn of time: do ghosts exist?

All photographs were taken by the author unless otherwise stated.

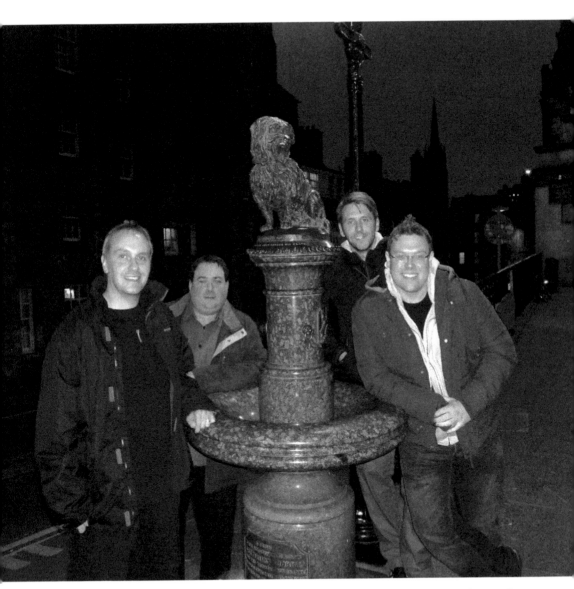

From left to right: Rob, John, Tom, and Rich make the acquaintance of one of Edinburgh's most famous characters – Greyfriars Bobby.

CHAPTER ONE
COLD, FRANKENSTEIN AND ARRGGHHH
EDINBURGH DUNGEON, 28 APRIL 2012

Chilling. Horrifying. Unforgettable. And undoubtedly the scariest experience of my entire life.

Thirteen hours earlier, I had left my home in Wallsend, just outside Newcastle-upon-Tyne, and could not have even begun to imagine just what was lying in wait after dark.

Six months after we left York following our final investigation, the team was to be reunited once again to take on Edinburgh, the historic capital of Scotland. Unfortunately, we were a man down, as Rich Stokoe was unable to come due to a recent burglary and Amy, his wife, understandably did not want to be left at home alone.

We made an early start, and 10.30 a.m. found my brother Tom, our good friend John Crozier, and myself in high spirits as we headed north on the A1 for the first chapter of our new adventure in a city declared in 2007 as one of the scariest on earth by leading online travel and leisure retailer lastminute.com.

So far, the weather in 2012 had been bizarre: March was the hottest since 1957, and this month had been the mirror opposite, as it was the wettest April since records began in 1910. Only a few days earlier, we'd even had the occasional flurry of snow. Thankfully, it was a rare dry day, with the sun shining brightly, but a nasty chill in the air.

We parked up on the outskirts of the city at 1.30 p.m. We were in no hurry, and didn't have anywhere in particular to be, so we walked slowly, without purpose and took in everything about this fantastic city as we headed roughly in the direction of the city centre. We passed a telephone box carrying an advert for the Edinburgh Dungeon, our venue for tonight with the tag line 'Fun, Drawn and Quartered' alongside a gruesome image. We arrived in the already busy Grassmarket, very much the drinking epicentre of the city, just before 2:00 p.m. But we weren't here to drink – John had other plans.

John had been excited about visiting Oink! hog roast for months, but it seemed that dozens of other people were equally eager for their fill of meat, as there was a huge queue down the steep slope of Victoria Street. John suggested that, since he'd be queuing for a while for his 'grunter' (the biggest of the three sandwiches on offer), Tom and I should head to the pub, where we could have a sit down and take the weight off, and he'd catch up with us.

We bid John farewell for now, and knowing we'd have a bit of time before John would catch up, we took a bit of a detour towards our ultimate destination to see a few of the sights. We headed down Victoria Street into the Grassmarket and then made our way back uphill towards Greyfriars Kirkyard. We stopped to pat the statue of Greyfriars Bobby on the head, an old Edinburgh tradition believed to bring luck, and I was hoping this simple gesture may bring good fortune for our time in Edinburgh over the next year.

I pointed out the Elephant House to Tom as we walked past the popular coffee shop, famous for being the birthplace of Harry Potter, as J. K. Rowling wrote the first book in the back room, which

overlooks Edinburgh Castle. Out of the corner of my eye, I spied a poster that stopped me in my tracks. 'Vacancy for a Harry Potter, please apply within', or at least that's what I initially thought it said. I turned to look at it properly and realised they were actually looking to take on a kitchen porter.

As we took a stroll along the Royal Mile, we passed another poster advertising Edinburgh Dungeon. We had done the tourist thing of going on the Edinburgh tour on our initial visit to Edinburgh a month earlier. It had been brilliant: well-acted, suitably gruesome and gory, while also being good fun for the children. There were also two rides on the tour, both scary for different reasons. One was called Extremis, and you found yourself strapped into a seat and dropped vertically from a great height very, very fast. Then there's a slow-moving river ride to the lair of the cannibal Sawney Bean, where the scares are psychological, eerie whispered sound effects and total darkness, interrupted by intermittent flashing lights, which flash just long enough to see the (actor's) arms reaching out for you. I knew the tale of Sawney Bean well, as I'd heard it around a decade earlier on a late night local radio show, and to this day it remains one of the most disturbing stories that I've ever heard.

Read on, but please heed of these words of warning that the terrible tale of Scotland's most infamous cannibal is not for the faint of heart.

Alexander 'Sawney' Bean was born in the sixteenth century, a little over 15 miles from Edinburgh, in the county of East Lothian. His father was a hard-working man, digging ditches for a living, but when Sawney reached adulthood he had no intention of pursuing an honest life. He met a woman by the name of Agnes Douglas, and they would begin a life together of the most abhorrent evil imaginable.

Rather than finding a conventional home, they moved into a coastal cave together in Bennane Head, positioned between Ballantrae and Girvan. It was an isolated spot, completely invisible when the tide was in, as the water came almost 200 yards into their subterranean abode, which stretched far below ground, some accounts claim as far as a mile down. This was the perfect hideout from which they could sneak out to rob and murder innocent passers-by at night before returning to their cave, completely hidden from view. However, their despicable deeds didn't stop at thievery and murder; the still warm body of their victim would be taken back to the cave, where it would be hacked into quarters, and sections roasted over a fire before being devoured by Sawney and Agnes. Any leftover 'meat' would be salted and hung on hooks, and the innards pickled.

Over the next twenty-five years, they produced six daughters, eight sons, eighteen grandsons and fourteen granddaughters, with many of the sons and daughters the result of inbreeding between Sawney and Agnes and their children, and all thirty-two grandchildren the result of incest. The forty-eight-strong clan had no contact with the outside world, other than their vicious attacks under the cover of darkness to satisfy their greed for gold and silver, and feed their insatiable appetite for human flesh. It's believed that, all told, over 1,000 men, women and children were murdered and consumed by the Beans. Unsurprisingly, this number of missing people had caused a panic in the area, with a several men being suspected, some of whom were arrested with no evidence, and in some cases further disappearances while the men were in custody. No one was convicted. The local people were scared to leave their homes, and would rarely travel alone.

One fateful night, a large group attacked a recently married couple, who were riding the same horse as they returned from a fair. However, the man was armed with a sword and pistol and held them at bay, charging at them on horseback in an attempt to escape the aggressors who had them surrounded. His wife was pulled to the ground, and before he had a chance to react, a group of the Beans swarmed her. She was screaming and begging for her husband to save her, but her screams turned to indistinguishable gurgles as her throat was slit. Some of the cannibals sucked

on the warm crimson liquid gushing from the gaping wound. Her eyes were wide with panic as others ripped open her stomach with their bare hands, tearing out her entrails and gorging on them as her husband looked on, horror-struck, frozen to the spot, unable to comprehend what was happening to his wife, who only moments earlier had been holding his waist, safe and sound, as they rode home. Suddenly, the man snapped back into action and screamed for help. Though resigned to the fact his beloved wife was gone, the instinct for self-preservation had kicked in. The Beans closed in on the man as he readied himself to fight for his life. In a rare moment of good fortune, his screams had been heard by a large group of people also returning from the fair, who rushed to the man's aid. Sawney Bean and his family's horrendous atrocities had been witnessed for the first time in a quarter of a century, and they were forced to flee through the woodland and the moors that they knew so well, finally making it back to their cave unseen.

The man had been the first person to be attacked by the Beans and live to tell the tale, and that's exactly what he did; he told the group what had happened and he showed them the almost unrecognisable remains of his wife's half-eaten corpse. He broke down as the horrific reality sunk in; his true love was gone and his life would never be the same again.

The group took the man to Glasgow where, upon hearing of the man's appalling encounter, the king himself rounded up 400 men and a pack of bloodhounds and headed for the scene of the shocking crime. The man was asked to act as a guide, and was forced to return to the place that would haunt his every waking moment for evermore.

When they finally arrived, there was no sign of Sawney Bean and his family. They searched far and wide, but the dogs picked up no scent; it looked like the Beans had moved on and the search party had missed their chance to catch this cannibalistic clan. They set up camp for the night, resigned that they would return to Glasgow empty-handed. But when they awoke the next morning, the tide was out and in the distance they could see a small entrance to a cave in the rocks. A scout party went ahead to check it out, taking the dogs with them. When they reached the cave entrance, they immediately dismissed it as being far too inaccessible to possibly be the Beans' hideout. However, the dogs began barking wildly, desperate to get to something in the caves. The king and his men lit torches and made their way down into the dark, dank, cavern. They could soon see indiscernible objects swinging from the ceiling ahead of them. Once the soldiers at the front got close enough to realise what they were looking at, many of them began to retch and vomit in disgust. Human legs, arms, torsos, feet and hands hung from meat hooks; it has even been written that tiny lifeless babies hung in their entirety from some of the hooks. Internal organs such as hearts, livers, intestines and kidneys lay in pickle. A great hoard of money, twenty-five years' worth of gold and silver and other items of value, were piled up in enormous mountains of riches.

They forced themselves to press on quietly and found Sawney and his family at the back of the cave. There was a brief struggle but the 400-strong company had the element of surprise and a huge numerical advantage and seized every member of the clan. The soldiers took the human remains from within the cave and buried them in the sands. The prisoners were marched in chains to Edinburgh. They were held at Edinburgh Tolbooth, which once stood along the Royal Mile. It is at this point that versions of the stories diverge, with two different, but equally gory, climaxes. The best-known version of the story is that Sawney and his family were transferred to Leith, where they were to be executed without trial. Sawney and the other men suffered a slow, lingering death. They had their genitals cut off and burned before their eyes. They then had their hands and feet cut off and were left to die in agony as one by one they bled to death. Agnes, her daughter and granddaughters were forced to watch their menfolk suffer. Then it was their turn. Three large bonfires were lit and they were burned alive.

The alternative ending takes place in Edinburgh, rather than Leith, and the punishment dealt to the cannibalistic prisoners is the same in all but one instance: the fate of Sawney Bean himself. So appalled were the people of the city upon hearing of the heinous acts committed that an example was to be made of the clan's leader. He was taken out on to Edinburgh's Royal Mile, where the people of the city had turned out in force; they wanted to see justice served and were baying for his blood. Four horses were brought out and Sawney showed no resistance as his arms and legs were tied, one to each animal. The crowd fell silent and there was an audible collective intake of breath, as they all knew what would come next. A gun was fired in the air and the horses bolted in opposite directions, the ropes tightened and there was a split second of resistance before Sawney was torn apart in a spectacular explosion of blood and gore. His head was connected to his right arm quarter, and as the horse galloped along the Royal Mile, the people of the city cheered, Sawney began to laugh manically, which unsettled the crowd, and then with his dying breath he screamed a curse upon the people of the city.

Historians seem unable to agree wholly as to whether Sawney Bean ever actually lived, or whether the whole bloody tale was invented as far back as 1700 to entertain and shock in equal measure. If it is a legend, it has taken a foothold in Scottish folklore and has remained in the nation's consciousness in the form of newspaper and magazine articles, novels, and even big screen adaptations. Wes Craven's 1973 film *The Hills Have Eyes*, which was given a big budget remake in 2006, was based on the story of Sawney Bean, and one of the best-known horror movies of all time, *The Texas Chainsaw Massacre*, is believed to have been inspired by the tale.

The flipside of the argument is that Sawney and his family did indeed exist, and most definitely killed and ate over 1,000 innocent people, but the exact year in which this took place has been lost in the passing of time, making it difficult to check records and find evidence to back these claims up. *The Guinness Book of Records* must be firmly in the 'yes' camp because, as recently as 1973, if you were to flick past the world's longest fingernails and the world's smallest cow, you'd eventually come to 'Britain's worst ever serial killer', named as one Alexander 'Sawney' Bean.

Whether Sawney Bean and his cannibalistic clan ever actually committed such unspeakable evil will most likely never be proven one way or another, but one thing that isn't up for debate is that it's one hell of a story.

Soon enough, Tom and I were heading back to meet up with John. He'd beaten us to the 'pub' he'd mentioned earlier, Frankenstein's, a bar we'd adopted as our new 'local', having stopped off for a drink on our visit a month earlier.

I was glad to get into the warmth of the bar and John was waiting for us at a table in front of a roaring open fire. I wondered if the bar had been named after the famous movie monster because of the belief that Mary Shelley, the writer of *Frankenstein*, found her inspiration at Greyfriars Kirkyard only a stone's throw away. She had been on her honeymoon in Edinburgh at the height of the bodysnatching period, when 'resurrection men' dug up bodies to sell for scientific experiments. There are, however, many conflicting claims made by cities all over Europe for being the birthplace of Shelley's horrifying tale, the most popular theory being Geneva. As I queued at the bar to be served, I looked around the place; it was dark and gloomy, but that was obviously the look they were going for with the movie posters of Frankenstein's Monster than adorned every wall of the ground floor, which was the centre of the three levels of the bar. I spotted a poster above the door that read 'World Famous Frankenstein pub established 1918, for connoisseurs of the macabre'. Then an A4 certificate on the wall caught my eye, which was to certify that Elite Paranormal Investigations conducted an investigation at the pub and experienced evidence of paranormal activity. When it

was my turn at the bar I ordered a bottle of Irn-Bru and a glass filled with ice and settled down with John and Tom for the first real chance I'd had to relax since leaving my house four hours earlier.

Just after 4:00 p.m. we put on our coats, grabbed our belongings and headed back outside for the short walk back to the car. We were talking about the night that lay ahead, in which order we planned to investigate the rooms, and which experiments we felt would be a good fit for each. Then a man approached us, grinning. He walked right up to me and shouted, 'Who you gonna call?' with a huge smile plastered across his face. I couldn't comprehend what was happening. I looked behind me to see if he was talking to someone else – nope, he was definitely talking to me! I looked blankly at Tom to my left, then John to my right. I looked back at the man with a vacant expression and couldn't think of anything to say – I just wanted him to leave me alone. He said it again, this time louder, 'Come on! Who you gonna call?' Tom nudged me, 'Go on then!' The penny suddenly dropped and I looked down at the huge Ghostbusters logo on my hoodie. The blank expression on my face changed to a smile as I shouted, 'GHOSTBUSTERS!' The man laughed and cheered as he jumped up and punched the air. There were fist bumps all around and he carried on laughing loudly as he walked off. We continued on our way.

Soon enough, we were back at the car and on the move again. Tom kicked his shoes off, put his feet up on the dashboard and slouched down in the passenger seat. He had a nap as I drove the ten or so miles to Drummohr campsite in Musselbrough, as we had booked to stay there in something called a bothy, which would be best described as a large wooden shed roughly 2 metres wide by 15 metres long. A separated room at the far end contained a sink and a toilet, and in the main area, running down both sides the length of the bothy, were two single mattresses end to end, lying atop a raised wooden structure, so in total it would sleep four people. There is also a heater, a flat screen television, a fridge and a kettle. It's not all five-star luxury, this ghost-hunting lark, but it was relatively cheap and it was our home for the night.

Our bothy – home, sweet home!

We decided to go out for our evening meal and then go straight from there to Edinburgh Dungeon, so we left anything we wouldn't need on our beds, changed into our ghost-hunting clothes and went back out.

We went to the Robin's Nest pub for tea, part of the Sizzling Pub chain. It was fairly busy, which was to be expected on a Saturday evening, but we had no problems finding an empty table, and picked one in a corner overlooking the beer garden, and grassy fields beyond way off towards the horizon.

We enjoyed our meals, and as we waited for our food to digest we discussed how much we were looking forward to tonight, but how disappointed we were that Rich hadn't made it. We raised a glass to the empty seat at our table, and drank a toast to our absent friend.

At 8.00 p.m. we left the pub. It had looked like a really pleasant evening when we'd been sat inside; the sun was shining and there wasn't a cloud in the sky. But now I was outside it was freezing! I navigated the city centre traffic and found a parking space a 2 minute walk from the dungeon. It was 8.30 p.m., and we had arranged to meet our hosts for this evening at 9.00 p.m., so we had a little bit of time to kill before we'd have to leave the nice warm car. I performed one last check of all of my equipment as Tom and John chatted excitedly about whether or not the Edinburgh Dungeon would live up to the scares the York Dungeon had provided a little under a year earlier, and in particular the 'poking' incident, which had given me the biggest scare of my life so far.

Unlike York Dungeon, Edinburgh Dungeon has information in the public domain about genuinely strange happenings reported by staff, and it even made the national press in August 2001. The dungeon had opened a few months earlier in April (on Friday the 13th, no less), and had been plagued by odd occurrences ever since. One employee believed that he saw a cloaked figure in the Sawney Bean exhibit, and several other members of staff felt uneasy in the dark, eerie corridors of the dungeon. The Witchfynder boat ride broke down nine times during the month of August, which was the final straw, as the claims that the building may be haunted were taken so seriously that an exorcist was called in. The exorcist claimed that the unwelcome spirit may have been attracted to the dungeon by the actors, dressed in costumes that encompass the broad spectrum of Edinburgh's horrible history, play-acting and telling gruesome stories for the entertainment of visitors. The exorcist, a Mr Carlyon, boasted a 98 per cent success rate at the time, and was confident that the spirit had been put to rest.

However, the ghostly goings-on continue to this day, with numerous phenomena reported, including staff frequently feeling as if someone has brushed against them in one particular corridor, and on one horrifying occasion elsewhere in the building a young boy was convinced invisible hands had grabbed his legs and he was rushed out of the building screaming.

We got out of the car at 8.50 p.m., just after the sun had set and darkness had descended over the city. The icy chill of the wind was cutting right through us, so when we rang the buzzer at the entrance to the Edinburgh Dungeon we were thankful that the door opened fairly quickly. Helen Adams, with whom I had made the arrangements for our investigation, welcomed us inside. I introduced Tom and John, and Helen introduced us to Jenny Sneddon, her colleague, who would also be on site throughout our investigation. Without further ado, Jenny took us on a tour of the building with all of the lights out, which was even creepier at night, with the daytime visitors replaced by an uneasy silence and terrifying, lifelike mannequins at every turn. We would have access to the staff room, which we could use as our base for the investigation, and we would be able to access virtually the entire building; we couldn't access the areas of the two rides for obvious reasons, in particular a word of warning about stumbling into the boat ride area, as we could easily drown.

When we went to the area made up to represent Mary King's Close, Jenny and Helen stopped to tell us that this particular location may be of interest to us, as at one time it was a close and the stone walls are genuine and original. Behind the solid stone walls were stables, and 'if you're feeling brave enough', there's a small doorway that goes into the area of what was once two stables. This area wasn't open to the public, as it's used as storage and an archive, but we were welcome to check it out if we wished. The actors who work there don't like being in the Mary King's area alone, they get 'creeped out'.

As we passed through a door, Jenny said that 'if we were feeling up the challenge', we could tackle the mirror maze in the dark. It was a room with one route through and mirrors at every turn, making it tricky to find the correct route through without walking into a mirror.

When we were back at base, John asked if the sound effects could be turned off, as in one area made up to appear like Greyfriars Kirkyard there were some horrifying sound effects on a loop which included rattling chains, indistinguishable whispers, the cry of a raven, the hooting of owls, and then the scream of a woman in unimaginable pain. They were really quite loud and could be heard from some of the nearby rooms, which was very unnerving. Sadly, it wasn't possible to turn them off, although we were assured every other effect had been switched off.

We were handed a radio in case we needed to contact them in their office. We entrusted this to John, and they kindly wished us luck for the evening.

I checked my watch. It was 9.30 p.m., so to make the most of the time we had we headed straight out into the dungeon and to our first room, and the first room on the tour – the Torture Chamber.

This is it! Time for our investigation at the Edinburgh Dungeon to begin.

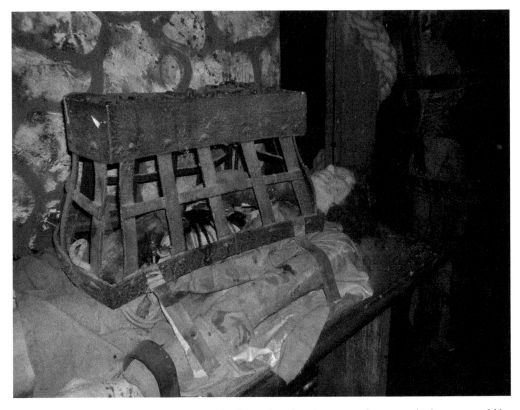

A mannequin depicting a popular, but horrific, form of medieval torture. The rat inside the cage would be forced to eat its way to freedom through the prisoner.

A large chair dominated the room, splattered with fake blood and gore. There were implements of torture placed nearby. On the daytime tours, the actor playing the role of the torturer would select one of the visitors to sit in the chair and some of the horrific forms of torture would be demonstrated, a reflection of man's inhumanity at its most brutal. Constant reminders of methods of medieval torture fill the room: chains and cages hang from the ceiling, a mannequin with arms and legs is tied to a wheel, known as a Breaking Wheel, and another, with its face contorted in agony (a common theme with the mannequins throughout the Dungeon) is tied down with a metal cage nailed to his chest, a rat is placed inside the cage and burning hot coals placed on top, causing the rat to take the only way out; by eating its way out through the man's chest.

I positioned my Olympus LS-5 digital voice recorder on the chair and pressed record. We spread ourselves out around the room and turned our head torches off; Tom sat on the stage close to the torture chair and began to ask aloud; the first attempt of our Edinburgh hunt to make contact with the dead.

Tom explained why we were there, who we were, and asked for some kind of sign that we weren't alone in that small room. I immediately heard two knocks, faint but clear, on a staircase behind me. I spoke up asking if anyone else had heard it, but they hadn't, possibly being hindered by the creepy sound effects we could hear from another area of the building. Encouraged by this start, Tom asked for a more definite sign, but this time our polite plea was unanswered. Not one to be deterred, Tom continued to ask aloud and the three of us strained our ears to hear anything out of

the ordinary, sounds that we could be sure hadn't been made by us, looking around the room, our eyes having accustomed to the almost absolute darkness, the only light an eerie green glow from an emergency exit sign – and for almost ten minutes we saw and heard nothing.

John then told us he had a bizarre sensation of something touching him lightly along his left arm, I asked for whoever was affecting John to do something more concrete and John said quietly that the sensation seemed to have shifted from his left arms to his right. He rationalised that perhaps it was air conditioning, so he remained still while I checked for possible sources of draughts around him. I couldn't feel anything, yet the light touches on his arms continued. 'Can you affect another part of me?' he asked, but with this the light touches stopped completely.

Buoyed by this strange occurrence, we pressed on once more in the hope of communicating with unseen spirits among us. With a change of approach, Tom asked a series of questions, leaving a gap between each one in the hope of hearing an answer or capturing a response on the recorder. 'What is your name?' I listened intently hoping for something, anything, to emanate from the darkness, but I was listening so carefully that when the question was met by the recorded scream from along the corridor it made me jump. Tom's questioning continued.

'Why do you remain in this building?'

Nothing.

'Did you live or work here in life?'

Nothing.

'Were you murdered?'

This time the question was met by a loud knock from somewhere within the room; all three of us heard it but couldn't establish the source. John and I urged Tom to continue.

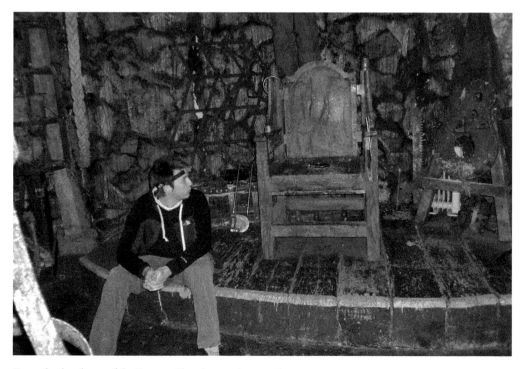

Tom asks the ghosts of the Torture Chamber to give us a sign.

He asked again, 'Were you murdered?'

There was another loud knock in response. It seemed to be coming from the stage area where Tom was sat.

'Are you here because you had unfinished business?'

Knock.

'Do you want us to leave?'

Two loud knocks.

It appeared that we'd been asked to leave, but we weren't going to be moved on quite so easily. Tom asked for a definite sign that we should leave, someone to touch us, move something, speak for us to hear, and we'd leave immediately without question. However, perhaps the spirit was angry or upset with us for not leaving at the first time of asking, as we didn't experience anything over the next ten minutes before we unanimously agreed to move on to the next area and begin our second vigil.

We moved along to the 'Mortuary' at 9.55 p.m. and the first thing that hit us upon entering was how much louder the spooky recording was, as this room was immediately before the Greyfriars setup. On the daily tour an actor, playing the role of the assistant to a doctor by the name of Robert Knox, would explain how two local men named William Burke and William Hare have been providing them with fresh bodies for medical research. They were initially able to supply fresh cadavers by digging up the recently deceased, but now the entrepreneurial duo had taken to murder in order to satisfy the increased demand. Burke and Hare, Irish immigrants living in Edinburgh, murdered seventeen people during a twelve-month period from November 1827 to

A body ripe for dissection, provided by the infamous Burke and Hare.

the end of October 1828, at which point they were caught. The evidence was not overwhelming, so William Hare was offered immunity from prosecution if he testified against his partner. Hare's testimony led to Burke being hanged on 28 January 1829, and it was fitting that his corpse should be publicly dissected at the Edinburgh Medical College. His skin was tanned and used to make items including a pocket book and a calling card case. His skeleton is still on display to this day at the University of Edinburgh's anatomical museum.

The room is dominated by a large table at the foot of three rows of lean-on seats, upon which visitors to the tours would sit. On the table is a (fake) body, ripe for dissection. Tom and I sat in the rows of seats at opposite ends of the room, myself in the front row and Tom behind. John stood next to the table at the front, upon which I had left my digital voice recorder to capture his every word as he spoke aloud, explaining that 'we come in total respect, we simply want to know more about the spirits with us, and gain evidence of life after death'. He requested that if anyone could hear his voice could they give us some kind of a sign that they are there – touch one of us, knock, speak to us, affect us in some way. I thought I saw something over my left shoulder move. Over my left shoulder was the darkest corner of the room. I told the others that I may have seen something, but it may well have been my imagination, so they suggested, as I feared they would, that I should go and sit in that corner. The room was pretty dark to begin with, but a couple of security lights meant that we could move around safely and easily without the need for a torch. However, I can't express how dark this corner was; I felt as if the darkness engulfed me as I took my seat, and John and Tom said that they could no longer see me at all.

John began once more to speak out, his voice filling the room. He asked a variety of questions, enquiring as to the spirit's name, their connection to the building, and whether they wanted us to leave. Sadly, we didn't experience anything out of the ordinary to any of these questions, so I suggested that we try a different approach.

I'd brought with me an EMF meter, which is a device used to detect electromagnetic fields. It was originally designed to help diagnose problems with electrical wiring and electrical shielding effectiveness, but has been adopted by ghost hunters to determine the presence of spirit. There is a widespread belief that ghosts emit an electromagnetic field that can be detected by one of these devices, which cost as little as £20, and any unexpected change in EMF meter readings may be due to paranormal activity. There is no solid evidence to back these claims up, but that's not to say that we should dismiss it as not being a valid experiment. We'd discussed this previously and agreed that an unexpected reading is by no means proof of a ghost being present with us, but we were hoping that we would have unusual readings over a continuous period of time in response to asking for a spirit to move closer to the small grey box, or perhaps in conjunction with another potentially paranormal occurrence.

John took the device from my bag and he pressed and held the button in. It began ticking gently as it sought out electromagnetic fields. I asked for any spirits in the room with us to let us know by approaching John, and no sooner had I finished talking than the tone emitting from the metre went higher, meaning the reading was increasing. I asked John if he had moved and he said he was stood perfectly still. I asked if the spirits could move even closer to John. The reading increased again to '8' on the scale of 1–10, emitting a high-pitched whine. This remained constant as I spoke the words that John dreaded, 'Could you move even closer again to John, so close you could touch him, so close that he can feel your breath on his skin?' The EMF meter spiked, reading off the scale, beyond a '10', and the high-pitched whine had become an electronic scream. This lasted for no more than a couple of seconds and then it completely stopped. The reading returned to a '1' on

the scale, and the noise was nothing more than a low ticking as the device searched in vain for an electromagnetic field.

We persevered without further results, and at 10.15 p.m. we decided that, with so many other areas of the building still to investigate, we would have to move on.

The next area was designed like the creepy graveyard of Greyfriars. The room had chairs made up like gravestones around the wall of the room, the wall was painted with creepy trees bare of their leaves, a church steeple and a city wall with spikes along the top, all bathed in eerie moonlight. The recording that we could hear throughout the building was coming from this room, so it was very, very loud, which would prove to be a major disadvantage to our vigil in this room as we'd have to focus on seeing something or feeling something, as we simply wouldn't be able to hear anything over the sound effects.

I spoke aloud, introducing the three of us. I asked if someone was there with us, and if they could show themselves to us.

After ten minutes of inactivity, and seemingly no response to our requests, we decided to give up the ghost (if you will pardon the pun). It's possible that someone, or something, may have been trying to communicate with us, but we knew it would be difficult to identify with the noise from the room.

At 10.25 p.m., I led the way along a dark corridor, almost bumping into a mannequin made up like a fourteenth-century plague doctor, complete with the mask with a 'beak', that would be filled with aromatic herbs to keep the bad smells away, which they believed at the time carried the Black Death. We turned the corner and entered the Mary King's Close area, the words of Jenny from our walkaround earlier still fresh in my mind – 'this is the area where staff don't like to come on their own.' The first thing we all commented on was how quiet it was; in every area we'd visited so far, we'd been able to hear the recording, but it was totally silent here.

When we entered, the wall on our left was solid brickwork as this area was once an actual close, and beyond the ancient stonework was a large room, which was originally two stables. There were two huge windows in the wall, but we couldn't see through them as they were dusty and dirty, which only added to the pretence of the area appearing as Mary King's Close would have done at the height of the Black Death.

With time at a premium, I was keen to see what lay behind the door to the old stable, and upon heaving it open it was clear that it wasn't used often – there were a few old chairs and mannequins, and a locked archive. John said that he would wait outside for me and Tom. He wasn't scared of what may lie in wait within, it was far simpler than that – he didn't fancy the 3 foot step down from the door to the floor level within the room. Equipped with a head torch, with my voice recorder and camera in my pockets, I left my bag behind with John, who illuminated the area for me with his torch as I jumped down. I turned on my head torch and began to explore as Tom climbed down behind me. The walls were all the original brickwork and I looked up to see the curved ceiling way up high. 'Urrghh, what's that weird smell?' said Tom in disgust as he reached ground level and dusted himself down. I knew the smell he meant, as I'd smelt the same thing hundreds of times before, most usually in castles or abandoned mansions; it was the musty smell of an old unused building. I suggested to John that if he were to close the door, we could spend ten minutes quietly in here while he sat quietly out in the area mocked up like Mary King's Close. He said he was happy to do that and wished us luck as he struggled to push the big, heavy door closed. Tom and I turned off our torches and the darkness was absolute.

Conscious of John being in the corridor outside, I spoke quietly and asked that if we weren't alone, to do something to let us know. This was met, seemingly on cue, by a bang which seemed to come from outside the door where John was. I whispered to ask Tom if he'd heard it and he had. Then we

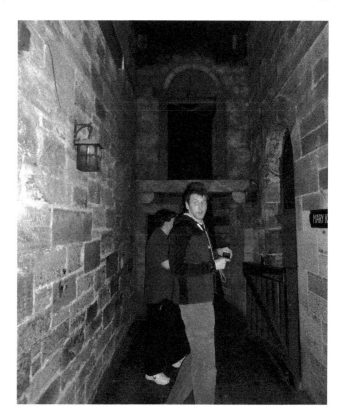

Tom and John investigate the Mary King's Close exhibit.

both clearly heard footsteps, which seemed to come from either just inside, or just outside of the room. Again, Tom confirmed he'd heard these too. The rational, and probable, cause of these noises was John wandering around outside, so I asked Tom to open the door so we could find out where he was. Tom clicked on his torch and slowly pulled the door open, the sight that greeted us made us both jump, there was a large man shaped figure filling the void, standing perfectly still leaning into the doorway, staring down at us. Tom shone his torch, and we were relieved to see it was John.

'We heard a bang out there, did you hear it?' I asked.

'No.'

'We heard footsteps too, definitely footsteps, from near to that door. Were you walking around?' I added.

'No. I've not moved a muscle since I closed the door.'

Tom looked at me, and I looked back at him. 'So since you closed the door you've been stood perfectly still staring at the closed door?'

'Well, yeah!'

Fair enough, John's actions may have been a little bizarre, but this was promising. The bang and footsteps Tom and I had clearly heard were still to be explained. I asked John to grab my EMF meter from my bag and pass it down to Tom. Since the sounds seemed to have come from somewhere near to the entrance to the room, Tom moved to that area and held the button down on the meter. I asked for any spirits with us to move nearer to Tom. We persisted with this for five minutes with minor fluctuations but nothing out of the ordinary. I suggested that we rejoin John back in the Mary King's area and see what that has to offer.

After clambering back up and out of the room, we walked a little way down from the entrance, next to the doorway to the next room. Tom and I sat quietly and expectantly on the ground, as John asked a series of questions and made a number of requests, all of which were met by silence. I decided to give the EMF meter another try, and as I pressed the button down on the meter I asked for them to come closer to me. The meter, which had initially registered a '2', jumped up to a '4'.

'Come on, come even closer,' challenged Tom. It went up to a '5'. 'Come on, come and play with us, we'd love to be your friends'. It stayed static on a '6'. 'What are you frightened of? Come and stand right next to us, or are you scared?' Tom goaded the spirits. The meter got louder as it registered a steady '8'. Then, ten seconds later, it dropped right back down to '0', and a constant tick, tick, tick as the electromagnetic fields had vanished. 'Damn, I felt we were getting…' I stopped Tom mid-sentence, as I had heard a disembodied voice within the room, what sounded to me like a female voice talking. It seemed I wasn't the only person as John had heard it too. We sat silently, waiting, hoping, and we didn't have to wait long. We heard it again, this time all three of us.

We sat silently, waiting to see if the voices returned. The silence was briefly broken by two loud thuds, which appeared to come from directly above us, but before we could address the noise from above the voice returned. It was definitely female, but it was at that moment that John seemed to have solved the mystery. He proposed that it was most likely the stationmaster's voice coming through the tannoy system at Edinburgh Waverley station, which was just behind the dungeon. We heard it several times across the next few minutes and agreed that it did seem the most likely explanation.

At 11.00 p.m. we moved through the doors into the William Wallace room. Half of the room is taken up by a stage with three decapitated heads on spikes, the central one of which has William Wallace's face projected onto it during the tours, and it's suggested that he was so tough that even chopping his head off didn't kill him. There is a vomit bucket to one side of the stage, and a chopping block and axe at the other. A sign reads 'AD 1305 23rd August, the main event – the execution of the freedom fighter William Wallace'. Hacked-off limbs and gore are scattered across the stage.

The first thing that struck us was how cold it was in this room, as so far the rest of the building had been a comfortable room temperature.

I placed my voice recorder on a stool next to the chopping block and took a few photographs, and we sat in silence for five minutes. It was really quiet, and very, very dark. Five minutes passed uneventfully, so I attempted to stir up some activity by asking aloud. We heard three loud bangs. We couldn't establish where they'd come from, but we'd felt them as we were all sat on the stage. We continued to ask for signs, but ten minutes later we agreed to head back to base. With an hour and forty-five minutes left before we had to leave, we could have a drink, and discuss how best to make the most of the remaining time.

Or at least that was the plan.

With the building a hellish warren of macabre exhibits and creepy corridors, with multiple routes to any one room, we weren't sure of the exact route back to the base. I clicked on my head torch and tentatively opened one of the three possible doors out of the room. This new room was bathed in torchlight and I immediately recognised it as being a room we'd passed through on the daytime tour a few weeks earlier, a mirror maze called Labyrinth. This was good news, as we knew this led to the entrance, and the winding staircase back to base.

When we'd tackled the maze of mirrors on our previous visit, we'd simply followed the kids in

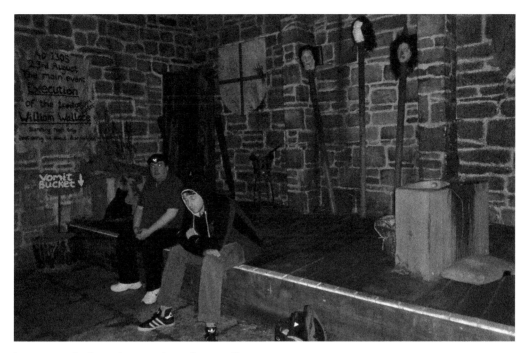

'FREEDOM!' John and Tom in the William Wallace Room.

front of us through. There are a couple of safe paths through, but there's also a fairly good chance of walking straight into one face first.

'Oh great,' muttered Tom, as he popped his head through the doorway to see what lay beyond, 'there's not much chance of encountering spooks in here, but a fairly high chance of smashing my face in on one of those huge mirrors.' I reassured him that we'd be fine if we used our torch beams to check each mirror and just take our time. I led the way with Tom behind me, and John lagging way behind. The room was noticeably silent, and almost completely pitch black. Thinking nothing of this fairly arbitrary room as anything more than a shortcut, I carefully navigated the first few mirrors. Then it happened, and it was so unexpected, so horrifying, that it was undoubtedly the most terrifying thing that any of us had experienced, not just on this investigation, but in our entire lives.

The room was filled by a deafening high-pitched female scream of terror and anguish. I froze, struggling to comprehend what was going on; it almost seemed to be happening in slow motion.

I was in for an even bigger scare as I heard a separate shrill scream inches from my ear and an icy cold hand grabbed my arm tightly. My blood ran cold and every hair on my body stood on end as I started to genuinely believe that we might be under attack. Behind me, I could hear John's panicked screams, which alternated between blasphemy and swearing over and over again as the hellish shrieking continued.

I span around to face my assailant and came face to face with Tom, who had screamed and grabbed me in fright. I looked beyond my petrified brother, and John's face was twisted in fear and panic. He was running backwards and forwards, arms outstretched, in blind terror trying to escape our unseen attacker while screaming and pleading for someone, anyone, to help him. The blood-curdling screaming stopped as suddenly as it had begun, but another nasty surprise awaited

us. Right next to where John was running back and forth a light switched itself on, and a figure stood up and looked at us.

We ran away.

The careful navigation of the mirror maze was abandoned as all three of us fled as if our lives depended on it, dodging and weaving between the mirrors. A few seconds later, we found ourselves in the reception area of the dungeon, and we all felt foolish and embarrassed as it dawned on us what had happened: the effects in the dungeon had been turned off, but somehow this one had been overlooked and a motion activated scream had sounded with us passing through. The figure that had jumped up was a spooky skeleton designed to frighten kids during the daytime tours. It had most certainly succeeded in giving us the biggest scare of our lives. Tom kept giggling, chastising himself for being so frightened and having let out a high-pitched scream and grabbed me. John was leaning over the counter, holding his chest and trying to catch his breath.

We returned to base and Tom was still giggling and shaking his head. We had a drink and John had a puff on his inhaler and then ate a KitKat to help calm himself down as we listened back to John's recording from a few minutes earlier in the Labyrinth. Ten minutes had passed since the terrifying ordeal we had endured at the hands of man-made effects designed to give people a fright. Tom and I burst out laughing as we listened. John could see the funny side but was still struggling to catch his breath.

We knew that, with just over an hour and a half left, we had to press on, and quickly discussed the order in which we'd tackle the remaining rooms.

The next room was a court room, similar to the room we called 'Judges' at York Dungeon. It was made up as a dock with mannequins conducting proceedings with a view over the rows of seats, which seemed to be reclaimed church pews. Rows of shelves were painted to appear like they are full of books. Tom sat in the second row, and John sat in the back row. I placed my voice recorder on the front row, pressed record and sat on a large seat made to look like a throne with my back to the wall of books. John spoke.

'Is there anyone else here besides the three of us? We're here with respect, please speak with us. We mean you no harm. If you are here please give us a sign of your presence.'

'Make a sound?'

'Move an object?'

'Touch one of us?'

A few minutes frustratingly passed without any response to John's questions except the eerie screams of the sound effects, which we could hear again. We tried a change of approach. Tom asked some questions.

'Please speak to us – if we can't hear you we have recording equipment that may be able to. How many people are in this room?'

We all heard a knock, which seemed to come from the Judge's dock.

Tom repeated his question. 'How many people are in this room?'

We heard a knock again, this time from the wall painted like a bookcase that I was sat with my back to, scarily close to me.

Tom repeated the question again, and as soon as he had finished speaking the light through the window in the door was suddenly blocked out by someone walking past. I looked over to Tom and John, who were looking expectantly around the room, waiting for another knock. I told them that someone had walked past the door and realised that from where they were sat they couldn't see the

Judge Dread! Could the court room provide the first possible sighting of an actual ghost?

door, so couldn't have seen what I had. I popped my head out the door, expecting to see Jenny or Helen as the staff room area was nearby, but there was no one there. John radioed through asking if anyone was moving around, but the response came through loud and clear that they weren't even on the same level of the building as we were.

We tried to recreate the light being blocked out, and I established that whoever it was that had walked past and blocked out the light must have been roughly a foot shorter than me, and I stand at 5 feet 10 inches.

Tom's questioning had generated the results, so he asked aloud again, asking for whoever it was outside the room to come closer, come and join us inside the room. I quietly took the EMF meter from my bag and held my thumb on the button on the side. It made a fairly quiet tick-tick-tick, and Tom encouraged the spirit with us to come closer to me. I felt like something was going to happen, but we persisted for another fifteen minutes without it materialising.

We moved to the only exhibit we'd yet to investigate: the Sawney Bean room. I checked my watch just in time to see it tick past midnight. The room is an exact reconstruction of the cave that is believed to have been home to the cannibal and his incestuous family, complete with blood and jointed human remains hung up just ready to be eaten. On the daily tour there are two actors playing Sawney's children, who explain their dad has gone out looking for food. On the day we took the tour, the actor playing Sawney's daughter pointed out that her 'ma would love Tom, as he's got a massive heed'. The tour is quite jumpy, as the actors move around really quickly, dodging and weaving through little tunnels and shortcuts behind the scenes in the 'cave'. You're forced to constantly try and keep your eyes on both of them, unsure where they'll pop up next.

We spread out as best we could in the fairly small room and I hung the voice recorder from a pillar. We clicked off our torches and stood silently in the darkness. We only waited for a few minutes but it seemed like a lot longer, as my eyes struggled to adjust to the blackness which seemed to be closing in all around me.

After a few minutes I suggested that we ask specific questions and I asked out for whoever was with us – and I did feel like we weren't alone – to let us know they were there.

'Could you give us some kind of a sign, knock, talk to us, touch one of us?'

I waited expectantly. John burped.

I asked again, specifically asking the spirits to copy my knocking. I knocked twice.

No response.

I still felt like we weren't alone, as if someone was with us, watching us, capable of letting us know they were there, but not wanting to. It wasn't paranoia, as I've been in similar situations in similar locations many times before.

The Sawney Bean room hadn't produced anything out of the ordinary in the thirty minutes we spent in there. The time was approaching 12.30 a.m., and with only thirty minutes left we had a decision to make: should we remain here or head to a location we'd been to already which we felt might yield better results? We all agreed to return to the Mary King's Close exhibit.

Back in the Mary King's Close area, John and Tom both started complaining about how cold it was; John was, unusually, without his massive coat, as he'd left it in the base room. It was definitely colder than it had been earlier, but I didn't seem to be feeling the cold as badly as they were.

Tom knocked on the wall, asking for whoever was there to copy him, there was no response.

After a long night, it was growing increasingly frustrating, as no matter what we asked, no matter what we tried, we weren't getting the results we were hoping for. We had to keep the faith and hope that our persistence would pay off.

I casually mentioned that I had this feeling that we were being followed around the building by a child. I couldn't explain why at the time, and I still can't explain it now, although the light blocked out from the doorway when we were in the court room could have been someone the height of a child.

Tom said that he'd felt that a child was with us in the first room we investigated, the Torture Chamber, and he couldn't explain why either.

If it was a child with us, perhaps he or she was too shy to show themselves to us. I challenged them to shake the curtain at the opposite end of the room from where we were sat on the cold hard floor. I suggested they could shake the curtain and run away if they were shy. Sadly, nothing happened.

We continued to attempt to rouse the spirits of Edinbugh Dungeon unsuccessfully, and when the time reached 12.50 a.m., it was time to draw our investigation to a close. We headed back to base to gather our belongings. Without even discussing it, we avoided the mirrored Labyrinth and took the long way back through the Graveyard room, the Mortuary, and the Torture Chamber.

Back in the staff room, John radioed that we had finished our investigation and Jenny and Helen came to see us.

'So, are we haunted?' Helen enquired cheerily as they walked in and took a seat.

We recounted the highlights of our evening, and it was only when we did this that I realised how many experiences we'd actually had at Edinburgh Dungeon: the footsteps outside the stables, the figure walking past the window, the EMF meter behaving strangely in the Mortuary, and we told of our heart-stopping experience in the Labyrinth. They both burst out laughing and then apologised as they must have forgotten to turn the effects off.

We thanked them both for giving up their Saturday night so that we could experience the Edinburgh Dungeon and we headed out into the night. It was bitterly cold, so I pulled my coat tightly around me in a hopeless attempt to keep the freezing temperature at bay. However, the almost sub-zero temperatures didn't seem to be bothering the scantily-clad revellers who were enjoying the famous Edinburgh nightlife.

We were back in the car a few moments later, I turned the heating up high and we left the city centre and made our way back to the bothy at Musselburgh. Once we'd left the A1, I navigated a series of narrow, unlit winding country lanes – it was all very *Scooby Doo*. The radio was turned down low but I couldn't help but smile to myself as the DJ on the local radio put on 'Thriller' by Michael Jackson, the late 'King of Pop'. It seemed apt. Out of the corner of my eye, I noticed the temperature display on my dashboard drop from 1° C down to zero.

We were back at the bothy around half an hour after leaving Edinburgh. We had left the heater turned up as high as it would go, but it was still a bit chilly. We had all brought sleeping bags so settled down as best we could to try and get some much-needed sleep. Once the light was out, we talked quietly about the experience we'd just shared at the Dungeon. After only a few minutes, Tom dozed off, John and I continued to talk but I could feel my eyelids growing heavy.

The next thing I knew, I was being woken up by loud banging coming from the far end of the bothy and I heard John and Tom talking. I desperately hoped it wasn't time for us to get up as I was shattered still. 'What's going on man?' I groggily demanded to know. John answered in his usual calm, measured manner, 'I'm going for a walk.' I struggled to focus, such was my tiredness, as I tried to make the time out on my watch. It was 6.45 a.m.

He continued to stomp around and rustle carrier bags as I pulled my sleeping bag over my head to try and drown out the racket he was making.

He slammed the door to the bothy and headed out for his walk.

At 8.00 a.m., I was awoken by John's alarm on his mobile phone. At precisely the same moment, John re-emerged through the door to the bothy, and as it was closing I could see it was raining heavily outside.

He doesn't wear a watch so I asked how he knew it was 8.00 a.m. He explained that he'd been for a walk around the site in the rain, but with it not being a big campsite that didn't take too long, so he sat on a green plastic garden chair on the decking outside the bothy and had a sleep outside as he didn't want to wake us up again.

He went on to say he hardly slept during the night and listed the reasons for this: he had a bit of a cold coming on, I had been snoring, and Tom had been making strange breathing noises, one of which sounded like a woodpecker pecking a tree. He also complained that he'd heard peculiar noises outside in the woodland behind the bothy, including one that he'd heard not long after Tom and I had fallen asleep, which he described as sounding like 'two monkeys having a fight'.

By 8.30 a.m., we were on our way home and John was fast asleep in the back of the car. Tom and I agreed we'd had a brilliant twenty-four hours in Edinburgh, and discussed our own personal highlights of our first investigation. We couldn't wait to come back and continue our search for proof of the paranormal in this glorious city.

CHAPTER TWO
GRAVE MISGIVINGS
COVENANTERS PRISON, 30 JUNE 2012

The British summertime was here again. If you've read *Ghosts of York*, you may recall that the previous summer we had eagerly anticipated our investigation at York Dungeon as I'd intentionally arranged it during a traditionally warm month, so we could bask in the guaranteed sunshine. However, the weather hadn't been great for us that day, and a year on we were enduring the wettest June on record; in fact, just two days earlier had seen a great storm that many of us will never forget, with two months' rain falling in just two hours as Newcastle was battered by the worst storm the city had seen in living memory. The streets ran like rivers, bringing the city to a standstill slap bang in the middle of rush hour. The Metro Centre was flooded, Newcastle Central train station flooded and closed, and footage of the Tyne Bridge being struck by lightning made breaking news worldwide as 1,500 individual lightning events occurred during the two-hour storm.

Despite the forecast today warning of a 60 per cent chance of rain, 2.00 p.m. found Tom, John, Rich and I sat in glorious sunshine on a wooden bench in Berwick-upon-Tweed, overlooking the golf course and the coastline beyond.

There were plenty of people around, with dog walkers and families heading to the caravan park. Rich and I were eating fish and chips and Tom and John were munching on sandwiches and pasties from Greggs. Unsurprisingly, it wasn't long before we were circled by greedy seagulls, with their beady eyes firmly fixed on scavenging our scraps. They came close, then moved away, then grew in confidence and came even closer and backed away. Tom chucked one of them a bit of bread, this was gulped down within seconds and a couple of the gulls started squawking, no doubt a rallying call to their equally greedy pals of 'Grub's up, come and get it!'

Once we had finished eating, we took the cliff-top walk back to where I'd parked my car. Our hunger had been satisfied by fatty food, and we laughed and joked without a care in the world.

At around 2.45 p.m., we were heading towards the A1, but we weren't going to turn north towards Edinburgh (our ultimate destination) we were going to head south towards Haggerston Castle Holiday Park, where I'd arranged a luxury caravan for us. Our plan was to spend a relaxing afternoon at the five-star Haven site, then head into Edinburgh early in the evening. After our investigation, we'd return to our comfy caravan.

Ten minutes later, I was turning left off the A1 through a white lion topped gateway, and along a winding tree-lined road, which led to a small car park outside of the reception. Rich jumped out and returned a couple of minutes later clutching a map of the park, four passes to get into the entertainment complex and the key for our caravan. He unfolded the map onto his lap, Tom and I twisted around and the four of us studied the colourfully illustrated sheet.

Our caravan wasn't far away, so only a minute later I was unlocking the door to a Gold standard caravan; a big spacious living area with a 20-inch HD television, a circular table already set out with

dinnerware, and long sumptuous seats. The kitchen area had all mod cons: a fridge, a microwave, a kettle, an oven and a grill. The bathroom and shower were clean and tidy, and the caravan had three bedrooms; two twins and a double. John was taken aback, he'd never stayed at a holiday park like Haggerston Castle before and he was mistakenly expecting a comparatively tiny caravan, the kind you'd see being towed up and down endless anonymous stretches of motorway, and the clichéd image of having to pee into a bucket.

Tom took the double room, and Rich and I took a twin room apiece. John was going to sleep in the living room area – by his own admission he doesn't like sleeping in the same room as other people if it can be avoided, as he likes his privacy. Also, he's prone to night-time walks – this way, he could do what he pleased without disturbing the rest of us.

Having left our stuff in our rooms, we sat down to decide how to spend our afternoon, as we didn't have to leave for Edinburgh for another four hours. Tom, John and Rich were spread out on the seat, which followed the wall all the way around the inside of the caravan. I sat on a stool facing Tom and John, and beyond them the large window looking out of our caravan had a pretty spectacular view with the castle for which the park is named to the right, and a huge lake directly opposite us; beyond that, the sun was high in the sky illuminating the water.

We were shooting the breeze as Rich chugged Rainbow Drops straight out of the packet.

'This is a really nice caravan, it'll be good to have this to return to after the investigation tonight,' he said between mouthfuls.

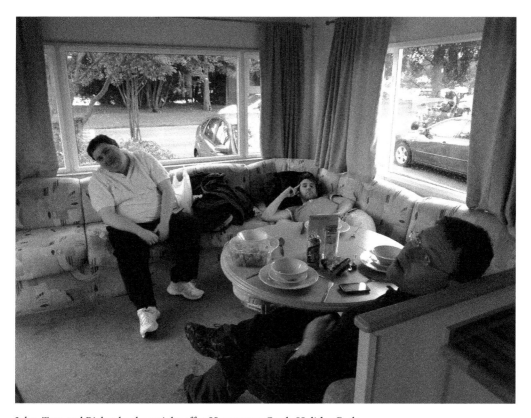

John, Tom and Rich take the weight off at Haggerston Castle Holiday Park.

'Yeah, unless *something* follows us back here, although I've never heard of a haunted caravan!' I joked. We laughed, but our laughter was brought to an abrupt stop when there was a loud bang from the far end of the caravan. Concerned looks were exchanged between the four of us for a fleeting moment before we laughed it off.

Outside, the sky turned ominously black and the inevitable happened a few minutes later – a massive downpour. We watched, warm and dry, as families dressed for the summer battled the elements, rushing to their caravan or the entertainment complex, whichever was closer, as the good old British summertime let us down once more. The rainfall got increasingly heavy, and there may well have been six hours before we had to be in Edinburgh, but I was secretly hoping that this wouldn't be in for the day, as our investigation this evening would be almost completely outdoors.

Thankfully, within twenty minutes the rain had passed, and the sun had his hat on again. John dished out our entertainment passes and we walked over to the main building, which housed an entertainment complex. The park was fantastic, with so much to do; we passed a boating lake with pedalos in the shape of swans and dragons, and every single one of them was being used by parents and children having a brilliant time.

The entertainment area was absolutely buzzing with sights, sounds and smells that took me whizzing back to dozens of childhood holidays at similar parks all over the country with my brother and my Mam and Dad; over-excited kids running around buzzing from sugary drinks and sweets, the flashing lights of fruit machines and video arcades; the sounds of laughing, talking, music, and money going in, and coming out, of machines; the smell of chlorine from the swimming pool, and flame-grilled burgers at the Burger King kiosk. Then I'd return to the caravan to play with my He-Man toys, having frittered away the pound my Mam had given me on the Tupenny Nudger fruit machine and the Penny Falls machines with the moving platform where you need to time putting your coin into the slot into perfection then hope the platform pushes some coins off to the lower platform, then ultimately off the end and down into the little coin collector tray where your winnings went. Inevitably, I'd have my little plastic tub of 2p pieces, and I'd lose the lot trying to get enough coins to come out for a Thundercats key ring, or for a Knight Rider watch to come tumbling down in a copper coin tsunami. Then some cocky kid would come along with no money at all, and just kick the machine so a load of coins dropped out.

In my childhood, I also used to enjoy those machines with a robotic claw, which I'd control to try and win a cuddly toy, often Mario or Sonic the Hedgehog. I'd carefully line it up perfectly above said toy, my brow furrowed in pure concentration as I made tiny movements to get it just right. I'd study the positioning of the arm from many different angles and when I was happy that it was spot on, press the fire button confidently. The arm plunged quickly and grabbed the head of the toy beautifully – there was no way it could have been better positioned. I'd punch the air in triumph, just in time to see the arm begin its return journey, and no sooner had it starting moving upwards the claw would open ever so slightly and drop the toy back in with its cuddly brethren, for some other mug to spend 20p trying to win. Just to rub salt into my wound, I'd stand and watch as the robot claw returned to where my prize *should* have been dropped, and it opened its robot fingers, releasing nothing into the hole.

I was like a kid all over again and as Rich, Tom and John wandered off to explore, I got some change to play on the fruit machines. After losing four whole pounds on Beaver Las Vegas, I decided it wasn't my lucky day and went to see what the others were doing. John and Rich were having a rather competitive game of air hockey, and Tom was trying his best to take the £5 jackpot

out of a Monopoly fruit machine. We were all having a great time, our minds a million miles away from what we were really on the road for – the ghost hunt which lay in wait for us that evening.

We'd had great fun, and we deserved it; we'd had a hard working week before spending our Saturday night in a place with a hellish reputation: the Covenanters Prison in Greyfriars Kirkyard, a former prison in the corner of an eerie graveyard that has to be locked because the city council are so fearful of visitors being attacked, pushed, kicked, scratched, bitten, or worse.

We stepped outside the entertainment complex into glorious sunshine. The earlier downpour couldn't have been further from our thoughts as we walked slowly. We'd had a dreadful summer so far and this was a rare treat.

When we got back to our caravan, Rich decided to go and have a lie down in his room and grab some sleep. Tom, John and I passed the time with a game of cards.

By 6.00 p.m., Rich was still asleep and the rest of us had run out of things to do to pass the time. John was browsing the internet on his Samsung Galaxy S2, I looked over at Tom and he was lying on his back looking at the ceiling.

'Should I see what's on telly?' I asked the others. Tom turned his head to look at me and shrugged; John looked up and said, 'Yeah, if you like.' Despite the lack of enthusiasm, I got up from my seat at the table and flicked the switch on the wall. The sound came through first as the picture began to warm up, I immediately recognised the voice of Hollywood funny man Bill Murray and got excited at the thought that *Ghostbusters* might be on. 'Bill Murray,' I smiled to the others and nodded towards the television, they looked up at me again and didn't seem too impressed. I continued to listen and didn't recognise the dialogue, when the picture appeared it quickly became clear that it wasn't *Ghostbusters*, it was *Garfield: The Movie*. Given the lack of interest from Tom and John, I didn't even bother trying the other channels, and backed into my seat and the three of us sat and watched it quietly. I checked my watch and saw that we'd have to leave within the hour for Edinburgh.

I wondered how the others were feeling about tonight's venue. It was possible that they didn't realise the notoriety the Covenanters Prison has earned within the last twenty years, as there have been literally hundreds of reported attacks by the malevolent spirits that are said to haunt the site of the world's first concentration camp. Even if the lads were aware of these attacks, I'd been careful not to tell them of the fate of the man called in to help these troubled souls move on. In 2000, the Reverend Colin Grant performed an exorcism within the prison. He was shaken by the strength and resilience of the spirits that, after the failed exorcism, he commented, 'I wouldn't be surprised if this kills me.' He died shortly afterwards.

I often get asked if I get frightened creeping around some of the scariest places on Earth in the dead of night, but I wasn't feeling at all scared, nor was I anxious, I was almost bursting with excitement. Ever since I became immersed in Jan-Andrew Henderson's fantastic book *The Ghost That Haunted Itself* on a weekend break with my wife at Eyemouth on the Northumberland coast in a caravan almost identical to the one I was currently sat in, I'd been eager to face this particular venue. That book set my imagination alight, and was one of the primary reasons that I selected Edinburgh as the focus of this book. I was no doubt one of the few people who would enter the 'Black Mausoleum', a nickname given to the tomb in which the tour ends, and the epicentre of the activity, and actually want to feel the full force of the negative spirits that reside there, regardless of what the result of that might be.

With time ticking away, I popped my head into my bedroom and picked my backpack off the bed and returned to my seat with the others. I unzipped the bag and carefully removed the

contents one by one and laid them on the table. Before me was the equipment I'd selected for tonight's investigation: my head torch, two Olympus digital voice recorders, a digital camera, an EMF meter, and plenty of spare batteries. Tonight, I had brought minimal equipment, as given the length of time we were likely to get alone at the venue, we were going to have to get back to basics and rely on our senses more so than expensive electronic gadgets in our search for proof of something otherworldly. I took my time checking each piece of kit thoroughly, checking for full battery charge, making sure the SD card in my camera had plenty of space; this was a routine I had done so regularly that I didn't have to think too much about what I was doing, akin to an Army sniper being able to strip down and reassembled his rifle blindfold.

By 6.45 p.m. Rich was awake, and noticeably chirpier for his nap. We had all packed some snacks and drinks, ghost-hunting essentials we'd need such as a camera and a torch, and an extra layer of clothing for the inevitable drop in temperature as night time fell.

We were all really excited as we piled into my car once more and set off for Edinburgh. This stretch of road is notorious for having more than its fair share of speed cameras, but we had more than enough time, so we were in no hurry. The roads were quiet, and we made the most of the journey as we drove along one of the most picturesque stretches of the A1 in a valley of luscious green hills and fields with grazing sheep, with the sea visible just beyond, glimmering in the early evening sun. We were merrily singing along to an eclectic playlist I'd put together with classics from artists as diverse as Stevie Wonder through to AC/DC, from the Black Keys to Plan B. John won't mind me saying that he hadn't heard of most of the artists and he only knew a few of the songs; however ,when he recognised the first few notes of 'All That She Wants' by his favourite band Ace of Base (I added it specifically as a little treat for him, my iPhone is usually completely devoid of any Scandinavian '90s pop) he sprang to life, singing every word and bobbing his head along to the tune.

As we neared the city centre, the traffic became fairly heavy, but we made good time and I parked up just after 8.00 p.m. outside the police station on Chambers Street. We got out, and as the others stretched their legs I grabbed my bag from the boot. The bustling nightlife was in full swing on an idyllic summer's evening in the cosmopolitan city of Edinburgh. People of all ages were dressed up to the nines for a big Saturday night out, whether it be couples going for a meal in one of the many fancy restaurants, or partygoers making the most of the myriad bars and clubs on offer, with many headed for the nearby Grassmarket, a historic market square dominated by public houses. As we walked along Chambers Street, on our right we passed the statue of nineteenth-century publisher and politician William Chambers, for whom the street is named. To our left was the impressive National Museum of Scotland. The street has a wealth of notable buildings, many of them Victorian; we passed the Edinburgh Sheriffs Court, and then the Tower Restaurant belonging to the National Museum of Scotland, but we paid them little interest as we neared our destination, which was in plain sight directly ahead of us: Greyfriars Kirkyard.

We navigated groups of stag dos, and then bobbed and weaved through the tourists taking photographs of the famous Greyfriars Bobby statue, and we passed through the gateway into the world-famous graveyard of Greyfriars. We stopped in front of the gravestone marked as being the resting place of Edinburgh's favourite dog, Greyfriars Bobby, although it is merely a folly for the benefit of tourists, as Catholic law states animals cannot be buried on consecrated ground. It was clearly working, as visitors had left all manner of gifts for the tragic little Skye Terrier: sticks and toys for him to play with, even money from all over the world. I looked around, the sun was descending but was still fairly high in the clear sky and there were still plenty of people in the graveyard, dog walkers and tourists, much like us I suppose. The Creepy Wee Shop in the

The grave of Edinburgh's best-loved dog, Greyfriars Bobby.

graveyard had long since closed for the day, and with it being Rich's first visit to the atmospheric graveyard, I took it upon myself to give him a whistle-stop tour as we had a little time to kill. I led the others anti-clockwise intentionally as I wanted to save the best until last.

We took our time and marvelled at the incredibly ornate mausoleums, and before long we found ourselves outside the locked gates of the Covenanters Prison. We were booked onto a tour at 9.00 p.m., which would allow us to get beyond these gates, locked by the city's council out of fear that visitors may be attacked should they be able to freely wander the Covenanters Prison by day, and especially after darkness falls. The tour guide would tell us the amazing stories and I couldn't wait. I stood right up to the locked gate, peering through the bars at the long, wide, sloping grassy strip of land beyond, lined with tombs either side not dissimilar to the ones we'd spent the last ten minutes admiring in the area of the graveyard that the council consider to not be a risk to the public.

'Is this place *really* that haunted?' asked Rich. I turned around and almost bumped into him, as he was stood just behind me, peering over my shoulder, flanked either side by Tom and John. They looked at me expectantly. It was only now I noticed how dark it was in this little corner of the graveyard as the sunlight was largely blocked out by trees. An unexpected cool breeze passed right through me and I involuntarily shivered. I was planning to let them hear the story from a professional tour guide within the next hour, but despite the possibility that anyone passing might mistakenly assume I was running Edinburgh's least popular ghost walk, I decided to indulge myself there and then and fill them in on the incredible, yet terrifying story, of the Mackenzie Poltergeist.

The Covenanters were a powerful political force in Scotland in the seventeenth century. On 28 February 1638, 60,000 signed the 'National Covenant' in Greyfriars church to confirm their opposition to the meddling of the Stuart kings in the affairs of the Church of Scotland. This document formed the basis of a treaty whereby the Scottish government would support the Parliamentarians in the English Civil War. This was the catalyst for a volatile period in Scottish history known as the Fifty Years' Struggle.

Greyfriars Kirkyard is a popular haunt for visitors to Edinburgh.

In 1661, the National Covenant was repudiated by Charles II. The following year, the Covenant was torn up and Charles' own bishops and curates were appointed to govern the churches and 400 non-conforming ministers were ejected from their parishes. This led to a series of battles against government troops, and at the Battle of Bothwell Bridge on 22 June 1679, 1,200 Covenanters were taken prisoner and brought to Edinburgh. Some were executed and their heads displayed around the walls of Greyfriars Kirkyard, and the majority of the remaining prisoners were held by the Lord Advocate George Mackenzie on a strip of land within the kirkyard now known as the Covenanters Prison. His mistreatment of the prisoners earned him the nickname 'Bluidy Mackenzie'. They were given little shelter, 4 ounces of bread each day, and little water. Hundreds died, and were buried in an area of the kirkyard reserved for criminals; the remainder were executed, transported abroad as slaves, or were given their liberty if they would sign an oath of allegiance to the king. For those who died here, the last face they would have seen would have been that of 'Bluidy' Mackenzie. Even the 257 prisoners transferred to American plantations as slaves died shortly after leaving the prison, for they were placed on board a ship at Leith, which sank in the far north of Scotland, just off the Orkney Islands, with all on board drowning.

George Mackenzie would live until 1691, when he died in Westminster, and ironically was returned to Greyfriars Kirkyard, where he was placed inside a grand mausoleum designed by architect James Smith mere metres from the Covenanters Prison.

He would rest in peace for over 300 years before rising once more to terrorise the innocent.

In December 1998, a homeless man was desperately seeking shelter from a particularly stormy winter night. He wandered into Greyfriars Kirkyard and, as he looked through the bars on the

The circular tomb is that of 'Bluidy' George Mackenzie.

door of one of the ornate mausoleums, he could see light through an opening at the back. Tempted by the intact roof and his desperation to be warm and dry, he forced himself through the tight opening. Inside the vault, it was pitch-black and he lay down, relieved to be out of the wind and rain. He was lying on top of an iron grate, and decided that it may be warmer below ground. He removed the iron grate in the floor and descended a short, twisting, stone staircase and entered a second chamber. However, he lost his footing and smashed through the wooden floor into a third chamber. He landed in a deep muddy pit, and lit his lighter. The room was illuminated, and what he saw horrified him. The unfortunate man was surrounded by grinning skeletons; the rotting carcasses pre-dating the tomb, which had been built on top of what appeared to be a plague pit.

Unsurprisingly, the man got out of there as quickly as he could, scratching his arms and cutting his head as he scrambled out of the tomb.

A member of staff at Greyfriars had heard a series of bangs from the tomb, and was en route to investigate when he was stopped in his tracks by otherworldly screaming. Before he knew what was happening a wailing, bloody, figure was charging out of the crypt, straight for him. This was too much and he ran for his life. Both men vanished into the Edinburgh night.

The member of staff turned up for work the next day and told of his terrifying ordeal before handing in his notice.

In seeking a place to sleep for the night, the homeless man had inadvertently unleashed a terrible, violent entity into Greyfriars Kirkyard, and 'it' has taken up residence in the Covenanters Prison. Strange activity was to be reported almost immediately after the vagrant's disturbance

The locked gates to the Covenaters Prison.

of the Mackenzie tomb; people were reporting being pushed, having their hair pulled, being scratched, bitten, and even being knocked out. The Mackenzie Poltergeist found fame locally, and as the frequency of these incidents continued to rise, national, and then then international media latched onto the compelling haunting.

Edinburgh City Council were concerned, and in 1999 they locked the Covenanters Prison gates for fear of someone being seriously hurt, or worse, and declared the location off-limits to the public.

Enterprising local author Jan-Andrew Henderson approached the council and asked permission to take controlled tours into the prison. The council agreed, and now the acclaimed City of the Dead Tour is exceptionally popular with ghoul-hunting Edinburgh tourists. Since these tours began, it seems that the paranormal activity has escalated alarmingly, particularly in a tomb known as the Black Mausoleum, which seems to be the epicentre of the activity, with guests to the tour regularly being attacked, and hundreds of people have lost consciousness during the tours. There have been a number of dead animals, mainly birds, found in and around the Black Mausoleum. People have had their hair pulled, been kicked and punched and even had fingers broken. Unexplained scratches, bruising, burns, skin gouges, and bite marks have all been frequently reported.

Jan and his tour guides have even heard from people who've been on the tour, and the frights don't always end when the tour does. People have reported that 'something' has followed them home, with strange occurrences such as dogs who would usually be clambering all over their owners with excitement upon them returning home, whimpering and cowering from them, not wanting to go near. Electrical phenomena have been reported as well, such as light bulbs blowing and electrical appliances switching on and off by themselves.

As I brought my horrifying tale to an end, I surveyed the faces of my three friends before me. All three looked back at me completely expressionless. No one spoke for what seemed an age as I tried to second guess how they were feeling, given what they'd just heard. Were they excited and eager to take on the worst that Mackenzie could throw at us? Were they fearful of what lay in

store for us within the Covenanters Prison? Perhaps they were angry at me for not letting them know just how dark and dangerous this place actually was before they left the sanctuary offered by their homes and family back in Newcastle, well over 100 miles away. I checked the time. 'We've got to go, it's 8.45 p.m.!' Everyone sprang back to life and we walked quickly and with purpose out of Greyfriars Kirkyard as we had to be outside St Giles' Cathedral on the Royal Mile by 9.00 p.m., the meeting place for Blackhart Entertainment's aptly named City of the Dead ghost tour (www.cityofthedeadtours.com).

We made it with a few minutes to spare, and I introduced myself and the lads to the tour guide, a local guy by the name of Calum Lykan. He looked every bit the archetypal ghost tour guide, dressed head to toe in black: black shirt, black jeans, enormous black boots, and a full- length leather trenchcoat.

The bells of St Giles' pealed above us at 9.00 p.m. and our tour began. Calum stood on the steps of the awesome cathedral, the distinctive crown steeple of which dominates the Edinburgh skyline for miles around, and we gathered around. He introduced himself to the twenty or so eager faces staring back at him, men and women from all walks of life, and all over the globe, in fact there were only two Scots among us, three including our guide. A young denim-clad lady standing directly in front of me whispered to her friend, 'This tour; is it scary?' Her friend shushed her and didn't answer, but she wouldn't have to wait long to find out for herself.

'Welcome to the City of the Dead tour, and we'll shortly head to a place which is beautiful during the day, but even better at night – Greyfriars Kirkyard. The only downside of doing this particular tour during the Scottish summertime, if that's what you'd like to call it, is that it's still a wee bit light this time of night. I like it when it's dark, and damp, and dingy, as that's how a graveyard should be presented to you. There are two reasons why the kirkyard is perfect for the City of the Dead tour; the first is that it's an enormous mound of dead people, that should be enough, but there's more to it than that. That's why we offer you a very unique experience that you'll only get with this tour. We will give you access to the Covenanters Prison, a locked off section of the graveyard that is home to something very interesting. I've been doing these tours now for nine years and I've seen the most terrifying things, all to do with the entity which we call Mackenzie. I can't tell you what Mackenzie is, but I can tell you what he does, what I've seen first-hand; interactions vary, they can be anything from a push or a scratch, to a bite or a punch, even hair pulling, nausea, and cold spots, and one of the biggest things we get on these tours: knock outs.'

I looked around at the group, there were some worried faces, eyes wide with fear and trepidation for what lay ahead. I already knew that this wasn't going to be your *usual* ghost walk. I knew that anyone booking onto this tour thinking it might be a bit of a giggle may well have bitten off far more than they could chew.

'No one is against walking through a graveyard at night are they?' No one spoke, but twenty heads shook in unison. 'The paranormal is rarely black or white, but there's no denying what's going on at the Covenanters Prison. Mackenzie has several hundred authentic, documented attacks to his name now, and one death.' The status of some of the group was immediately elevated from worried to genuinely concerned. Calum knew it too and twisted the knife further. 'This is going to be a fun group tonight, I can tell. We're going to have screaming, panicking, running all over the place.'

With this, we left St Giles' and Calum led us to Greyfriars.

As we walked towards Greyfriars, I commented to the lads that it was beginning to get dark – the sun was low in the sky, which was a deep, rich, inky blue. We probably had thirty minutes of light left before the sun would disappear beyond the horizon.

We entered Greyfriars Kirkyard and Calum stopped in front of the headstone near the entrance made up for Greyfriars Bobby. 'This is a graveyard and it goes without saying that we need to show respect. However, if you should find yourself stood on the grass, or we cut across the grass to get to the location of our next story, don't feel that it is disrespectful; the truth is that it's unavoidable. If you don't want to walk on top of the dead, then please turn around and walk back out of the gates, as there are bodies below your feet right now.'

We walked counterclockwise and stopped at the headstone of John Gray, Greyfriars Bobby's master, and Calum regaled us with the Greyfriars Bobby story. He had the group hanging on his every word as he told us some of the other classic literary works penned after their writer had visited Greyfriars: Bram Stoker's *Dracula*, Mary Shelley's *Frankenstein*, *A Christmas Carol*'s three ghosts were dreamt up by Charles Dickens when walking the graveyard, and of course the much more recent Harry Potter series, written by J. K. Rowling while sitting in the Elephant House, which overlooks Greyfriars.

One moment we were enjoying the joviality, then Calum unexpectedly hit us with a figure which made us all stop and reassess. 'There are only 490 headstones in this graveyard, but you are actually stood atop of half a million dead bodies, this is officially one of the largest burial mounds on planet Earth.' He left a few seconds of silence to allow this to register. Then he continued. 'Actually, half a million is Edinburgh City Council's official figure, however historians believe it to be closer to double that amount.'

With that, it was the time we'd all been waiting for, and I personally had been waiting for ever since I first read about the Mackenzie Poltergeist – time to go to the Covenanters Prison…

As we neared the Covenanters Prison, I checked my watch and it was almost 10.00 p.m. Twilight had crept up on us almost unnoticed as we'd listened to our guide, and as the last few precious

The group hang on Calum's every word as he tells us the darker side of Greyfriars Kirkyard.

moments of daylight ebbed away, Calum removed the locked chain from the gate, but didn't open it. He stood on a low wall outside the gate and we gathered around in a semi-circle. He could sense the anticipation of the baying crowd and took a deep intake of breath before telling us, masterfully, the harrowing history of the Covenanters Prison – the same horrendous tale of unjust persecution and death that I had related to Tom, John, and Rich in the same spot only an hour earlier. When he reached the part of the story where the Covenanters were marched into the prison in irons, Calum pulled open the gate and allowed us to march in as he continued to talk.

Shortly after entering the prison, Rich stopped in his tracks, causing me to almost walk into the back of him. I tapped him on the shoulder and it was almost like he snapped out of a trance as he turned around. I asked him if he was alright, and he explained what had happened.

'As we entered the gated Covenanters Prison, our guide asked which of our team was "the inductor". He explained that spirits latch onto particular types of people and they typically experience the most phenomena. Since the experience at the National Railway Museum in York nearly two years prior, and each of the strange happenings at the other vigils in York, I found it quite easy to convince myself of being the Inductor. Plus it was quite a cool name, certainly worthy of a T-shirt. Before I could offer myself as our resident magnet of ghostly activity our guide finished his sentence, "…because the inductors are usually the ones who get knocked out."

'I kept my mouth shut.

'As we walked down the soggy grass towards the tombs, I was expecting at any second to get an unseen fist in the face, disembodied hands around my throat, or simply to fall unconscious and wake up later with a huddled mass of tourists around my damp, grass-stained body. At one point, about ten steps into the prison, I had an overwhelming feeling of nausea; putting it down to a

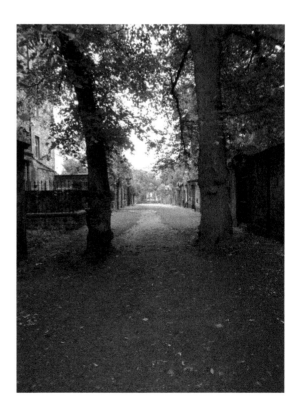

The moment I'd been waiting for – we were
finally inside the Covenanters Prison.

fear of invisible attackers, I ignored it. But it vanished as quickly as it had come. I made a mental note of where I was when it happened and would return later once the tour concluded and the four of us were free to roam.'

Calum led us further into the prison and ushered us into a gloomy tomb halfway down the strip of land on the left.

The four of us were the first to enter, so moved right to the back. There was almost absolute darkness inside. Once the final member of our party was inside, Calum took his place in the doorway, the last drops of daylight casting his long eerie shadow across us.

Calum commented on how warm it was inside the tomb. 'This is wrong, it shouldn't be warm in here; this should be fun.'

'Poltergeists by tradition have a focal point, usually someone within a family group, often a teenage girl. However, this one attacks anyone, it doesn't seem to care. So is it a poltergeist? What is it? It's rewriting all the books, it started off in the Mackenzie tomb, it moved to this mausoleum. It's learning, it's growing more powerful, it's evolving.'

An American tourist stood in front of me stood open-mouthed and quietly cursed.

The girl who'd earlier asked her friend if the tour was scary was stood next to me and she looked absolutely petrified, her voice was little more than a whisper; it quivered as I overheard ask her friend, 'will you hold my hand?'

'If you feel unwell, if you feel anything, let me know as soon as possible.' There was some nervous laughter, before Calum added, 'this isn't a joke.' Suddenly I was rocked by a headache; it hit me out of the blue, but I said nothing.

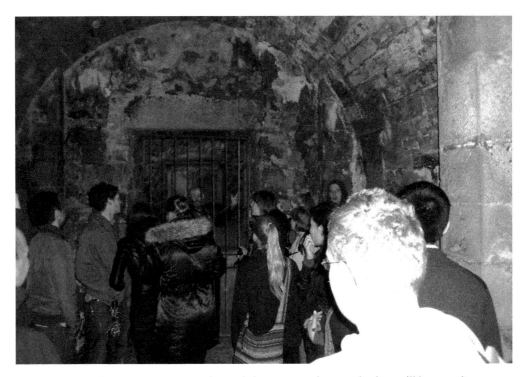

We're inside the Black Mausoleum, and those who've came on the tour thinking it'll be a giggle are most definitely not laughing now...

Calum was in his element as he proceeded to tell the nervous crowd the story of how the Mackenzie Poltergeist was stirred by a desperate homeless man in December of 1998.

Everyone on the tour stood silently listening to every word Calum had to say, looking around wide eyed, waiting, anticipating. It was almost inconceivable that nothing would happen. He brought his story to a surprise climax, which I won't spoil for anyone who reads this and then decides to take in the brilliant tour for themselves.

It was 10.20 p.m. and there was one last stop on the tour; the tomb of Mackenzie himself, just outside the gates to the Covenanters Prison. This is where the four of us would leave the group, as we had arranged to spend some additional time in the Covenanters Prison on our own. Calum led the tour to the Mackenzie tomb and we were left alone.

Tom went to explore the prison in general and Rich wasted no time in revisiting the area in which he'd felt nauseous earlier when we entered the prison. John headed for a tomb just along from where I was stood that Calum had suggested as being active. I was left alone in the Black Mausoleum, in which we'd just heard terrifying stories of attacks by Mackenzie. I wasn't afraid, though – in fact, I felt invincible as the adrenaline coursed through my veins, and I welcomed this opportunity to single-handedly face down this dangerous, unpredictable, vicious entity.

I was operating in a one-dimensional world, I could see nothing in the absolute darkness, and hear nothing but the shattering silence. It was enough to send a tingle down all but the most hardened of spines.

I pressed record on my Olympus voice recorder and broke the silence. 'Come on Mackenzie, I know you are there, do your worst,' I called out into the echoey crypt. 'I've heard you can make people pass out, scratch people, push people, come on then, do it!' I continued, trying to ignore my headache, which continued to get worse.

I waited in silence for ten minutes and a figure appeared before me. It was Tom back from his exploration of the prison.

Tom joined me in the depths of the tomb and in challenging Mackenzie to display his power. There was almost an electric atmosphere; oppression hung thick in the air. Tom shone his torch beam on a wall, and asked Mackenzie to show himself in the light. We waited, but he wasn't prepared to make an appearance.

'If you want to communicate with us, let us know, we simply want to know you exist.' Tom tried to reason with whoever may be with us. He felt a cold breeze on his face.

We continued for twenty minutes but we were hugely disappointed with the lack of activity. We left the tomb and found John and Rich standing inside a tomb with the inscription above the door reading 'James Rutherford, Writer to the Signet'. We asked how things had gone and they'd had very little, much the same as us, although Rich said that he'd experienced something strange when he returned to the spot where he'd felt ill.

'After leaving the tomb, I tried to navigate back to where it was that I felt sick. I stood there ... nothing. Retraced my steps from the gate down the grass again ... Nothing. Then I just stood in that place for a few quiet minutes ... Nothing. Disappointing. All jokes aside, I had expected it to feel a bit surreal – this was a concentration camp, after all. An early blueprint for future horrors inflicted on humanity.'

'Then something happened. In the windless prison, a large twig on the ground moved, I caught it out the corner of my eye. As I spun to look at it, the twig moved again, the nausea returned and I knew something was there. I was already recording audio (an automatic habit when entering haunted areas since our success at the site of Dick Turpin's hanging at York Tyburn) but I took a picture of the twig too. When reviewing the photograph, I noticed it was a mass of white light, I

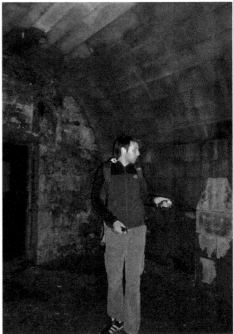

Above left: The Black Mausoleum – Rob takes on the Mackenzie Poltergeist. (*Photograph by Tom Kirkup*)

Above right: Tom challenges Mackenzie to demonstrate his power.

assumed I had just got my finger in the way of the lens but I wanted to be sure. Given the large size of my phone, I realised my stumpy computer programmer fingers couldn't reach anywhere near the lens when taking photographs because the shutter button on the screen is right at the bottom, while the lens is on the very top part of the device.'

We agreed it might be an idea to swap tombs, so Tom and I stayed where we were and Rich and John headed to the infamous Black Mausoleum.

Fifteen minutes passed by quietly, then there was talking outside in the prison. I looked outside, looking left I saw Rich pop his head out as well, they must have heard what we'd heard, and when I looked right I saw half a dozen people standing inside the gate of the prison. Rich went over to challenge them – we had permission to be here, but no one else should have been, so he asked them to leave. It turned out to be an opportunist tour guide who had been taking his small group around Greyfriars, saw the gates of the Covenanters Prison were unlocked and thought all of his Christmases had come at once. The tour guide was particularly obnoxious and wouldn't leave; however, Calum returned at the perfect time and quickly dispatched him.

Our investigation was over, but before we bid farewell Rich wanted to show Calum the photograph he'd taken earlier.

'I showed our guide the photograph and he said that they hadn't caught much in the way of light phenomena at the Covenanters, but he seriously doubted that was my finger because of its irregular shape and the spread of the light suggested it wasn't from a solid object close to the camera. Pleased with the assumption that my fingers were of ordinary size and shape and that I had possibly captured something otherworldly, I showed the lads the photograph.'

'Given its incredible history of torture and death, and the tales the tour guide told, I had hoped to bring a wealth of evidence back of something-after-death. But we're beginning to learn that's just not how this stuff works – you take what you can get and while it is easy to dismiss individual strange things happening every so often in day-to-day life, once you start actively searching and compiling a book like this one, it becomes more difficult to dismiss as the evidence keeps trickling in.'

'One more light phenomenon in our arsenal. Check!'

We shook Calum warmly by the hand and thanked him for taking his own time to accommodate us.

We walked through Greyfriars, now quiet and empty, with the only noise coming from outside as the Edinburgh nightlife was in full swing.

The roads were quiet, and as I drove we chatted about the stories we'd heard on the tour, and the conversation moved on to the possibility of spirits latching onto someone and following them home, or to another location. Many people believe that this can't happen, and an equal number believe it is possible. Scientifically, the existence of ghosts cannot be proven, and if ghosts do actually exist we can't be sure as to what they are, whether they are recordings of people from a bygone age, or whether they are some form of conscious spirit, able to see us and interact with us. It is therefore impossible to know whether they could somehow follow you home.

We were back at the caravan for around 12.45 a.m., and I turned the television on. *Kindergarten Cop* was on. 'Are we staying up to watch this?' John asked. He had no choice; we were sat in the living area, which doubled as his bedroom.

By 1.30 a.m., I was beat and the headache was still nagging away at me so I was the first to head off to bed, and opening the door to my bedroom was like opening the door to a fridge, it was freezing!

This photograph was taken at the same time Rich saw a twig move in the windless prison. Could the mass of white light have a rational explanation, or is this proof that the Covenanters Prison is haunted? (*Photograph by Richard Stokoe*)

Thankfully, I'd had the foresight to bring a sleeping bag so climbed inside that and put the covers over me and I soon warmed up. I lay awake, thinking about the evening, and as I did so I heard Rich, and then Tom, head off to their own beds too. The TV went off and the caravan fell silent.

I was woken up by banging, not in the caravan, but on it. Bleary eyed, I fumbled around in the darkness for my mobile phone to check the time – it was 5.00 a.m. I sat up, the banging continued. Was it the ghost of Mackenzie toying with us for daring to challenge him in his lair? No, it wasn't. I've stayed in enough caravans to know that it was in fact seagulls on the caravan roof. God only knows what they were doing, but it sounded like there were hundreds of them up there doing Riverdance. I lay down and pulled my sleeping bag up over my head and quickly drifted back to sleep.

I was awoken by John's alarm at 9.00 a.m. He didn't stop it and it was getting louder and louder, so I opened my door to see that John wasn't there but his phone was. I stopped it and wondered where he was.

I had a shower, and felt alive again. I dressed and packed up my stuff just as John walked back into the caravan. He told me he'd been up since 8.00 a.m. and had been for a walk around the caravan site.

It got to 9.30 a.m. and Tom wasn't up. Rich was awake, showered and good to go.

I shouted to Tom again – no reply.

A few minutes later, he emerged, but he walked strangely down the caravan – sideways like a sleepy crab, doing something odd with his gangly arms which reminded me of Jar Jar Binks.

John put his enormous black winter coat on and said he was ready to go. I asked him, again, why he doesn't buy a lightweight summer jacket, a question I've been asking him regularly for the thirteen years I've known him.

At 10.00 a.m., we jumped in the car again to head home. It was a glorious summer's day, undoubtedly the best day of the summer so far.

A week later, I met up with John for nothing more than an impromptu social get together, and the conversation turned, inevitably, to our Covenanters experience, having had a week to mull things over.

As the topic of conversation seemed to be drawing to its natural end, before we moved on to discussing something else, John mentioned, almost as an afterthought: 'Not long before we left the Covenanters, I decided to take a walk down to the bottom of the prison as I hadn't been down to the far end yet. I felt fine walking down to the bottom, but then suddenly felt really eerie – that's probably a fairly normal thing to feel alone in a graveyard, except how suddenly it came on. I turned around and walked back to the rest of the team (faster than I'd walked down...) and felt I was being followed, and then I heard footsteps other than my own. My rational explanation for the footsteps is that the grass was wet, so I could easily have had something stuck to my shoe that was making an additional noise a split second after my footstep.'

'A few days after our ghost hunt. I was walking to my parents from Kingston Park Metro station. As you pass the park there's trees and bushes between the footpath and road. As I walked along birds were flying out the trees ahead of me in panic; each tree vacating only as I got near it. I've never seen anything like it.'

'When I got to my parents' street, there are more trees in the middle of the court, it continued and a small bird flew straight into the wall of one of the houses and fell. I didn't check whether it was still alive, but probably not. I've seen plenty of birds fly into windows – either they attack their reflections or can't see the glass, but this was a brick wall!'

I said, 'Maybe Mackenzie was with you!' with a smirk. He looked back at me and nodded. I thought better than to remind him of the dead birds found near the Black Mausoleum...

CHAPTER THREE
DON'T LICK THE WALLPAPER!
MARY KING'S CLOSE, 13 OCTOBER 2012

John Blackburn from Mysteria and Ian Lawman are going to take you on a ghost hunting weekend of epic proportions! An Edinburgh weekend that will blow your mind! Do you have what it takes to survive a weekend exploring Edinburgh's dark secrets with Mysteria Paranormal Events? Please note: This event is not for those of a nervous disposition.

That was what I had read on Mysteria's website about an investigation they had arranged at one of Edinburgh's scariest places. And the 'please note' warning was in a red font, which I took to mean it was going to be scary – very, very scary. These guys weren't messing about. The four of us had joined the Mysteria guys at York Guildhall the previous year, and were lucky enough to be invited to join them again this evening. We had been excitedly counting down the months, then weeks, then days, and it was finally here. I couldn't wait!

This would be the third different season in which we'd headed for Edinburgh to tackle to city's spooks. It was autumn, Halloween was just around the corner, the leaves had begun to turn, and the dark nights had noticeably drawn in over the last few weeks.

Before packing my equipment and clothes together for Edinburgh, I checked the BBC website for the weather forecast – partial cloud cover, highs of 11 degrees, lows of 6 degrees, a 0 per cent chance of rain.

As I left home and walked towards my car, my backpack slung over my shoulder, sleeping bag under my arm and coat clutched in my hand, I paused to look up at the blue sky above. There wasn't a cloud in sight, and all in all it was a really pleasant day. I pressed the button on my central locking key fob and the lights on my Ford Focus flashed to let me know that she was unlocked and ready to go.

I drove over to my parents for the first of three stops to collect the rest of my fearless ghoul seeking unit – my younger brother, Tom. Our parents' house was a convenient meeting point and it meant we got to briefly say a cheery hello to our Mam and Dad. He was on time parking up just before midday, and he climbed into the passenger seat, took his shoes off and put his absurdly long legs up on my dashboard.

By 12.30 p.m., three quarters of the Geordie Ghostbusters were reunited as John was now sat in the back of the car. We were picking the final member up from a supermarket car park literally a two minute drive from John's parent's house.

I pulled into the Tesco car park in Kingston Park, and it was mega busy given it was Saturday afternoon. I found a quiet corner away from the supermarket itself and John rang Rich. He was on his way, being driven by his dad, but he would be ten minutes late, so I parked up and we waited.

Rich's flash Audi pulled into view just after 12.40 p.m., and parked opposite me. Rich jumped out of the passenger side and gave us an 'I'm sorry for being late' look as he rushed around to

the back of the big German car to gather his gear. His dad, who was driving, gave us a wave; I smiled back at him and gave a nod of my head.

Rich squeezed his bags into the already fairly full boot of my car, and climbed in behind me clutching an eight-pack of Pepsi Max, his soft drink of choice.

For the first time in over three months, the four of us were back together, and off to do what we do best – dare to seek out the dead in some of the most chilling places in the UK.

I drove out of the busy car park and hit the A1 for a fairly lengthy drive north, not to Edinburgh initially, but to Musselburgh, where we had booked our accommodation.

We had lots to catch up on, so the chat flowed freely as the miles raced by.

As we reached Berwick, Tom asked if I'd stop at McDonald's as he fancied a bite to eat, and Rich piped up that he could use the toilet if I was stopping.

'At the roundabout ahead, take the first exit,' a familiar Irish lilt reverberated through the speakers. It was my TomTom, my faithful guide on many long journeys over the last few years. I'd picked the Irish voice as I was curious as to how he'd say 'third', and never got around to changing it, and now I didn't want to, as we'd became firm travel companions. I didn't take the first exit; I disobeyed him by taking the third exit, turning right towards the Golden Arches of McDonalds. 'Turn around,' he said in his usual patient manner. I ignored him, and turned right into a busy car park, made busier by an enormous snaking queue of cars waiting for the drive through. 'Turn around,' he said again. Two pre-recorded words that somehow seemed more demanding than his last command. Rather than face being told off for a third time by TomTom, I turned him off.

As we drove out of the car park, I turned the TomTom back on, 'at the roundabout, take the second exit,' he said. I took the second exit. I'd appeased his Celtic wrath, and we were firm friends once more.

As we crossed the border into Scotland, the sun vanished behind a cloud and the sky turned dark. I noticed the majority of the cars heading south on the opposite carriageway seemed to have their lights on, so I assumed it would get worse the further north we got. It didn't take long to realise I was right and it started to rain. The BBC website had assured me this wouldn't be the case in Edinburgh, in fact there was a 0 per cent chance, so I was confident that we'd leave the rain, which had become a downpour, behind before we reached our destination.

We arrived at the Drummohr campsite in Musselburgh just before 3.00 p.m. and it was a bit chilly, but it was dry and looked like it hadn't seen any of the rain that we'd driven through and left behind some 30 miles back.

We checked in, and a man in a little motorised cart guided us to our bothy, named Beauly Bothy, the exact same one Tom, John, and I had stayed at on the night of our investigation at the Edinburgh Dungeon back in March. The three of us took the same mattresses we'd had that night, leaving the first bed on the right free for Rich. It was probably colder in the bothy than it was outside, but we'd all brought sleeping bags, pillows and plenty of thick clothes to wear for bed when we returned, which wasn't likely to be before 4.00 a.m. I turned the heater up high, and within five minutes it was pumping out some much needed warmth. I sat on the end of the mattress and held my hands over the small electric heater mounted on the wall, rubbing my hands together, like those homeless people standing at a brazier you see in Hollywood movies.

We changed into our ghost-hunting gear, as we wouldn't return before our investigation, despite it being over eight hours away, and rearranged our bags, leaving behind anything we wouldn't need. We also layered up in preparation for our afternoon in Edinburgh in autumn – well, Tom, Rich and I did; John had his massive coat and knew that's all he was ever likely to need, however cold it may be.

We arrived in Edinburgh just before 4.00 p.m. and looked for somewhere to park near the venue we were investigating tonight, as we didn't want to be wandering for miles in the wee small hours. We ended up parking along from Edinburgh Dungeon in a tricky little space with an awkwardly placed lamp post and extraordinarily high kerbs, just the right height to cause serious damage to the alloy wheels of drivers unable to parallel park. I had no intention of smashing in the wheels of my very own Mystery Machine and reversed in like a seasoned pro.

Rich said he'd wait at the car, and Tom, John and I walked to the parking meter. It was £2.20 an hour, but thankfully we'd only have to pay for two and a half hours, as it was free after 6.30 p.m. and I'd leave it there until we returned after our investigation. We pooled our loose change and put coin after coin in, the time on the digital display creeping up until it eventually changed on the drop of a 20p from 6.26 p.m. to 8.31 a.m. the next morning. As I walked back to the car, ticket in hand, I felt rain on my face. I looked at the others and before I could ask if it was raining, a fine drizzle started to fall. So much for a 0 per cent chance of the horrible wet stuff!

We crossed the road and passed the Sportsman bar, taking a shortcut up an alleyway with a sign above it saying 'Royal Mile and Castle'; it was a steep flight of stairs up a dark, narrow alleyway. We passed a couple of small bars, the second of which was called the Jingling Geordie. We came out on a busy Royal Mile and headed for the bar that has become our 'local' in much the same way that the Cross Keys did during our time in York. We headed for Frankenstein's on the George IV Bridge. John had decided weeks in advance he wanted a hog roast from Oink!, so he took a right turn down towards the Grassmarket and arranged to come and meet us afterwards.

'Frankies', as we affectionately referred to it, was fairly quiet, certainly much quieter than we'd seen it on previous Saturday afternoon visits, and we picked a high table with four bar stools placed around it.

John appeared ten minutes later, looking devastated. He sat down and said nothing. He was pale and looked troubled. He looked down at the floor. The three of us exchanged looks, nodding towards him and mouthing, 'What's wrong with him?' I wondered if he'd had a phone call and had

Frankenstein's pub.

some bad news. After what seemed like an eternity, but was actually only about thirty seconds I said, in my most concerned tone, 'What's up mate, are you alright?' He looked up and shook his head at me dejectedly. 'They were closing up, they've completely sold out of hog roast, and it's only quarter past four.' He bought a pint to cheer himself up and made do with a burger from the menu.

We chatted and laughed like four mates sitting in pubs all over the land would have been doing at exactly the same time. Tom told John and Rich about his recent engagement to his long-term girlfriend Aimee and we toasted this good news. As the hours passed, the bar became really busy, with all of the tables taken and people leaning on the bar, or against the wall.

The conversation turned to a fairly regular topic when the four of us come together – ghosts, and in particular the evening that lay ahead. Tonight would see us joining Mysteria Paranormal Events, and two dozen members of the public, to investigate a location famed the world over for the ghost said to lurk in the shadowy underground closes.

In the seventeenth century, Mary King's Close and adjacent closes were at the heart of Edinburgh's busiest and most vibrant streets, and they were open to the skies above and busy with traders selling their goods to the Old Town's inhabitants. A series of lanes and alleyways grew out of long narrow streets with tenement houses on either side, stretching up to seven stories high. These are the 'wynds' or 'closes' where Old Town folk made their homes.

Closes were named after the most prominent citizen or the most commonly found business to be on the close. Mary King was the daughter of advocate Alexander King, and was a successful businesswoman in her own right, trading in fabrics for a living. By the 1630s she was a widow, and owned several properties in the close, living at the top of one of the closes with her four children. It was highly unusual for a close to be named after a woman at that time, indicating Mary's standing in the town up until her death in 1644.

In 1645, the bubonic plague struck this close-knit community, most likely brought into the city from Europe via the port at Leith. There is an unsubstantiated claim that the local council decided to contain the plague by incarcerating the victims, bricking up the close for several years and leaving them to die inside. It's doubtful this actually happened, although the Black Death still caused panic and misery, and decimated the population. Sufferers would display white flags in their window to indicate that the Black Death had found its way into their home. They would then place themselves and their families into quarantine. Essential supplies would be delivered to the sufferers daily, and the plague doctor; Dr George Rae, would make regular visits for draining of buboes. It would be a terrifying time for everyone, especially children, made worse by Dr Rae tending them in their sickbed while wearing his fearsome plague doctor's suit with his beak mask stuffed with sweet and strong smelling herbs such as lavender. It was believed, mistakenly, that the bad smell was how the plague was transferred.

The close was partially demolished, with the lower floors of Mary King's Close and four of the surrounding closes used as the foundation for the Royal Exchange, built in 1753 (now the City Chambers) and over 250 years later the floors below remain largely unchanged.

Despite the city changing above, Mary King's Close was being covered over piece by piece, condemning it to darkness. The final surviving business in the close didn't close until the very end of the nineteenth century. Andrew Chesney was a saw maker, and was the last of three generations of Chesneys to live in the close. He operated his business until 1897, when the council gave him £400 (equivalent to £33,800 today) to move out so they could enlarge the Royal Exchange. Chesney was an old man by this point, and took the money and moved into Cockburn Street. This enabled

the council to shut the close off completely to the sky above and hide it beneath ground, to be quickly forgotten by the people of the continuously developing city.

During the Second World War, the underground vaults were reopened for the first time in over forty years to be used as an air-raid shelter.

What remains today of Mary King's Close is a spooky warren of dark, claustrophobic underground streets and spaces, a far cry from the Royal Mile above. Shrouded in myth and mysteries, with bloodcurdling tales of ghosts and murders, it was opened as a commercial tourist attraction in April 2003 and set out as a historically accurate example of life in Edinburgh between the sixteenth and nineteenth centuries. You enter the attraction through Warriston's Close and Writer's Court, where a replica sign for 'Mary King's Close' has been hung. The tour allows visitors access to the ruins of several underground close remains: Mary King's, Pearson's, Stewart's and Allen's Closes.

In the last decade, it has grown into one of Edinburgh's top tourist attractions, helped largely by its infamous reputation not only as one of the most haunted place in Edinburgh, but one of the most haunted places on the planet. The close has had a reputation for strange happenings since at least the seventeenth century, with stories of plague victims that died here and came back to haunt the places they knew in life.

Sounds of a party or crowded tavern are often heard and footsteps are heard pacing the close from time to time, believed to be those of one of the close's last residents, Mr Chesney. Other people have heard scratching coming from inside a chimney where a child chimney sweep is said to have gotten stuck. His desperate screams were ignored and he was left to slowly die.

By far the best-known tale is that of little Annie, who haunts the room named for her. Historically there is no proof she ever existed; she first came into the public's consciousness in 1992 when Japanese psychic Aiko Gibo visited the close. She had been fairly uninterested in the tour until she reached a small room where she was suddenly struck by an overwhelming feeling of sickness, hunger and cold. She initially refused to enter the room, but when she did she said she claimed to make contact with the spirit of an eight-year-old girl called Annie. She contracted the plague and her parents left her quarantined in the house, where she died scared and alone. She was heartbroken and didn't even have her beloved teddy bear to hold. The psychic suggested getting a cuddly toy from one of the many souvenir shops on the Royal Mile and leaving it for Annie. Ever since, people from all over the globe have left gifts in Annie's room, including dolls and other toys as well as money. The cash is collected regularly and given to the Sick Kids Friends Foundation in honour of little Annie. Despite the uncertainty around Annie's existence, there can be no denying the inexplicable experiences visitors have had in Annie's room; people have been overcome with emotion, and some have even begun crying involuntarily. Visitors have heard disembodied whispering, and some have even claimed to see the ghost of a young girl.

Mary King's Close is also the organisation which funds and manages the annual Mary King's Ghost Fest in Edinburgh, a unique and popular citywide festival in May each year, which sets out to explore and uncover more about the dark tales and strange paranormal activity for which Edinburgh is internationally renowned. It lasts for ten days and has won various awards over the years.

During Ghost Fest 2008, an amazing photograph was captured at Mary King's Close, which would fascinate paranormal enthusiasts worldwide and back up the location's standing as one of the most active places in the world.

Around midnight on Saturday 10 May, the general manager, Stephen Spencer, activated an infrared camera, which had been installed a couple of months earlier, to take photographs of

tourists in the close as a keepsake for them to take away as a reminder of their visit. He only activated it to check it had been turned off, and it's a good job it hadn't, as that image contained what appeared to be a ghostly figure standing in front of the archway.

Mary King's Close spokeswoman Lisa Helsby said at the time, 'There's a trigger for the camera on the wall and we usually press it last thing at night to check that everything has been switched off properly.'

'We'd had some events for the Ghost Fest on this particular night, and when they'd finished, Stephen pressed the button before coming back up into the office. He was the only person down there and wasn't in the shot himself, so it was a total surprise when the image came through. If everything had been switched off properly, the photograph wouldn't have been taken at all, so it was a complete fluke. It's not been tampered with or altered in any way – it's exactly what was taken at that moment in time. It definitely looks like a ghostly person in the distance and we've had quite a few visitors who have mentioned seeing a heavyset figure in that location before.'

Former historian of Living TV's *Most Haunted*, Richard Felix, who was in Edinburgh for Ghost Fest, saw the image and said he felt the photograph is 'convincing'. He added, 'I don't think it has been doctored and it's one of the best examples of this kind of phenomenon that I've come across during my career. It's especially interesting because the figure appears to have the same dimensions as other apparitions reported there over the past few years.'

The photograph was not the only piece of compelling evidence to come out of that year's Ghost Fest. Richard Felix joined a local paranormal team, Ghost Finders Scotland, to perform a series of experiments at Mary King's Close. One experiment involved planting digital voice recorders, while members of the team and members of staff asked a series of questions in the hope of achieving

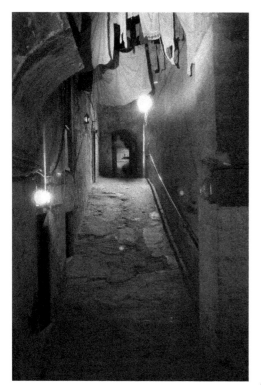

The compelling photograph captured during Ghost Fest, 2008. It is one of the most convincing ghost photographs in recent years. There's clearly a figure at the top of the close, but who is it? (*Photograph provided courtesy of the Real Mary King's Close*)

responses from the Close's spectral residents. When the recordings were played back, replies to questions were clearly audible. One of the loudest was recorded in the house of Andrew Chesney.

One of the staff asked, 'Are you sick of seeing us yet?' and the reply recorded said, 'Yes I am!' In another recording, staff asked, 'Would you like us to leave here now?' and a voice replied, 'Just get out!'

No one is sure who the figure in the photograph is, but it has been speculated it may be Andrew Chesney himself. Another school of thought is that it may be that of Major Thomas Weir, a prominent figure in the seventeenth century. He was a soldier turned occultist and was garrotted and burned alive at the Gallowlee in 1670 for witchcraft. While awaiting his execution, he made a further confession of incest with his sister, Jean Weir, who had been sentenced to death at the same time for being his partner in the dark arts, and was hanged at the Grassmarket.

However, before the ghost hunt, which would kick off at 10.30 p.m., I'd booked us onto one of the tours which run throughout the day and early evening at the Real Mary King's Close (www.therealmarykingsclose.com). Our tour would begin at 7.15 p.m.

With thirty minutes to go before our tour was due to start, we polished off our drinks and left Frankenstein's. By now it was pitch-black outside, and although it had stopped raining, the temperature had dropped dramatically. I zipped my coat up as high as it would go against the biting chill and we headed back to the Royal Mile.

By 7.15 p.m., we were in a group of around twenty people being checked into the tour led by a bonnie young lassie by the name of Megan. I'd never actually been into Mary King's Close before and had been under the impression from what I'd read that it can be cold in the close, but that couldn't be further from the truth. We had all layered up and it was red hot down there – before long, I'd taken my coat off and Tom (and even John!) had followed suit.

After an hour, the tour came to an end, and it had been thoroughly enjoyable, stories and the history well told and we thanked our guide. We now had a couple of hours to kill before we would return to Mary King's Close.

We decided to return to Frankenstein's for a drink, and the hope of a sit down.

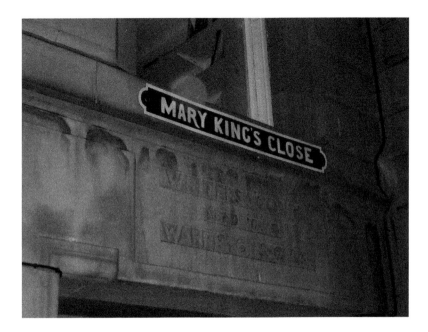

Mary King's Close, the most haunted place in the world?

The bouncers were on the door, so we thought we might not get in in our ghost-hunting gear, but there were no problems and we were wished a pleasant evening. It wasn't too busy, but it was very loud and there were no empty seats. We stood at the bar, ordered a soft drink and surveyed the clientele, which had changed radically since we had left only a couple of hours earlier. There was a DJ up in a booth behind the bar, and we walked in to Michael Jackson's 'Billie Jean'. As the music faded, there was a crash of thunder piped through the speaker system and a loud groan from above us. Everyone looked up and watched for several minutes as Frankenstein's Monster came to life. Sound effects played over eerie music as a life-size Frankenstein's Monster travelled along hydraulic rails on a metal bed then was lowered to around 10 feet off the ground, the music roared to a crescendo as the enormous green monster sat up and looked around.

He lay back down and the lights dimmed as he travelled back to the position in which he had started. The party music started again and a group of lads had their own little dance off, which the DJ spotted and shouted through the PA system, 'If you're going to have a dance off, at least get on the floor and do it properly' and he seamlessly switched the music to 'It's Like That' by Run DMC *vs* Jason Nevins. A small crowd gathered around them as they took turns to throw some shapes and show off their best moves. It was weird being out totally underdressed, completely sober and being surrounded by people dressed up for their big night out, all completely wasted. As the song came to an end, the dance off was still going strong so the DJ span 'I'm Too Sexy' by Right Said Fred. The lads were joined by a big lad dressed up for a birthday or a stag do (I was assuming, he might not have been in fancy dress at all) as Daffyd, from Little Britain.

We left Frankenstein's once again at 9.45 p.m., and the night air was bitterly cold now, so we were glad it was only a short walk. We bypassed the entrance to Mary King's Close as there was a Starbucks just beyond and Tom and Rich wanted to buy a hot drink to warm up.

We got to Mary King's Close at 10.00 p.m. and the gift shop, which was to be our base for the evening, was already full of our fellow ghost hunters. I picked out John Blackburn, the owner of Mysteria Paranormal Events, and went over and introduced myself. We had talked on the phone several times before but never met face to face. I introduced him to the lads, and thanked him for allowing us to join that night's ghost hunt.

At 10.15 p.m., John from Mysteria spoke up to get everyone's attention and welcomed everyone back for a second evening (they had all been together the evening before at the South Bridge Vaults and the Covenanters Prison). There were twenty-seven members of the public including the four of us, John and two mediums; Ian Lawman, the self-proclaimed 'bad boy of the psychic world', well known from TV programmes such as *I'm Famous and Frightened*, and *Most Haunted*. He was joined by medium Bryan Boyle, who hails from Fife, a little over 25 miles north of Edinburgh. A few members of staff were on duty for the evening and were gathered behind the customer service counter. John pointed us out to everyone else and explained why we were there. When he added that I am donating all of my royalties from sales of *Ghosts of Edinburgh* to charity, we were given a very kind round of applause.

We had ten more minutes to organise ourselves and get a drink, or nip to the toilet before we would head into the close for a medium guided walkthrough of the areas we would have access to.

A bespectacled man with a very gentle Scottish accent came over to meet us. He bore a striking resemblance to Curly Watts from *Coronation Street*, and as we chatted it was clear he was a nice guy. He had all manner of pendants on black string around his neck, seemingly gems and symbols which he felt may protect him on the investigation.

Rich had been to the toilet as we exchanged pleasantries with Curly, and when he returned he explained that he thought he'd just had his first paranormal experience of the evening. He

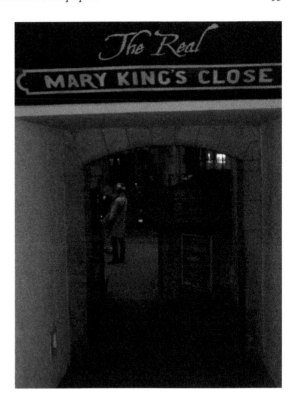

We return to Mary King's Close, and our investigation is about to get underway.

recounted the tale for us; he was at the toilet when he heard a funny noise, accompanied by a strange fragrance in the air. He turned around and felt a fine mist on his face. He stood quietly waiting to see if anything further happened. Then he realised that it had been one of those automatic air fresheners that go off every now and then in public lavatories.

At 10.30 p.m., the brave ghost hunters headed en masse down the darkened staircase for our first journey underground into the incredibly haunted Mary King's Close.

The first room was just down the first flight of stairs, and was the first room on the tour we'd taken earlier, a small room made up like a typical house on the close.

Ian Lawman addressed the eager ghost hunters, none of whom were first timers, having tackled the vaults the previous evening. 'Look around you when you get into a room, look for light sources and identify where shadows will be cast. Don't get caught out thinking you've seen a shadow moving when it's perfectly explainable. It's human nature to jump to conclusions when you're in a scary place, and it doesn't get much scarier than Mary King's Close.'

Ian asked, 'How does everyone feel?'

'Dizzy,' complained one lady.

'Anxious,' shouted out Curly, while he fingered his lucky pendants.

'I feel as if I'm on a boat, rocking,' said a lady behind me.

Ian agreed with the rocking sensation, saying he felt unsteady on his feet, because the floor, although it looks new, wouldn't have been the original floor. It would have been perhaps a different floor, lower down, making him feel like he's sinking.

'I've a burning chest, my heart's racing, and I feel a little tipsy almost like I'm drunk.' He continued, 'I can also sense a man who smells quite "herby", like he smells of herbs. I'm not sure if

he's a doctor, or something similar. I won't say too much, but we'll see if he makes an appearance later.'

Ian stepped back, giving the floor to Bryan Boyle to step forward and in his strong Scottish brogue give us his first thoughts of this area of Mary King's Close. 'I can't help but smile to myself when Ian was talking, as I was also getting the floor, but I was seeing it as brick. I'm also seeing two bowls with money, and changing coins of some kind.'

He left it at that, short but sweet. Ian explained why they were being a little vague. 'We're intentionally not telling you too much as we want you to have your own experience, and don't want to influence you.'

We moved on to the next area. As we walked, everyone was commenting on the temperature down here. It was uncomfortably warm. I didn't have a coat on and was wearing just a T-shirt, but the heat was stifling, made worse by over thirty of us in such a confined space.

The next room was the cowshed. Ian asked us to spread out around the room forming a huge circle, turn our torches off and see how this room felt.

'How do you feel in here?'

There was initial hesitancy, then someone said, 'better than the last room' and there was a chorus of voices agreeing.

Ian responded, 'Does anyone feel worse?'

'Yeah, I feel worse,' confirmed a quiet female voice.

'I feel dizzy,' another lady added.

'Nervous,' said a guy behind me.

'Cow s**t!' Curly cried out.

'For me,' said Ian quietly, 'I'm trying to get warm, I feel really, really cold, and in reality it's warm so I know it's spirit energy that's causing it. I also feel like I'm giving birth, or about to give birth. I get a kind of "cattly" feel, like someone who would tend to animals; cows or sheep.'

Bryan spoke. 'I agree with some of what's been said, I feel a bit disorientated. I'm also aware of a strong stench like the lady said.'

'It was me,' Curly interrupted. 'I'm a man.'

Bryan continued. 'Is that a doorway over there?' he asked, pointing in the darkness towards the doorway into another room. Everyone said yes. 'Somebody's watching me from that doorway. It's a woman with a bonnet on. I'm also getting animals, and I know you said cows, but I don't get that I get horses.'

An American lady spoke up in agreement with Bryan. 'Yeah, I'm getting, like, animals here.'

An American man then spoke up. It was the lady's son, and we'd later find out that he was named John. 'I get a strong urge to look at the floor, I feel like I should be looking at the floor for something.'

John Blackburn sounded concerned when he spoke, 'I do get a nervy feel in here, I am a little on edge, and I feel the further into this place we go the worse this is going to get.'

The Plague Room, as I'll refer to it, was through the door Bryan had pointed out a few minutes earlier. It's a small room, which looks down through a small dirty window onto Mary King's Close below. There are bunk beds in the room containing mannequins of a family with small children suffering from the plague. They are being treated by a doctor wearing a plague doctor suit including the beak mask.

Ian spoke first. 'It's definitely a different energy in here, isn't it?'

'Sickness,' Curly blurted out.

'I'm terrified, almost verging on panicking and getting out,' American John said, looking around to see if anyone else felt as he did.

'I feel there were sick people in here,' shouted the American woman.

'Burning all down one leg,' cried out another voice.

'I feel like I'm moving down, like I'm being dragged down.'

'It's home, but I want to get out,' our very own Rich chipped in.

'OK, yeah well I'm getting a lot of these sensations,' Ian said calmly. 'I still feel like I'm sinking down into the floor. I feel quite cramped in here – I'm not sure if the room was used for storage at some point. I feel quite fluey, quite feverish, like my lungs are filling up with fluid. I have major health issues. I'm also aware that there are definitely spirit children here.'

Bryan said, 'My left arm is itchy.'

'My neck is itchy!' said a clearly astonished woman.

'It feels like my arms should have scars on them,' Bryan continued.

'I'm getting three names in this room. The first is Jonathan Swift, the second and third are just first names – Elizabeth and Thomas.'

'They met their end!' Curly shouted. 'They were brought here to die!'

We were led by a member of staff to the next area for us to check out during our pre-investigation walkabout. It is a room known officially as 'Ghosts and Ghoulies', and is a long room with wooden floor and seats in which we'd seen a short video telling a ghost story from the early days of Mary King's on our earlier tour.

'It's quite negative in here for me, how do you feel?' Ian asked the group.

'I feel really angry for some reason,' said a lady with a fairly posh London accent.

'I feel threatened, like someone wants to go for my throat,' said John Blackburn, holding his throat as he spoke.

'I've been made aware of a lady,' Bryan spoke quietly, 'Elizabeth who was in the last room; I see her with a basket of bread, going around the close giving this bread out. Also getting a male, he's a drunk, staggering around being ignored by everyone.'

'It's funny you said drunk,' Ian looked at Bryan as he explained, 'as I saw a man swaying, but I wasn't sure if he was drunk, or ill. I can see also see a man being dragged by two other men, he's dead and they've got one arm each dragging him behind them. My chest has become really tight, coughing blood. Oh, I can now also hear aircraft above me, and the sound of bombs dropping. I'm not sure if during the war this was used as an air-raid shelter of some kind. There's a lot of movement in this room. It could be interesting.'

'There's movement everywhere!' exclaimed Curly, clutching onto his protective pendants as if his life depended on it.

We left this room in single file, and made our way to the room best known by paranormal enthusiasts – Annie's room.

We didn't enter Annie's room, as there was too many of us, so we gathered in the area outside. John asked the group to be very careful of the walls and the low ceilings as they came into the area. He added that some of the walls in here were made of the ash from the bodies of criminals mixed into plaster.

Rich was the first person to speak. 'I'm getting a really sweet smell here.'

'It's really sickly, though!' added Curly, eager to express his thoughts.

American John added that he was getting a 'spicy smell'. Just as it was in danger of sounding like a wine tasting evening, John Blackburn said quietly, 'I'm really nervous. I feel like there's someone

in the dark doorway to that room over there.' He shone his torch on the doorway he was talking about, and it was the doorway to Annie's room. There was someone stood in the doorway and they were now illuminated in the LED glow from the light of his torch. That figure was me. 'Rob, you are not alone in that doorway, there's definitely someone else there. Whatever happens, if anything, let us know straight away.'

'I know the stories people generally know about that room but I get something different in there, another really strong male energy.'

Bryan had picked up something different. 'I'm feeling a family with five children. I get the name Morgan, which I think is one of the children.'

'I see a woman sat on the floor, and she's crushing herbs on the floor, not to eat, but to cover the smell of something up.' As Ian spoke, he had his eyes closed and was acting out the crushing of herbs with his hands. 'I also feel she's going to use some of these herbs to make a broth for her daughter who was ill. Sadly, it didn't work and she passed away at a young age.'

We passed through Annie's room in single file, checking it out quickly as the group was far too large to go in together.

The next room on our tour had a wooden floor and four large illustrated boards detailing the lives of the people who lived in the Closes.

By now, Ian didn't have to ask how people felt, as they began to shout out how they felt upon entering this new space.

'Wobbly.'

'I'm swaying.'

'Yeah swaying, like I want to fall over,' agreed Curly.

'I've got a stomach ache.'

'I've got a very coppery taste in my mouth, almost like blood,' said American John, who twisted his face in disgust as if to let us know just how bad the taste was.

John Blackburn was happier in this room. 'I'm feeling light, a lot less intimidated than I have done elsewhere.'

Ian agreed, 'Yeah, I feel good in here. I've nothing more to add really.'

With Bryan having nothing to add, and no one else speaking up, we wanted to maximise our time so we moved to the next area – Mary King's Close itself. However, we weren't going to include the close in our walkabout tour, it was merely a stop off for a room they considered to be far more interesting, a room we'd not seen during the daytime tour – Chesney's House.

John explained, 'On the daytime tour you'd never go into this room because the floor is badly damaged, so when we go in we need to be careful and can only allow eight people in at any one time. Also be careful of the walls, as back in those days when they fixed wallpaper to the walls, they did it with an arsenic solution as this stopped bacteria and mould growing. Do not touch the walls.'

We waited patiently, people huddled around in their small groups of friends, as the first group went into Chesney's House.

Two groups of eight had been in and out of Chesney's house and we joined the final group.

Ian and Bryan were waiting inside and as I entered I spied a sign above the lavatory proudly boasting of Chesney's house being privileged to have the first flushing toilet in the close.

'Feel free to lick the wallpaper!' Ian joked to us and the four girls who made up our group. We spent a few minutes wandering around the small house, treading carefully on the badly dilapidated floor. Ian asked the four of us about the book project, and I introduced myself. Both he and Bryan showed a keen interest and were kind enough to wish me well.

After an hour and ten minutes on the uncomfortably warm walk around, we resurfaced in the gift shop. We had a little bit of down time, so I mingled and had a drink.

John explained we would split into three groups and rotate between three areas that had been identified as being the most promising: group one would start in the cowshed with Ian, group two would go to Chesney's House with Bryan, and group three (of which we were members) would go with John to Annie's room and the area around it. After thirty minutes in each area, the team leaders would stay still and we would rotate.

At midnight, we broke into our groups and, one group at a time, we went to our designated areas.

Our group had contained nine investigators, and we stood in the area outside of Annie's room with metal supports holding the roof in place, where we'd earlier been told to watch the delicate walls. John asked us to stand in a circle, and as best we could stand boy-girl-boy-girl, as this would help energy to flow. He then asked us to hold hands.

For the benefit of the four of us who hadn't been there the evening before, John explained that he works with spirit energy, and his style of mediumship is different to that of Ian and Bryan.

With our torches off, and everyone holding hands with strangers of the opposite sex, John stood in the centre of the circle we'd formed and began to do his thing.

'I want you all to imagine up above my head is a crystalline ball of energy, and this ball of energy is slowly spinning around. Imagine you can feel the heat of this energy spinning around. What I want you to do now is take an umbilical cord of energy from this ball of energy, and take the cord to your centre of your forehead. Now the centre of your forehead is a chakra point, some people call it your third eye. You've got two other chakra points you'll be using tonight, and they are in the palms of each hand. That's one of the reasons we're holding hands. The other reason is so if you're touched, you know if can't be someone else from our group as you're all holding hands and I'm here in the centre.'

'Imagine that you're drawing this energy from your third eye down into your stomach now, and you can see the white energy moving down into your stomach, you might even feel a tingling sensation in your stomach now. Can you feel it?'

Nobody replied.

'Talk to me, can anyone feel that?'

A quiet female voice said 'yes' in the darkness.

'Now the energy is building up, getting stronger and stronger, and you're taking it up from your stomach up to your left shoulder. You can now see this energy flowing down your left arm and you're now passing it into the hand of the person to your left, and the person to your right has passed you their energy into your right hand. Imagine this energy flowing through your body and then pass it onto the person to your left again, and you do this over and over again until we have a circle of energy flowing through all of you faster, and faster and faster. Concentrate on that now, we've only got thirty minutes in this room so we want to build up as much energy as we can.'

'I will now call out to the spirit. Open the door, lower the temperature and bring yourself through! Come on, open the door, lower the temperature and bring yourself through. We are summoning all of the energies from Mary King's Close to come through and work with us.'

'Come closer.'

'Guys, keep your feet about 6 inches apart and in your mind ask show me which way is yes, and you'll feel yourself swaying. Then ask which way is no and you'll move in a different direction.'

'Come forward spirits, are you going to communicate with us? If so, please pull in the direction of yes.'

We were asked what we felt. I felt nothing. But three female voices, one of which was American, quickly confirmed they felt they'd swayed in the direction which indicated 'yes'.

'Do you feel any tinglier than you did before?'

A few people nodded and there was a murmur of agreement. 'Rob?' John said, putting me on the spot. I felt nothing, so that's what I said. So he asked if he could work with me, inviting me to join him in the centre of the circle. I wasn't sure what it would involve, but I agreed. I let go of the ladies' hands stood to either side of me and took a stride forward. The circle closed behind me. John positioned me opposite him within the circle and I stood still, hands down by my side.

'Guys in the circle, keep the energy flowing, spinning faster and faster through you. Keep your hands together, but make sure your arms are loose and floppy. Watch in the centre of the circle, use your night vision and watch between where Rob and I are standing.'

'Spirits, I want you take a hand from the circle, and pull a hand into the centre of the circle for me please. Bring it forward, bring it forward, bring it forward. Bring a hand towards me now, bring it to me, bring it to me…'

He continued to say 'bring it to me' repeatedly, getting louder and faster for several minutes, then one of the female links in our circle stepped towards John. This spurred him on.

'Come closer, lower the temperature, bring the hands forward. Guys, you should see the centre of the circle between me and Rob getting darker and darker, can you see that?' The majority of the group gave a synchronised 'yes', although Rich, John, and Tom said nothing.

'That's the spirit energy joining us, when the spirit energy appears it gets much darker. Come on, bring those hands forward, bring them closer to me.'

He said this same sentence repeatedly, and the circle began to close as clasped hands were seemingly dragging people towards us. I felt a fist strike me firmly in the small of my back. I turned around and came face to face with the American woman. She apologised and then protested her innocence, as though it was her hand that had hit me, she hadn't done it – *they* had.

The circle got smaller and smaller, and John requested the spirit energy to continue to bring the hands forward, but now make them go up as well, making the hands and the arms go higher and higher.

I looked around at the eight faces that made up the circle, and there was a mixture of fear and bewilderment, and not only did the circle carry on getting smaller, but arms begun to rise. Sixteen arms connected to eight interlocked fists were rising steadily into the air. I turned around to see how the guys behind me were getting on, and received one of those rising fists straight in my face.

I was stood in the dark, surrounded by strangers, and I'd been punched twice. I could have saved myself travelling all the way to Edinburgh, and experienced the same thing in the Bigg Market in Newcastle on a Saturday night.

The circle was now almost completely closed. I had, mostly, strangers pressed up against me, and I was stood facing our guide John in the centre, arms and fists towering above us.

'OK this has been a fantastic result so far, thank you for this, spirits. Now show yourself. Show your face in the centre of the circle.'

John encouraged us all to watch between the two of us, and wait for the face to appear.

Everyone was watching intently, but no one saw anything.

John wasn't deterred by this, and suggested we try something different.

'Thank you for working with us, spirit. We're now going to move into the next room and would like you to come with us. Come and join us in the room where the toys are. I want to take you into the next room, spirit.'

John explained that since the spirit would be leaving the circle and moving to the next room everyone should find their arms and hands returning to normal.

'Before we all move, I'd like a volunteer.'

'I'll do it,' said Tom, almost before John had finished his request.

John asked me to rejoin the circle and take Tom's place. He then asked us to all turn around where we were stood, so the circle remained but we were all facing outwards rather than looking at John who was still in the centre.

Tom was asked to stand in the doorway of Annie's room.

I was facing the doorway to Annie's room, so could see Tom take up his position, and heard John behind me speak loudly. 'There's someone in the doorway of the room you're standing in, and they're blocking your way. I want you to push them out of the way. Push past him and come to me.'

'Tom, do you feel anything at all? Can you tell us what you're feeling, if anything?' John said expectantly.

'I feel fine,' came Tom's comfortable response, 'although I can feel something almost like static around my head.'

'Come on, force your way past him, push him out of the way. Push forward. Come closer spirit, please.'

'My legs feel quite heavy now.'

'Push him towards me now, push him towards me now,' John repeated over and over.

After another thirty seconds or so, Tom said his legs felt even heavier.

John persevered but Tom didn't budge.

Time was pressing, so we all relocated to Annie's room. It was a much more confined space, but the ten of us fit relatively comfortably. John wanted to keep the energy flowing, so had us join hands again. He told us we would try transfiguration. He added that we have an auric field around all of us. This is our life force, and when we work with energy, we can transpose the spirit's face over ours onto our auric field.

In order for John to allow his face to be taken over, he said that we'd need to change the energy in the room, change the vibe. How he suggested we would do this is to hum. He would point as each one of us in turn and we had to hum for as long as we could – that way, even though we would need to take a breath, it would sound like one long continuous hum. The origin of this technique dates back many thousands of years when the Tibetan monks harnessed the eternal *om*, and they worked with energy all the time. They used healing energy, and we were going to be harnessing the same kind of energy.

John pointed to us in turn, and before long, it sounded like we were surrounded by a swarm of angry bees as a hum filled the room, the vibrations in the sound echoing all around us. As we continued to hum like the nation's worst choir warming up for a *Britain's Got Talent* audition, John once more asked the energy to join us.

Once he was satisfied the spirit energy was with us he asked us to stop humming, and the room fell silent.

John stood in the corner of the room and we broke our circle to gather round. He said he would close his eyes and illuminate his face slightly with a red torch. We were to watch to see if it changed as he willed he spirits to use his auric field to show their own face. We waited with bated breath and watched his eerily lit face. No one spoke until John finished and asked us what we saw. I personally hadn't seen any change, although his face was very dimly lit and we were watching so

intensely that I could imagine it would be easy, especially so late at night, for your eyes to play tricks on you. One lady said that she thought his face had turned darker, and someone else said they saw his eyes open, even though she could tell they were still closed at the same time. No one else had seen anything.

We had overrun our allotted thirty minutes at Annie's room by almost fifteen minutes, so it was time for our group to rotate, and our nine-strong ghost-hunting team, the snappily named 'Group 3', were on the move to spend some time with Bryan Boyle and Andrew from the Real Mary King's Close staff at Chesney's House.

We spread out carefully and evenly around the room. We had to be wary of touching the walls, or stepping into a hole. As soon as Bryan spoke, it was apparent this would be a very different half an hour, despite both John and Bryan being mediums.

'Would you like to try some calling out first, or if you like we could do a circle and I could do some mediumship and see who's here?'

An American woman suggested calling out first.

'OK, can you stand still? This floor is very noisy and we need to listen carefully and be patient as we wait between questions.' Bryan explained. 'If there are any astral beings or any spirit beings here with us can you come forward please? Can you make a noise or touch someone gently?'

We waited silently for almost a minute, which is a long time to remain silent, but it paid off when we heard a series of footsteps on the creaky floor in the room with us.

Everyone looked at one another, and Bryan, as if he knew it had been coming, said, 'Told you, now you know why I said to wait.'

'Any astral beings or spirit people could you make a noise, bang on the door, touch someone?' There was no response. 'I know this room is active with spirit people, I can see you, we mean respect so will you please come forward and let us know?' There was no response.

Unannounced, the American lady said, 'Can you please come back now? We've come a long way and we want you to show us you're here.'

With no response, Bryan stepped in and said that earlier he'd been aware of spirits in the room, but he wasn't any more. The American woman nodded and said, 'It seems very flat, don't it, y'all?'

There was some agreement and then Bryan was asked what the previous group had experienced in there. He was about to explain, but no sooner had he started talking than he was rudely interrupted by someone in our group whispering and talking over him. It was our very own John.

John turned to Tom, Rich and I as we were stood listening to Bryan. He whispered, 'Did one of you just poke me?'

Tom was first to protest his innocence, and pointed out his arms were folded and had been since they took their positions around the room. Rich and I both said we hadn't. By now people had realised that the rude Geordie lads were having our own conversation and even Bryan had stopped talking.

'Are you alright?' he asked, clearly aware we were discussing a 'happening'.

'It felt like someone touched me,' John said to everyone.

'What's your name, and would you be happy for me to ask for them to do it again?' Bryan said, seemingly buoyed by this occurrence when things had seemed fairly quiet.

'I'm John, yeah that's fine.'

'You just touched John, could you do it again?'

Everyone waited, eyes fixed on John.

Nothing.

Bryan seemed puzzled by this, so grilled John further. 'Where did it touch you, and did it feel like a definite physical touch?'

'Yeah it was on my arm just here and it was a definite prod, that's why I immediately blamed Rob,' he pointed at me. Everyone laughed except me.

Bryan seemed convinced one of the spirit people was to blame for this so continued to attempt to make contact. 'Spirit person, you touched John, can you do it again, or touch somebody else?'

Nothing happened.

Bryan returned to telling us what he experienced with the previous group. He went through a whole range of emotions, angry, anxious, scared, then he felt like he was going to well up and cry. It was at this point he picked up on a male who he believed to be Mr Chesney, for who the house was named. And he found him to be a very angry individual.

Since it was so quiet, he suggested that we form a circle to try and stir up some energy into the room. He said it would be best if we were able to stand boy-girl-boy-girl, just as John had asked us to during our previous vigil. He explained that men and women carry different 'charges' like the positive and negative terminals of a battery, and that this helps the energy to flow. He asked if we'd have anything against him saying a prayer of protection, no one did.

Once he'd finished his prayer he asked if anyone felt anything. Tom said that he felt static around his hair, as he had done in the previous room, making his hair almost want to stand up. Also his ears felt tingly.

Bryan said this could be a sign of energy. So after asking Tom's name he asked the spirit people to show themselves. When this failed, he asked them to show themselves to his 'psychic sight'.

'It's important that when it's quiet you don't let it get you down. Patience is vital.'

It was all very quiet. However, Bryan continued to request the 'astral beings' to use our energy to make themselves known. He continued for several minutes while the rest of us stood silently, waiting, hoping. Bryan stopped asking when he said he felt as if someone was telling us to get out of 'their house'. He asked aloud if this was Mr Chesney, and challenged him to do something, anything, and we'd leave his house. Sadly, though, this didn't materialise.

Bryan closed our vigil with another prayer, to ensure any spirits didn't latch themselves onto us. It was almost 1.30 a.m., so we had a few minutes to spare before we'd head off. We left Chesney's House and stood out on Mary King's Close. Everyone chatted among themselves as I marvelled at the close. It was strange to think that where we were stood only a few hundred years earlier would been a thriving, populous area in the centre of Edinburgh's Old Town, open to the skies above, and now it's a subterranean ghost town. I felt an involuntary shiver pass through me when I looked up the close to the location of the amazing Ghost Fest 2008 photograph and almost imagined seeing the same figure walking down towards me.

Time was ticking by, and we were still waiting. The group from Annie's room hadn't turned up to take over from us, meaning that there'd been a breakdown in the chain somewhere. One of the groups hadn't moved on, which would eat into the time we got in the final vigil of the evening – the Plague Room beyond the cowshed with Ian.

It turned out that the reason for the delay was that a young blonde girl in her early twenties had fainted in the Plague Room and had to be taken back to the gift shop.

By the time we got into the Plague Room it was 1.50 a.m., so we had thirty minutes before we were due a break. Ian asked how we'd found the previous two locations, and it seemed we'd all been pretty disappointed so far. However, Ian said that the previous two groups in this room had both been terrified, so hopefully we'd saved the best until last.

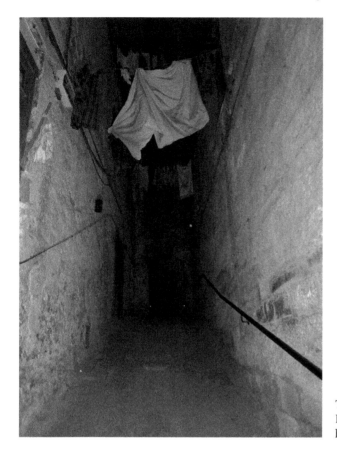

The once-thriving community of Mary King's Close, which stood seven stories high, is now a subterranean ghost town.

He explained that outside the window was the close below, so we may see the torches of Bryan's group, and out of the door to the bottom of the adjoining cowshed is near Annie's room, so we may see light under that door from John's group moving around. Ian asked us to stand in a boy-girl circle, which we were used to now, and he said a prayer of protection.

Straight away, two of the female members of our group began to complain of a tightening in their chest. Ian asked the spirits of the children who died in that room (represented by the mannequins) to come forward and make themselves known to us. Almost immediately, people began to hear things. Some people, including myself, heard talking just outside the door at the far end of the cowshed. Others, including Tom and Rich, heard footsteps in the corner of the room we were stood in. A quick check outside the door revealed no one was outside.

'We ask the family who died here, the children and the mother and father, to come forward again and make yourself known again, show yourself if you're able in light form. Maybe we can help you, but we need to hear from you first.'

At this point on the recording I was taking throughout the evening, there's a very clear, yet indistinguishable mumbling in the background, like two or more people talking quickly over one another. Yet at the time we heard nothing and no one commented on it. It lasts for just over a minute then totally stops.

John said he could hear creaking coming from the bed with the mannequins in it. Ian suggested we move away from the bed to ensure it's not us moving around causing it to creak.

Once we'd moved the creaking seemed to stop. We stood silently, hand in hand, waiting to see what would happen, but before we knew it, it was time to head back above ground for a break.

At 2.20 a.m., we resurfaced in the gift shop, blinking in the strong light. My legs were aching, as I'd been on my feet for seven hours now, so in the absence of a free chair I sat on the floor and took the weight off. Bryan Boyle was holding hands with the girl who was still sobbing, and we were told that he was helping her with his psychic healing.

After a twenty-minute break, we were heading back into Mary King's Close for our final vigil. The Mysteria guys had decided, after a bit of a chat, that the Plague room and cowshed areas had proved the most interesting, so for the remainder of our evening we would return and see what would develop with all thirty of us present.

We were stood in a huge circle, filling the room, and John said we needed to ensure that we had a woman between all of the men, boy-girl, as best as we could. Within a few minutes, we'd managed to do this and we turned out all of the torches. We were plunged into darkness.

John asked us all to concentrate on building energy. There was a lot of excited, or possibly nervous, chatter, which was quickly hushed.

'We want to alter the vibrations in the room now, so what we're going to do is I'll point a torch at you and as the light passes you, you will begin to hum, just as we did earlier in Annie's room.' He pointed a torch at each of us in turn and within seconds the hum was deafening. As our humming got louder and louder, filling the room, Ian asked for the spirits to come and join us. 'Keep coming, keep coming.' When he was satisfied that the spirit energies were here, he asked us to stop.

The room fell silent.

Ian talked to any spirits here with us. 'Please use our energy and walk among the people here.'

It was silent for around thirty seconds, but with the obvious weight of anticipation from the huge number of people in the group, that thirty seconds seemed like ten minutes.

'How are you, Bryan?' Ian broke the silence.

Bryan said he felt fine, and didn't sense anything.

There was a bit of a commotion to my right, with a few people furthest from the entrance to the cowshed whispering between themselves.

'Are you guys OK?' asked Ian, aware that this interruption was impacting everyone.

The people getting overexcited hadn't been in our group. They explained that a guy called Trevor, who had a strong Yorkshire accent, was feeling someone behind him trying to make him turn around to face the Plague room, he was holding his mother's hand, and she could feel him being moved around.

Apparently this had been a bit of a theme throughout Trevor's evening, with him feeling himself getting pushed and manipulated by unseen hands during the earlier vigils. John had taught him to imagine a blue shield, which would protect him and help him to beat it.

'I'm going again!' he cried out, while turning out of the circle.

The guy who looked like Curly tried to help by shouting some words of encouragement. 'You're the best one, Trevor! He's the best one.'

Trevor stopped twisting, and we carried on asking for spirits to influence people within the circle. Ian asked us all to repeat 'open the door' in our heads, and will the door at the far end of the room to open. This would be fantastic if it did happen, as it would be totally inexplicable as everyone within the building was present in the room with us, with the exception of the upset girl from earlier and a member of staff who'd stayed in the gift shop to comfort her.

I wasn't feeling anything out of the ordinary. I was really tired, and the uncomfortable heat being generated by so many people in the small room was making me even sleepier. I also found the whole thing a bit surreal. We had Trevor twisting, and as I repeated, 'open the door' in my head, Curly shouted, 'We're all getting smaller!', then American John cried out, 'I feel green and fuzzy.'

This couldn't be any further from how we would usually conduct our own investigations, and I was trying to work out how I could apply these experiences that other people were having, and sadly the conclusion I came to fairly quickly is that these experiences are only evidence for the people who have them, or their friends and family who accompany them and know them well enough to know their character and trust what they say to have happened. Instead, it may well be a case of seeking attention, having a bit of a laugh, or wanting something to happen so badly that they feel the need to embellish the truth to make it appear more paranormal that it actually was.

I'm not necessarily saying that's what was happening here, as everyone seemed very sincere and no one appeared to have come along 'for a laugh', but I still felt nothing unusual as voices from other people in the group continued to emanate from within the darkness to say how they were feeling. Someone said they felt dizzy, another person claimed they felt a woman was stood in the centre of the circle. There was another interruption from Trevor and his mother as he shouted that he was twisting again. I was hoping for some physical evidence, sounds, smells, or something visible, but it didn't seem to come.

We all calmed down once more and the room fell silent. We stood listening to Ian trying to summon the spirits to come to us and make themselves known. Bryan said he was getting the spirit of a man called Henry Maxwell, who was wearing a top hat, a long black coat, and was dressed very smartly.

Bryan was then interrupted by Trevor screaming, 'Arrgghh, what's that horrible thing?' while pointing at something. It was our John's face, who was stood just to Trevor's left. Then he started twisting again. A few people shouted, 'Get him out!' possibly in concern, but it appeared to be mainly due to frustration as he had become a constant interruption, and with the heat and the undoubted tiredness people were feeling, patience was a virtue in short supply.

Bryan took Trevor and his mother up to base, leaving the rest of us to continue. We closed the circle and Ian tried to gee up the ghosts into putting on a bit more of a show for us. A female voice, a very well-spoken London lady, said she felt abandonment, as if we were surrounded by children who were brought here and left here alone, confused as to why their parents would no longer love them or want them.

As she spoke, a lady next to her said she felt as if someone was tugging at her trouser leg. This seemed promising.

The posh-sounding London lady said she felt dizzy, like she was going to fall.

'She's going to go!' cried Curly. Her friends seemed a bit concerned, as she was rocking, John suggested we break the circle and give her a chance to get back to normal, as there was a chance of her falling down. We made the most of this short interlude, people rubbing their shoulders after spending much of the evening holding hands. Ian suggested it might be an idea for us all to move into the much smaller Plague room, as a few people had felt drawn to it over the last ten minutes. It was going to be a tight squeeze, but we all got inside – it wasn't comfortable, but we were in.

We held hands boy-girl-boy-girl for the final time, and Ian asked the spirits of the family who died in that room to come and join us.

'Come forward and make yourselves known to us now.'

Curly complained that someone had just grabbed his 'bits and bobs'. But it was quickly pointed out there wasn't a free hand in the room, so it couldn't have been any of us.

The Plague Room was to be the venue for our final showdown with the ghosts of Mary King's Close.

The last few minutes passed uneventfully, so Ian closed down our session and we headed back upstairs for the final time. As we made our way from the cowshed up to the gift shop it was clear everyone was in high spirits and had a really good night and people laughed and chatted excitedly. You'd never have thought it was 3.20 a.m.

The Mysteria guys debriefed us all and we discussed how we'd found the evening. We all gave our guides a huge round of applause.

We thanked the members of the Real Mary King's Close staff, John, Ian and Bryan, and said goodbye to everyone else, and the four of us headed out into the cold, wet Edinburgh night.

We were all in agony with being on our feet for so long, so when we returned to the car the relief was audible when we were finally able to sit down. It was 3.45 a.m. and I was in desperate need of sleep.

I parked up outside the bothy just after 4.00 a.m., and upon opening the door we discovered the heater had turned itself off and it was unbearably cold. We got ready for bed, and discussed the ghost hunt we'd just experienced. We were all in agreement we'd had an enjoyable, memorable evening, but as far as seeking our own personal evidence of the paranormal we'd sadly learned little. It would be great to get back to Mary King's Close on our own and do our style of investigation, relying more on our equipment and our senses to detect anything otherworldly. However, with Mary King's being such a sought-after venue and a limit on the number of investigations there each year, could I make a few calls and actually secure an investigation for our small band of hunters there?

CHAPTER FOUR
'HELLO GHOSTS?'
DALHOUSIE CASTLE HOTEL & SPA,
2 NOVEMBER 2012

After a long week at work, Friday evening saw the four of us headed north making the first leg of the trip along the winding A1 through Northumberland on a bitterly cold November evening. Tom was in the passenger seat, which had been the norm for so long that he no longer had to call 'shotgun'. His face was illuminated in my peripheral field of vision as he was Googling our ultimate destination on his sparkly new iPhone 5, having just asked me just how haunted tonight's venue is actually believed to be.

My right-hand side was lit brightly by an enormous full moon glowing brightly against the clear night sky. It appeared so large, so low in the sky, and so close that it seemed that if I was to open my window I could reach out and almost touch it. As I made steady progress along the quiet single carriageway, it was there throughout, as if it would chase us all the way to Edinburgh.

'According to *The Telegraph* newspaper's website, Dalhousie Castle Hotel & Spa is one of the most haunted hotels in Britain, and another website, Spookystuff.co.uk, backs that up by saying something along the same lines.' Tom reported.

'Really?' the voices of Rich and John asked enthusiastically in unison from the darkness of the back seats.

I smiled knowingly to myself, having researched the magnificent thirteenth-century castle on the banks of the River Esk extensively before I made an approach to see if they'd be interested in having the North East's finest spectre-seeking ensemble descend upon the historic fortress after dark to find out what otherworldly entities may be lying in wait for us.

The paranormal pedigree of Dalhousie became even more apparent as Tom's voyage of discovery along the information super highway continued.

'Celticcastles.com has it listed as one of the top ten castle-hotels in all of Europe, it also makes the top ten most chilling haunted hotels in the world on weburbanist.com, and an Australian newspaper called the *Herald Sun* described it as one of the most haunted hotels in the world after a reporter was scared witless by the spirit of a ghost called Lady Catherine. Hey, there's a YouTube video of the reporter's night at the castle.'

Tom plugged his iPhone into the speaker system of the car so we could all hear the audio from the video clip as he sat and watched. What followed was an Australian woman by the name of Helen Parker giving a little of the history of Dalhousie, then as night time arrived, and the castle's guests headed to their rooms and the lights were turned off throughout, her solo ghost hunt began.

'Hello ghosts?' she called out expectantly. A couple of hours passed without event, and 2.00 a.m. found Helen in the Dungeon restaurant alone, reflecting on the lack of activity to the camera and suggesting that perhaps all this ghost stuff is just 'hocus pocus'. No sooner had she finished talking than there were several loud bangs as she screamed and a series of edited beeps

masked her expletives as she ran away. Tom explained a chair next to where she was sat had started moving and banging on its own.

This really whet the appetite of the team, and we couldn't wait to get there and see if something similar would happen to us. However, that would have to wait for now, as we were approaching the first stop of our journey – McDonalds just off the A1 at Berwick. Tom hadn't eaten since leaving work and Rich fancied a coffee.

We were against the clock so we were back on the road within only a few minutes. It was already nearing 7.45 p.m., as we'd been late leaving due to Rich being held up on his way to John's, where I was picking him up, although he'd tried to win us over with talk of a delicious lemon cake he'd brought. Our plan was to get to the apartment right in the centre of Edinburgh that we would call home for the next forty-eight hours, quickly drop off our bags and then get back in the car and make the short twenty-minute drive to arrive at Dalhousie Castle Hotel by 9.30 p.m.

That was the plan, but it wasn't to be. No sooner had we rejoined the A1 than the road a mile or so ahead of us was ablaze with flashing red and blue lights. Police cars blocked the access to the A1 north from the next roundabout – the road we needed to take.

With no obvious alternative route north, we had to do what a number of other motorists were already doing – queuing up on the roundabout to ask alternative directions as there were no diversion signs.

'The road ahead is closed, so you're going to have to double back, turn right at the next roundabout and go up through Coldstream,' said the fed-up police officer, who'd clearly repeated those same words dozens of times already.

Rich quickly worked out the alternative route on Google Maps, and estimated that this forced change of route would add around an hour to our journey, and that's if all the extra traffic taking the little country lanes didn't slow us down further.

Ten minutes later, we came to a complete standstill in a snaking queue of traffic on a dark, winding country lane. We couldn't see how far ahead it stretched, but we could see that there was no traffic coming towards us in the other lane, and quite a few cars in the traffic jam were performing three-point turns and heading back the other way. Five minutes passed with no movement at all. Ten minutes ticked by, and we hadn't moved an inch. I didn't really know what to do – there was no point doubling back as there was no other route north. Thankfully, a few minutes later we began to move, and drove past the cause of the hold-up; the wreckage of a five-car smash. Before long, the traffic was moving along nicely and we were felt like we were finally making progress. It was obvious we were going to be very late to our accommodation, although the key had been left for us so that wasn't a problem, but we felt the need to contact Dalhousie and let them know.

Rich rang ahead and apologised. They were great and said it wasn't an issue. However, I'd agreed we would stay no later than 2.00 a.m., so this delay was eating into our time.

At just after 10.00 p.m., an hour behind schedule, we finally parked up in the centre of Edinburgh, and when I say right in the centre I mean *right* in the centre of Edinburgh's Old Town, as our accommodation for the weekend was an apartment right on the pedestrianised stretch of the Royal Mile. I parked up in an empty space outside Boots on Cockburn Street and we got out into the cold night air. We grabbed what we needed from the boot of the car and quickly headed to our apartment, located in the suitably historic and eerie Advocate's Close. We looked up at the Advocate's Close sign above the ancient archway leading down the dark alleyway, where there was a plaque on the wall charting notable residents of the close in centuries long past.

Advocate's Close
Residence of Lord Advocate Sir James Stewart 1692–1713. Also Andrew Crosbie the jovial Counsellor Pleydell.
Earlier Sir John Scougal Painter of William III and Queen Mary.

As John retrieved the key, I hugged my coat tight around me to fend off the icy chill whistling down the narrow close. It was immediately noticeable how quiet it was, in contrast to the noise and bustle of the busy Royal Mile only a few metres away from where we were stood. I took a deep breath. The unmistakeable smell of fireworks hung in the air, with Guy Fawkes Night just around the corner, and I drank in the view of Edinburgh at night; Waverley Station was busy with Friday night commuters, and the brightly lit and unmistakable Princes Street lay beyond. It might have been a nightmare to get here, but it's a wonderful city, and this view alone was worth the prolonged journey.

Opening the door to our apartment, we were greeted by a clean, tidy, modern, comfortable, and mercifully warm place that we could call home for the next forty-eight hours. We didn't have too long, as we needed to get over to Dalhousie, but there was time to check out our luxurious digs, a little treat to ourselves after staying in Musselburgh in a bothy on our last trip only a few weeks earlier. With winter creeping up on us, we'd all agreed on our drive home from Edinburgh last time round that it was getting too cold to sleep in a big shed. There were two bedrooms, both with double beds, and a living room with two big sofas. Earlier in the week, Rich and Tom had said they were happy to sleep on the sofas, and Tom had even brought along an inflatable camping bed and his sleeping bag, leaving me and John a bedroom each. We certainly weren't going to argue with that generous, if slightly foolish, offer. John's room was en suite and offered a glorious view over Edinburgh. My bedroom looked down onto Advocate's Close, whereas the living room, another bathroom, and a newly fitted kitchen were downstairs.

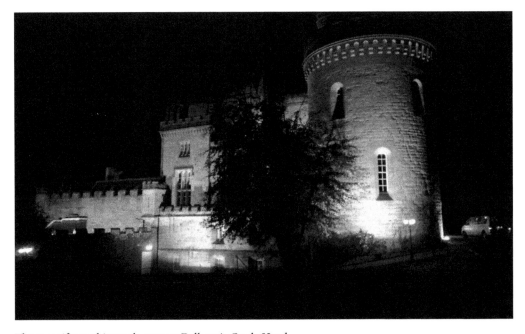

The magnificent thirteenth-century Dalhousie Castle Hotel.

Within ten minutes, we'd changed into our ghost-hunting clothes, packed the essentials, including drinks and snacks, and we were back in the car for a short twenty-minute drive to our ghost hunt.

'Is that it?' asked Rich, as we all looked out to our right and were greeted by the imposing sight of Dalhousie Castle. It was the first time any of us had laid eyes on the castle, and it was a truly was a magnificent spectacle, illuminated against the backdrop of the full moon and a blanket of twinkling stars.

We turned into the entrance to the castle grounds and drove along a gravel track lined with trees. We parked up outside the castle entrance and before we entered we decided to take a few photographs of the exterior of the magnificent building.

Tom wandered quite a way back down the gravel driveway to take his photographs, and within only a minute he came running back over to show us that he'd captured something strange in a photograph. We gathered around and there was a weird smoky mist in the image. It appeared too dense to be breath, and almost looked like cigarette smoke, but Tom doesn't smoke – none of us do. We'd already had a result and we'd not even begun yet!

We were keen to get out of the cold, and grabbed our stuff from the car. At 10.30 p.m., our ghost hunt would finally get underway. I had a few tricks up my sleeve for this weekend that the others hadn't known about until now, as I lifted my new ghost-hunting equipment case out of the boot, a medium-size protective B&W branded case, with a shoulder strap. Within my 'box of tricks' was all of my usual equipment, but also a number of exciting new gadgets that would bring a new dimension to our investigations. I couldn't wait to reveal all to the lads.

Upon entering the hotel, it was immediately apparent that the hotel was every bit as impressive inside as it was from the outside, with high vaulted ceilings, highly polished woodwork, and huge paintings and tapestries simply enforcing the grandeur of the place. We headed for the reception desk and we

Tom captured a strange wispy smoke in the bottom right of the image when photographing the hotel. (*Photograph by Tom Kirkup*)

were warmly greeted, with handshakes all round, and offers of tea or coffee. However, having lost an hour already we were raring to go, and without further ado, the night porter, who introduced himself as Peter, offered to tell us a little of the history, the castle's ghosts, and give us a tour of the castle.

We were taken to the Dalwolsey Lounge, a comfortable sitting room, where we all took a seat and waited eagerly for Peter to fill us in on the largely unknown paranormal happenings at Dalhousie Castle.

'The original castle was built in the thirteenth century, however only the vaults and thick walls of the foundation level remain of the original Dalhousie Castle. Much of the present structure was built in 1450, although many extensions and alterations have occurred over the following centuries. Entry into the castle used to be via a drawbridge over a moat, which I'll show you just later.' With such a long and eventful past, it was clear that this magnificent building would have its fair share of spectral residents.

He then told us of the Australian reporter, who was unsurprisingly at the forefront of his mind with the event being so recent and having brought the castle to the attention of the world. We discussed it, and explained that we'd just seen it on YouTube and he assured us nothing was set up or faked, and that she was absolutely terrified of staying in the castle after she fled the dungeon.

'There are two rooms in which I see things,' continued Peter in his strong, yet totally clear, Scottish accent. 'The first is room 17, the Robert the Bruce room; and the other is the William Wallace Suite, which is right up the top of the castle where the flag is. There used to be an original staircase out of the Robert the Bruce room which used to spiral down the castle. People have been horrified to see a figure in their room, and it is like a replay as it is always seen walking through the television and vanishes into the wall behind it. This is where the original staircase used to be.'

'In the Wallace Suite, there is again a shadowy figure seen to walk through a wall and that's because back in the thirteenth century there was a house on the top of the castle. The only way to get to that would have been through the Wallace Suite.'

Sadly, the castle was fully booked, so we wouldn't have access to either of these rooms. Rich asked if there is much activity throughout the parts of the castle we would be able to access, and how it manifests itself.

Without speaking, Peter handed over a rolled up sheet of A4 paper he'd been carrying to Rich. Rich unrolled it as the three of us peered over his shoulders. It was a black-and-white print out of a photograph of a man and a woman at a formal function, my immediate guess would be a wedding. She was dressed smartly in dark trousers, and dark cardigan, she had a white top underneath. She was wearing a large white hat with a dark ribbon around it. She was stood up, with one hand resting the back of a large leather chair where a man sat. He was nursing a drink and was wearing a bow tie, shirt and jacket, and a kilt. Oh yeah, and between them was a ghost. I'm always really wary of photographs presented to me as being a 'ghost photograph' because of something called pareidolia. This is a psychological phenomenon in which the human brain can be tricked into seeing or hearing something that doesn't exist, such as seeing faces in clouds, messages in music when played in reverse, even people claiming to see the face of Christ on a piece of burnt toast. If you're told to look for something or listen out for something there's every chance your brain will identify it, even when it's not actually there. However, there was no danger of that with this. I couldn't see a face, as it appeared they were facing the man and woman, however I could see the back of their hair, see their arms, I could make out the creases in their clothing, which appeared to be a dress. The figure's head and shoulders were transparent, but further down they were more solid. They appeared to be stood up, although I couldn't see any feet, possibly hidden

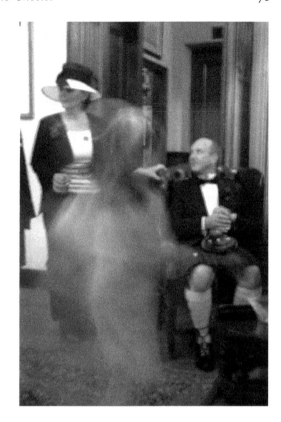

The amazing photograph Peter showed us, which appears to include the ghost of a girl. (*Photograph provided courtesy of Dalhousie Castle Hotel*)

beneath their long dress, but they were shorter than the woman, and were roughly the same height as the seated man in the tall chair.

I was looking at one of the most remarkable photographs I'd ever seen, and it was clear that my fellow ghost hunters were equally impressed.

'That was taken just outside in the reception area in around 2000. They're the mother and father of the bride. A photographer was capturing people having a good time, but no one saw anything at the time this photograph was taken.'

'That's not the only photograph we've had taken here like that, either. Other photographs appear to have strange smoky things moving around in them.'

We all looked at each other, all being reminded of Tom's photograph from no more than ten minutes earlier. We showed Peter but he didn't seem at all surprised, like a man accustomed to seeing similar photographs.

'We have people complaining of being freezing cold too, but as soon as they move from where they are or stood up they warm up. When they go back to where they were cold, it's back. It happened to me a couple of years after I started working here. I was working in the big hall, which I'll take you to shortly, and he was in the corridor outside here. And he shouted for me to shut the windows and the door leading to outside as he said he was freezing cold, and I shouted back, "You're joking, I've not got the windows open and I'm red hot, I'm sweating," but he was shivering, he just couldn't get warm. I went out to see how he was and I was icy cold too, but as soon as we came back in here it was warm again. That was my first ever experience here.'

'We have lights go off and on, and dim and go brighter as well, that's fairly common.'

'We had a girl who worked here in the back office. She did the wedding tours and helped with the weddings. I was working one night and she was staying over as a guest with her partner, it was the first time she'd ever stayed over. I got paged to reception at 1.30 a.m. and they were both standing there. He was half asleep, but she was wide awake. She looked pale as a sheet and she was shaking. They'd packed their bags and brought them down with them. I asked them what was wrong, and she said, "tell me about the William Wallace Suite, Peter". I asked what she meant; it's a really nice suite. "No, I'm serious, I'm terrified, tell me what happens in there". I told her that it's believed to be one of the most haunted rooms in the castle. She seemed almost angry that no one had warned her. It turned out that they were asleep in bed when she woke up panicking and couldn't move. She could see a shadowy figure on top of her pushing down on her chest and she couldn't catch her breath, or even speak. He woke up with her thrashing about as she tried to catch her breath, and he put the light on and the whole thing stopped.'

'The Wallace Suite is popular with the bridal party staying over prior to getting married, as it's a big room and it's a good size for getting ready. There was one occasion when I was called up to the room at 4.00 a.m. by a terrified group of girls demanding to know why a housemaid was walking around cleaning their room at four in the morning. I explained there wasn't a housemaid on duty, but one of them had seen a woman wandering around their room, and woken up another just in time for the other to see the woman's reflection in the mirror walk into the bathroom. There was no one there when I checked. But I had to move them to another bedroom as they were too scared to sleep.'

'In the Robert the Bruce room, there was an American lady staying here with her mother. She was in the shower, and the shower was all steamed up and she could see a woman standing still in the bathroom through the steamed up shower door. She assumed it would be her mother so began chatting to her as she showered. It turned out her mother had popped downstairs to reception and she was the only person in the room.'

'There are a lot of these stories where it seems someone has seen the ghost of a woman, and this is due to our most frequently seen ghost is that of Lady Catherine, sometimes called the Grey Lady as she wears a long grey dress. Catherine died in 1720 at the age of sixteen. She was captured from an English family and brought up at the castle. She became the mistress to one of the Ramseys who ruled over Dalhousie Castle. His wife found out and locked Catherine away in an upstairs room. She was brought food and water, but when her love didn't come to find her, she chose not to eat or drink. She was broken-hearted and lost the will to live. Whether she died of thirst or hunger is unknown, but she did die all alone in that locked room. It's believed that she can't stand bagpipes, and has affected pipers on many occasions. It's also said that because she died broken-hearted she hates weddings, and regularly makes appearances when we have a wedding party staying in the hotel.'

'We also have the ghost of a wee dog. Now this dog was called Petra and was up on the roof in 1972 and fell off to its death. Whether it fell or it was startled by something and jumped no one's sure. But that wee dog is buried next to the chapel. I've had guests come to me in the middle of the night and say that they can hear a dog scratching at the door to their room, panting and barking, trying to get in. Others have said they can hear a dog howling and can I make it stop. The answer's no, I'm no psychic – I can't make this little doggie stop wandering the castle at night.'

'There's also a young boy, aged around five. He's another of the castle's better-known spirits, but it's always written that he fell from the roof, that's not true at all. He died the same way as Catherine; he was locked in a room in the castle and starved to death.'

'There's a man with white gloves, no one knows too much about him, but he can be quite mischievous. He's the one to blame for the temperature changing and lights going on and off.'

The interior of the beautiful hotel is every bit as grand as the exterior.

'They're the main ghosts of the castle, although I've no doubt there are others. But how about we go and have a look around some of the other rooms?'

We left the cosy sitting room, and headed out into the main corridor. It was still relatively early, but it was amazing how quiet the castle seemed already. Peter asked us how much we wanted to know about the reported occurrences in each room, and Rich suggested that he could tell us a little bit about each room, but not give us too much information about the ghostly happenings, as we didn't want this to influence our investigation.

Peter led us into a long function room with large circular tables with clean white tablecloths and red seats around them. A row of ornate chandeliers ran down the centre of the ceiling for the length of the room, and the enormous bay windows were covered with long, lush, deep-red curtains, the colour of which matched the seats. This was the Ramsey room, the largest of Dalhousie's function rooms. It is often called the long room, and this nickname derives from a period in the castle's history from 1925 to the 1950s where the castle was used as a school. This room was used as a playroom and the children used to call it the long room, due to its length.

Peter pulled back one of the curtains to show us that the bay window behind this curtain wasn't a window at all. It was a door leading out onto the battlements. Despite it being a bitterly cold night we followed him outside, and even though it was around 11.00 p.m., the huge full moon hung in the sky like an enormous beacon, allowing us to see the fields and woodland for miles around. The view was breathtaking.

We left the Ramsey room and Peter showed us the original dungeon with 11-inch-thick walls. Prisoners were lowered into the room by rope, giving them no chance of escape.

The next leg of the tour took us to the Brechin room, a smaller circular function room which can be booked as for meetings or presentations during the day and is luxuriously decorated, with a thick plush carpet, and wall-affixed cabinets, designed to be curved to match the walls of the circular tower room. This part of the castle was added around 500 years ago

We were then taken into a room called the Gun room, which is strange in that you enter the room onto a balcony and have to descend a staircase into the room. We passed through here to get

to an area that was part of the original 800-year-old Dalhousie Castle, the worryingly-named Black Corridor. This would once have been the stone corridor that prisoners would have had to pass through en route to the castle's dungeon. It is now the corridor in which the spa can be found.

The dungeon was our next stop. This large barrel-vaulted room provides a unique setting in which to experience the castle's fine dining, in a strange contrast to its early history, when these ancient stone walls had seen untold horror, bloodshed, torture, and ultimately death. It was eerily quiet, having been closed to diners and hotel guests for several hours, and the spooky atmosphere was enhanced by the low lighting and full suits of armour and weapons that decorate the walls.

Peter showed us where the original castle drawbridge and portcullis would have been, and then off to the side showed us a narrow winding staircase. It was tricky to climb with my big box of ghost hunting gear, which I had to take off my shoulder and carry by the handle. When we reached the top, we were back in the Ramsey room.

Peter left us and wished us good luck, letting us know to give him a shout if we needed anything. We thanked him and began our hunt in earnest. I checked my watch and it was 11.40 p.m., giving us just shy of two and a half hours. We were in the Ramsey Room, so we all agreed this was where we would begin. I nipped to the toilet, leaving the others unpacking their gear and getting started.

I returned no more than a few minutes later to find the other three bubbling over with excitement. Rich was almost bursting as he told me that as I'd been answering a call of nature, *something* within the room had answered a very different call. They'd been sitting at a table preparing for the investigation when a chair, positioned on its own, within a bay window had, as Rich described it, vibrated of its own accord. I asked exactly what he meant by vibrated and they all said that it had kind of rocked back and forth and banged on the floor. This immediately reminded me of the YouTube video where the Australian reporter ran away from the banging chair in the Dungeon restaurant. I calmed them down and, as always, we tried to rationalise. Perhaps it was a loose floorboard, combined with a car turning around in the car park outside somehow causing the vibrations. John said that he'd been jumping up and down all around the chair and nothing had happened. I turned the lights down low using the dimmer switch – we didn't want total darkness, as we wanted to be able to see the chairs in case it happened again. We all sat around the table closest to the 'vibrating chair' and John asked again, 'Is there anyone here with us?'

Nothing.

He asked again, and as we all focussed in on the chair, a loud knock came from the opposite end of the room, making us all turn our heads in unison to look in the direction that it had come from. With this new development, we spread out around the room. Rich stayed at the table we were sat at, John sat on a chair right next to the 'vibrating chair', Tom sat on a comfy chair about halfway down the room, and I sat at the extreme far end of the room in a darkened corner where the knock had appeared to have been.

We continued to ask, however every question was greeted by an eerie silence. With so many rooms left to explore, and with time slipping away, we moved on, agreeing that we'd return before our evening at Dalhousie was over.

Just after midnight, we found ourselves in the Brechin room. There were comfy chairs around the perimeter of the room, and we sat down. Earlier, during Peter's tour, he'd told us of a man in white gloves who's been seen throughout the castle, but this room appears to be his favourite haunt, and he is blamed for the phenomena here, including one particular incident which Peter experienced first-hand. One night he was the night porter on duty when a former owner came to him and asked why he'd not turned the lights off in the Brechin room, as it was late at night and

The Ramsey Room, also known as the long room.

after guests retire to bed he would go around and make sure all the lights are off in the communal areas. He knew he had turned the lights off, but went up to check and, sure enough, the lights were on. He turned them off, convincing himself he must have not flicked the switch properly, and returned to the reception. Shortly afterwards, as Peter was doing some paperwork, the owner came back and blurted out, 'Are you going to pay my electricity bill? You've been back up to the Brechin room and left the lights on again, I've just seen them go on when I was outside.' Peter explained he'd not moved, and hadn't been up to the Brechin since turning the lights off earlier. A matter of weeks later, the owner was sitting quietly at night in the adjoining room with only his dog for company, the door to the Brechin room was open, and the lights within the room suddenly turned on. Both he and his dog got out of there in a hurry, and from that night on Peter was never again blamed for this all too common occurrence.

We spaced ourselves out and took a seat. John was talking when Rich interrupted him to complain that he suddenly felt icy cold, and as soon as he stopped talking his mobile phone which was on the seat next to him seemed to be thrown to the floor. Tom said he'd seen it happen. Rich definitely hadn't knocked it, and it appeared to be have been fairly central on the chair.

We discussed this between the four of us, and as always we tried to rule out rational explanations, but we all agreed that it seemed very unlikely that it had just fallen, so could it be that we were in the presence of a spirit? We didn't want to waste a moment and began attempts to communicate with whoever may have been in that small room with us.

'If there's anyone here in this room with us,' John said quietly, 'and if you knocked the device off the chair, please make yourself known. We know you have been able to show yourself to people in this room, so if you were able to show yourself to us we would appreciate it. We mean you no harm, and we come in total respect. We're curious as to the existence of ghosts and come in search of proof. Could you do something to let us know you're here? Could you make a sound, touch one of us, say something to us, please do this now?'

We waited for a short while, and the only sound we could hear was that of a plane overhead, a sound we would hear regularly during the evening due to the close proximity to Edinburgh Airport.

I had a suggestion. 'Peter mentioned lights being switched on in here, so why don't we turn the lights off completely, and ask for them to be turned back on?'

'Brilliant idea,' agreed Rich. Tom and John nodded. I got up and crossed the room, and switched the lights off. We were plunged into darkness. I put my torch on so I could safely find my seat. Once I was sat down I turned the torch off again.

We asked for the man said to reside within the room to turn the lights back on, we all looked up in the darkness, towards where we knew the impressive chandelier hung, hopeful that it would turn on and once again, and bathe the pitch black room in bright light. However this wasn't to be. We continued to ask for signs for over ten minutes with no results.

However, just as we were about to give up I could hear footsteps in the room next door, a dining room with tables already set out for the next morning's breakfast. I was just about to speak up when John beat me to it.

'Can you hear that? There's someone walking around next door.' We could all hear it, and the footsteps were getting louder as it was obvious they were heading to the room in which we were sat quietly, waiting for the inevitable.

Our eyes were attuned to the darkness now, and we all stared at the closed door as the handle slowly turned. I shuffled uncomfortably in my seat and I realised my palms were sweaty and my

The Brechin Room – the most common occurrences in here are lights turning themselves on when the room has been empty.

heart was racing. It was one of those 'fight or flight' moments, but we had nowhere to run as our only exit was through *that* door. The door clicked open, the click sounded so very loud in the silence. The door slowly swung open and I could clearly see a dark, shadowy figure stood perfectly still in the doorway.

After what seemed like an eternity, but in reality was mere seconds, the figure reached out an arm, and switched the light on. It was a member of staff. He was a little startled to see us sat there, but he took it surprisingly well. We said hello and explained who we were, as the others chatted and laughed about our scare, I realised that I had conflicting emotions over what had just happened; in the immediate moments following the light coming on I was relieved to find it was a member of staff, but given why we were there, it was now bitterly disappointing.

At 12.35 a.m., we headed down into the lowest part of the castle and found ourselves back in the Black Corridor.

It was time to try a new experiment. I dipped into my big, black case of ghost-hunting stuff and returned clutching a small, black plastic box, which looked just like a small portable radio. That's because in a previous life this curious gadget had been a portable radio; however, it had since been converted into a device called a Frank's Box.

The Frank's Box is named for its inventor Frank Sumption, who designed the first incarnation of the device back in 2002. He claimed to have received the idea for the gadget from the spirit world. It works on the principle of Electronic Voice Phenomena (EVP), whereby spirits are able to communicate in the white noise between radio stations. The Frank's Box is designed to scan all AM radio frequencies sequentially for less than a second each, and in this white noise the spirits can communicate with the user. The device is viewed sceptically by a large proportion of the paranormal community, as many of these frequencies are occupied by radio stations so you will hear bits and pieces of words and songs and this could lead to coincidences. Alternatively, it could be a form of pareidolia, and the listener could make their own interpretations of what they are hearing to suit their requirements.

These devices aren't readily available for sale, and I had to have mine imported from the United States, where someone had bought a standard radio and adjusted the electronic circuitry for it to cycle through each station for the required duration. I did a lot of research before handing over my hard-earned money, and there have been some astounding results which have managed to convince even the most hardened cynics that there may well be some benefit to using these devices as part of an investigation.

I turned it on, the screen glowed orange, and then a split second later the digital display sprung to life displaying the frequency 520 AM, and a loud noise, the sound of a radio not tuned in to a station, the sound of white noise.

Tom spoke loudly above the hiss of the white noise and asked for anyone in the corridor to speak to us. I held the up button on the device for a few seconds and it began to scan through the frequencies.

He asked questions ranging from 'what is your name?' to 'what year did you die?' We continued with this line of questioning for around fifteen minutes, but sadly didn't have any luck with the Frank's Box.

We walked around the corner, and through the door into the Dungeon restaurant.

Tom and John went to the furthest area of the dining room, which was in total darkness. Rich and I sat in the smaller dimly lit central area opposite the original ancient stone archway which would have once had a portcullis. I was sat at the very table the Australian reporter was sat just before the chair started banging and she fled.

Tom, Rich and John investigate the Black Corridor.

Tom and John sat in silence in their room, and Rich spoke, asking for some kind of sign that we weren't alone.

I heard a voice a few seconds later, and it was Tom asking what we were all thinking.

'What was that?'

There'd been a loud bang outside the restaurant, back out in the corridor, which seemed to come at the perfect time to be a response to Rich's plea. We weren't jumping to any conclusions, as we realised there were residents staying here, although why one of them would be in the spa area at almost 1.00 a.m. was unclear. Rich and I went to check it out to try and get some answers. There was no one there.

We returned to our seats and Rich asked again, 'If you made that noise, could you please do it again?'

There was another loud noise out in the corridor, this time followed by another, and another, and another. They were footsteps, and they were heading towards the restaurant. We sat quietly, no one speaking, waiting to see what would happen. The doors swung open with a loud creak and a member of staff walked in. He walked straight past us, he may not have even noticed us, and went up the stairs through the archway. There was an audible sigh of relief, and with that mystery solved we carried on.

'Lady Catherine, are you here with us?' asked John. 'Can you make a sound, or move some furniture?'

'What was that?' he asked quickly afterwards.

'What was what?' the other three of us responded in unison.

'I saw a flash of light move quickly in that middle section where you and Rob are. Do either of you have torches on, or are you taking photographs?' Rich and I were puzzled, as we'd seen nothing and neither of us were using anything that would generate light or a flash.

'Can you do that again if that was you Lady Catherine?' said John as we all looked around expectantly.

'Talk to us, we're here to listen,' added Rich.

We continued for five minutes but all was quiet. Rich and I joined John and Tom in the furthest section of the restaurant, spreading out within the room, sitting at a table each.

'We're all here now, Catherine,' I said. 'Why not pull out one of these chairs and sit with us?'

We heard a whistle come from the central area that Rich and I had just vacated.

The display on my Olympus voice recorder, which I'd just placed on the table a few minutes earlier, caught my eye. It was turning off. As I turned it back on and pressed record, I told the others as I couldn't understand why it had happened as it was fully charged, John hushed me mid-sentence and placed his finger to his lips. I stopped talking.

'Listen,' he whispered. I heard it, footsteps. They weren't heavy workman boots like we'd heard earlier, these steps were much more delicate, but they were clearly footsteps. And this time they were in the room with us.

After no more than a minute the footsteps simply seemed to fade away to nothing.

'I feel really cold,' whispered Rich, his teeth almost chattering. The atmosphere in the room had changed; it felt like we were no longer alone.

'If you are taking Richard's energy and making him feel cold, can you do this to one of the others around this table?' asked John, as Rich hugged himself to attempt to warm himself up.

I felt a blast of cool air whizz past me, like a rogue breeze. I told the others and attempted to establish if there was air conditioning or an open window which could have caused it. It appeared there was nowhere in this small area of the restaurant that the cool air could have suddenly came from.

'How does everyone feel?' queried John.

'I feel fine,' said Tom.

No sooner had the words left his mouth than the neatly folded napkin set out on the table before him lifted up on the table and fell to the ground next to his foot.

'Did you knock that?' asked Rich, as Tom looked down at the napkin on the floor in disbelief. He shook his head.

'Could you do that again, this time at one of the tables that we're not sat at so we can be sure that it was definitely you who moved it Catherine?' I requested, hopefully.

By now, every time we asked for a sign we were getting knocks and bangs all over the room. The problem was, we couldn't be sure if it was the member of staff we'd seen earlier in an adjacent room, or if they were simply the sounds of an old building.

At 1.20 a.m., we moved back along the Black Corridor, and while the other three headed to the Gun room I nipped to the toilet.

As I returned along the silent corridor, my blood ran cold as I heard a whispered voice *right* behind me. I stopped in my tracks and listened intently, my inner voice was screaming at me to run back to the Gun room, tell the others and then come back – safety in numbers. But I fought this instinct and stood perfectly still. The urge to flee intensified as I realised that there was more

The Dungeon restaurant.

than one voice whispering behind me – there were several male voices talking among themselves. To my horror I clearly heard a deep voice say, 'Talk to us.'

I'll be honest – at that moment in time, I wanted to be anywhere else than in that corridor, but against my better judgement, I swallowed hard and spoke.

'Hello ghosts?' I said quietly. There was no reply but the whispering continued. I plucked up the courage and turned around, half expecting to come face to face with several shadowy phantoms. There was no one there, and I could no longer hear the voices.

I stood quietly, and I could hear my heart pounding away in my chest. I was horrified to realise the voices were still there, but now appeared to be behind me, in the corridor between where I stood and the room where my friends awaited my return. A male voice clearly said 'Rob'. I couldn't decide if this was ghost hunting gold dust, or my worst nightmare. Every hair on my body stood on end as I listened to the several voices talking in a low whisper right behind me. I challenged myself to turn around, but I was frozen to the spot. I knew if I didn't turn around and the voices stopped I'd always regret it, so I counted to three in my head and span around quickly, but again there was no one there.

The voices were somehow behind me again! It was at this moment that the penny dropped, and it was a frustrating realisation. My Olympus digital voice recorder was in my back pocket and had somehow started playing. The voices I could hear were the four of us talking ten minutes earlier in the Dungeon restaurant. I chuckled to myself, annoyed at getting so worked up, and made my way back to join the others.

I felt a little foolish, so chose not to tell the others and took my seat. Tom had made his way up the sweeping, curved staircase onto the balcony with elaborately decorated ceiling above him. His vantage point meant he was overlooking the other three of us on the lower level. I sat at the head a long table, and Rich and John took seats elsewhere around the table. We decided to turn the lights off completely, the switch was next to Tom, so he flicked it off, and the room was swamped in darkness. We sat silently and there was an eerie calm about the room. This room is the castle's very own private wedding chapel, and it's clear to see it would make a beautiful wedding venue. It has an attractive chandelier hanging overhead, atmospheric lights fixed to the wall with flickering candle-effect bulbs, and a highly polished wooden floor with a strip of red carpet running down the centre, with beautifully decorated stained glass doors beyond which open out onto the terrace where guests and the newlyweds can experience celebratory drinks.

'I can feel a cold breeze moving all around me,' Tom whispered.

We sat quietly while he tried to establish where it was coming from, then it seemed to stop.

'Can you give us a sign that there is someone here with us, make a sound, speak, appear to us?' John asked.

We heard a loud bang from inside the room.

We then heard it again, we investigated further and established it was a storage heater cooling down.

It was really cold in the room as there was a draught coming from the door at the back of the room, which opens up onto the terrace. There was a wooden door covering it up but there was still a very obvious draught making John, Rich and I very cold indeed. However, we did our best to ignore this and John carried on.

'Can you give us some kind of sign that you're present? We are curious to your existence and we've come a long way to see you.'

After twenty-five fairly quiet minutes in the Gun room, we had a decision to make. We had fifteen minutes left and then we would have to bring our time at Dalhousie to an end, so should we spend that time here, or head back to one of the rooms we have already investigated? We unanimously agreed to head back to the Ramsey Room, where the most interesting occurrence of our investigation had occurred when the chair seemed to move and vibrate.

Within a couple of minutes, we'd relocated and spread ourselves out around the room, in pretty much the same seats we had been sitting in earlier. I took a new piece of kit from my case and decided to use it to help try and stir up some activity. I asked John to position it in the centre of the room and flick both switches on the side. This would 'arm' it to give us a visual and auditory indication if there was a presence near the box.

I explained to the guys that the Paracorder 667 (available at www.moditronic.com) is a new piece of kit available to paranormal investigators and works on the basis of the 'flashlight phenomenon', which is a really simple idea that took the ghost hunting world by storm when it was shown on a US ghost hunting TV show in 2010. It works on the basis of unscrewing a torch, or 'flashlight', so that the bulb is barely touching the power source. If a spirit is able to touch the torch, the bulb will touch the power source and light up, thus proving the ghost has enough energy to move the torch and complete the circuit. This is hardly an exact science, so the guys at moditronic.com decided something more conclusive could be designed using the same principle, and thus the Paracorder 667 was born. There is a wire which, if touched, completes the circuit and lights up a red bulb and makes an alarm sound.

'Hey, the sticker on the box says it contains EMF Vortex technology…?' John was intrigued.

As an added bonus, the Paracorder 667 also includes a built-in device that pumps out electromagnetic fields (EMF), which it's believed, although can't be proven, can be used by spirits to make themselves stronger and have more influence on their surroundings. The instruction book for the Paracorder 667 explains that this acts as 'ghost food', and is very enticing for the spooks.

After John had positioned the device, I flicked the light switches off completely, although the room wasn't totally dark as there was a dim beam of light coming in through the bay windows, and the bright glow of the red LED of the Paracorder in the centre of the room.

The seat I occupied looked towards the corner of the room with an ancient spiral staircase which went down to the Dungeon restaurant, and I had a sudden idea that one of us could go and sit down there – alone. I put the idea out there, and Tom jumped out of his seat and said, 'I'll go!' incredibly enthusiastically, considering how dark and ominous the room was. I suggested he keep an eye on the time and head back up just before 2.00 a.m., which would give him around ten minutes, but it was worth a go; to divide and conquer seemed to make sense.

Rich, John and I discussed how to approach our final ten minutes, and John pointed out that the chair moved when none of them had asked for anything to happen. We agreed that, rather than make requests, we would sit quietly and listen, watch and wait.

I could hear the sound of the wind whistling outside – it seemed to have really picked up over the last few hours, and no doubt the temperature would have plummeted even further. I was thankful we had a nice warm apartment awaiting our return.

The ten minutes passed by quietly, and without anything of note occurring.

Just before 2.00 a.m., a bright light appeared in the far corner, the staircase Tom had descended almost ten minutes earlier. It was a bright light going around in a circle, reminding me of a lighthouse. It was Tom's head torch as he made his way back up the staircase. Sadly, he had nothing out of the ordinary to report either.

We packed our belongings away, and headed to the reception to thank the night staff and say our goodbyes. The temperature was below zero when we got outside, but I was parked just next to the entrance so we threw our stuff in the boot and jumped into the car. I cranked the heating up to full and we drove out of the gravelled car park, and along the almost deserted roads back towards the centre of Edinburgh.

We got back to the Royal Mile around 2.30 a.m. and parked up in the same space I'd used when we'd stopped here briefly a few hours earlier. As we got out of the car we almost fell over two very drunk local lads having a proper fight, with swearing and punching. We ignored them and made the short walk to Advocate's Close and our home for the weekend.

We were all exhausted after a long week at work and a late night, so we said our goodnights, agreed on what time to be ready for in the morning and went to bed.

CHAPTER FIVE
CUSSIN' BOOTS
THE SOUTH BRIDGE VAULTS, 3 NOVEMBER 2012

I awoke at 7.50 a.m., and I was still shattered, having had less than five hours of sleep. However, I had to move my car before 8.30 a.m., as that was when the parking became chargeable. I stretched and rubbed my eyes. I grabbed my towel and checked the weather through my window. It looked dry, which was good enough for me. I tiptoed downstairs, trying my best to not wake Rich and Tom who were sleeping in the living room opposite the bathroom.

After a shower I felt a little more human, and returned to my room to get dressed. At 8.15 a.m., I gave John a knock, as he is always up early, and he was happy to keep me company as I moved my car. I asked if he'd gone for a wander during the night, as he often does much to the bewilderment of the rest of us. I'd been woken around 5.30 a.m. by someone creeping past my door then quietly leaving the apartment. He said he'd slept right through and it wasn't him. I found this a bit strange, and couldn't imagine it would have been Rich or Tom, but I could ask them later.

A brand new day was upon us but yet again it was freezing cold outside. I'd worn an extra layer on top of what I had been wearing for the ghost hunt at Dalhousie last night, and I was already glad of it. It was strange seeing Edinburgh this early in the morning with hardly any tourists around. Market stalls were getting set up for a busy Saturday, which would be even busier with a home coming parade starting at 9.00 a.m. along the Royal Mile.

We climbed into my car and made the short drive to Leonard Street, a car park we'd identified as being one of the cheapest in and around the city centre. The little wooden shack to pay was closed, but there was a sign explaining that I should leave a note in my windscreen with my time of arrival, when I plan to leave, and my contact details, and that I'd have to return later to pay. I did this, and we returned to the Royal Mile, taking a slight detour to pop to Greggs to get something for breakfast, both of us opting for hot food to warm ourselves up as it was bitterly cold.

By the time we walked the mile or so back to the apartment it was almost 9.00 a.m., and the streets were getting busier. The parade meant there was a strong police presence in the city centre.

When we got back into the apartment, Rich and Tom were awake. John and I joined them in the living room and as they lay in their sleeping bags and we chatted about all manner of things.

When I got around to asking Tom and Rich how they'd slept, and if they'd been upstairs during the night, they both said that they'd slept soundly and not got up during the night, so I was still not sure who I'd hear creeping around in the early hours.

They both got showered, and at 9.50 a.m. the four of us headed out into Edinburgh, and to our next ghost hunt. As the people of Edinburgh went about their daily routine, the four of us would be heading underground to take on one of Edinburgh's best known haunted hotspots. The entrance to the South Bridge Vaults, more commonly known as the Edinburgh Vaults, is on Blair Street, which was only a stone's throw from where we were staying, so the walk took us only a few minutes.

Despite being a relatively recent chapter in Edinburgh's history, the story of the South Bridge Vaults is mysteriously sketchy. The Vaults are a series of chambers formed in the nineteen arches of the South Bridge, which was completed in 1788. The South Bridge was built as far more than a simple crossing from Old Town to Southside. It was actually Edinburgh's first purpose-built shopping street. With this in mind, around 120 vaults were built beneath the surface of the South Bridge to be used as storage space for the businesses on the bridge.

South Bridge officially opened for business on 1 March 1788, and locals avoided it initially as it was believed that the Vaults were cursed, due to an untimely death. Upon the bridge's completion, it was deemed a fitting honour that the South Bridge's eldest resident, the respected wife of a local judge, should be the first to cross this architectural marvel.

Sadly, in the week leading up to her big day, she died. Alternative options were considered, but with promises made to the lady's family it was decided that she should still be the first person to cross the bridge, even if it was to be in a coffin. The locals were appalled and declared the bridge to be cursed. Such was the superstition in the day that most of the locals totally avoided the bridge, believing that to cross it would bring death to themselves or a loved one. Instead they would take the much longer and less practical route through the deep valley of the Cowgate.

However, the Vaults would become hugely successful, and land upon the bridge was fetching more per square foot than anywhere else in Europe.

The underground Vaults, however, weren't thriving in the same manner, and only operated as planned for less than a decade. Construction of the bridge had been rushed and the surface was never sealed against water. The Vaults began to flood. Abandonment of the Vaults as a viable option for storage began as early as 1795.

With the Vaults gradually being left abandoned and ignored by the businesses on the bridge, the empty rooms were adopted and adapted by enterprising new users, who had no permission and right to be there. Slum dwellers took over and it became a renowned red light district with countless brothels and pubs operating within the abandoned complex. The Vaults also served as additional slum housing for the city's poor. Living conditions were appalling. The rooms were cramped, dark and damp. There was no sunlight, heating, poorly circulated air, no sanitation, and no running water. Many of the small rooms acted as makeshift homes to families of more than ten people. Crime, including robbery, rape and murder, was rife in the shadowy and lawless underground Vaults. It has been written that Burke and Hare, the infamous serial killers who sold corpses to Dr Robert Knox, are rumoured to have hunted for victims in 1827 and 1828 among the city's poorest residents who still called the Vaults home.

By around 1835, the conditions in the Vaults had deteriorated in the extreme, making it impossible for anyone to live or operate there and the Vaults complex closed down for good. It's not known when or why, but in the years that followed tons of rubble was dumped into the Vaults, making it inaccessible. And with that, they were completely forgotten. No one remembered the Vaults. No one spoke of the Vaults. And since nothing of the Vaults' unsanctioned use was ever documented, it seemed they were completely lost to history.

However, that was to change in 1985, when a former Scotland international rugby player found a strange tunnel leading beneath the South Bridge, and into the long lost labyrinth of rooms and chambers that make up the South Bridge Vaults.

It was only during the subsequent excavations that it was discovered that people had lived in the Vaults when rubbish pits were identified containing toys, medicine bottles, plates, clay pipes, damaged stoneware, and horseshoes.

The South Bridge Vaults were almost completely forgotten for 150 years, until their accidental rediscovery in 1985.

Today, a section of the Vaults on the north side of the Cowgate arch are open to the public for daily ghost tours ran by Mercat Tours (www.mercattours.com). These spaces have lost none of their original atmosphere. They are still dark and claustrophobic, and the ghost-seeking tourists who come to Edinburgh all year round flock to the Vaults.

The paranormal happenings are reported so regularly that the Vaults have been described as the BBC as 'possibly one of the most haunted places in Britain'. This quote was made following a BBC television programme recorded at the Vaults in 2009, which went out on BBC Three in January 2010. It was a one-off special called *Joe Swash Believes in Ghosts*, with a one-man ghost hunt starring the former EastEnders actor, and winner of *I'm a Celebrity...Get Me Out Of Here*. Joe heard nothing unusual during his overnight stay in the Vaults; however, inexplicable voices were captured which were truly spectacular. One voice appeared to be that of a Catholic priest reciting the last rites. Swash heard nothing but the voices continued to be heard on the recording for twenty minutes; at this point, there's a sound like children yelling and then all voices cease. BBC sound engineers studied the EVPs and initially thought the sounds may be coming from a nearby bar or nightclub, however this was proven to not be the case – the voices were coming from *inside* the Vaults.

Living TV's *Most Haunted* featured two shows from the South Bridge Vaults, one of which was part of their Halloween 2006 'Most Haunted Live', and the American show *Ghost Adventurers* also investigated the Vaults.

The paranormal occurrences are said to take many forms including, but not restricted to: cold spots, eerie lights, strange swirling mists, disembodied footsteps, the barking and crying of dogs,

torches, cameras and other electronic devices failing. There are also at least two resident ghosts, but you'll hear plenty about those during our investigation…

Sarah met us in the small office, as the Vaults weren't open to the public yet. She took us down into the dark Vaults, as she was going to light candles in the rooms in preparation for the tours beginning at midday. As we entered the dank warren of chambers and Sarah began to light candles, flames flickered and danced, strange shadows moved on the walls, the atmosphere was tense, and the air was cold to the point where I could see my breath. Sarah didn't tell us anything of the place, and that suited us just fine. The less we knew, the better, as we didn't want ideas planted in our minds giving us clues as to what we were 'supposed' to expect. We wanted our experiences to be our own, and if we found out afterwards that they matched up with what other people have experienced there, all the better.

Sarah returned to her office upstairs to carry on with her paperwork. She left us in a room she called the White room, named for its whitewashed walls. This room meant nothing to the others, but this was a room I'd heard of and it has gained itself an infamous reputation as being the most haunted room in the Vaults. I decided to keep this to myself.

It was eerily quiet, the only noise the constant rustle of a Marks & Spencer's carrier bag that John clutched in his right hand. He'd brought an apple, some chocolate, a can of pop, and a big, heavy hardback novel. I would have asked why he'd brought a book along on a ghost hunt, and when he was thinking there might be a bit of time for him to sit down and read a chapter or two, however having known John as long as I have now, I know this is the simply the kind of thing he does.

We only had two hours. Time was at a premium, so I suggested that we begin our investigation in the White room and then reassess our position after fifteen minutes. Everyone agreed and John, who by now had pretty much made the role of 'asker-outer' his own, began to do his thing.

John asked for proof that we weren't alone, but we heard and saw nothing. John said he did think the room was quite oppressive, but the rest of us felt fine.

We start our investigation in the White Room, the most active area of the Vaults.

10.15 a.m. came far too soon, and we moved on. We split into two groups – John went with Rich and Tom joined me. Rich and John walked off to the far end of the Vaults, while Tom and I left the White room, turned left and stopped at two vaulted rooms nearby. I went into a room with rubble on the floor, a dim light on the wall, and six small alcoves in the back wall. Tom was opposite me in a room with a really low ceiling, and with him being 6 feet 3 inches tall, it was impossible for him to stand up straight.

We stood quietly for five minutes, listening for anything out of the ordinary. We couldn't hear Rich and John, but we could hear an irregular clicking noise which seemed to be coming from further along the corridor. We listened to it for a few minutes and it continued so we went to check it out.

We found ourselves in a large room that opened up above us to a room twice the height of the rooms we'd been in up until now. It was clear that the sound we'd heard was the drip-drip-drip of water from the ceiling above. The room was so damp that stalactites had formed and the water was running down them and dripping onto the floor below.

With the dripping noise accounted for, we returned to the two much smaller rooms.

'If there's someone here with us, let us know,' I said quietly as Tom and I stood still in our respective rooms. 'Touch one of us, show yourself, say something. Come on, we know you're here, so why not just show us what you're capable of?' I challenged.

We waited in silence for five minutes during which I heard and saw nothing, but I could feel the energy in the Vaults changing, as if there was something going to happen. However, it wasn't going to happen just yet.

We made our way through the huge open room, and trod carefully across the boggy floor. We found Rich and John in a corridor just beyond. It appeared they'd had as little success as we had. As we discussed our next move, I took a few photographs, and in the first photograph I took I was surprised to see a huge ball of light right in front of me in the image.

I'm not usually impressed by orbs, and that's a statement that might not go down too well with some of my fellow ghost hunters ,who believe that orbs are a form of manifestation of spirits. In my experience, they're always insects, dust, or precipitation hanging in the air. However, it was difficult to tell what this was, as it appeared so large and so bright compared to the smaller orbs, which were clearly dust.

As we gathered around my camera to try and establish if this was something or nothing, there was a metallic noise right next to where we were stood. It sounded like something bouncing off the wall.

'Was something just thrown at us?' Rich asked the question I had been about to ask. It could have been; stone throwing is one of the more commonly reported happenings down here. It could have just as easily have been something falling from the ceiling and hitting the ground. I had a look around and found a nail on the ground behind where Rich was stood. Could this have been the object that made the noise? We had no way to know for sure, so we tried to ignore it for now and moved on.

We moved into a large room, which was even wetter than the room in which Tom and I had heard the dripping earlier. It was so wet that planks of wood had been laid out on the floor from one door to the other, making it possible to pass through the room without sinking down into the muddy ground.

We used up a further ten minutes in this room, and then moved into another large room with a peculiar gate in one corner. As the guys made attempts to communicate with the phantoms that lurked here, I went to explore what was behind the big, heavy gate. The creaking of the gate was deafening, as if it hadn't been moved in years. I shut it behind me and walked into a narrow corridor, which was so dark I was unable to see my hand in front of my face. I took my head torch

The bright light I captured by chance
when taking a series of photographs.

from my pocket and slipped the elasticated strap around my head. I clicked it on and the bright light ran off ahead of me, flooding the corridor. There was a wooden door at the far end. I slowly made my way towards it, being careful to avoid walking face-first into the dozens of cobwebs constructed by the arachnid occupants of this particular corner of the Vaults. I reached the wooden door and tried the handle. It was locked. This room will have to remain a mystery for another day, I didn't have time to consider it, as there were ghosts just waiting to be found in the areas of the Vaults that we could access.

I returned to Rich, John and Tom, who were drawing yet another blank. With forty-five minutes gone, we returned to the White room. It had seemed like something might happen earlier, and it was time to give it one more chance. Now we'd been down here in the dark for a short while, I had almost forgotten that it was daytime outside in the world above.

The first thing I noticed when I ducked beneath the entrance and entered the White room was that my big, heavy, ghost-hunting case had been knocked over. It's a really sturdy case designed to be stood up on the bottom, or laid on its side, and there's no way it would just topple over, especially with us being underground. There are no draughts whatsoever, and there was no one in the Vaults except us.

We stood silently in the room. After a couple of minutes I walked out of the White room and stood outside looking in at the guys.

'What are you doing?' asked Tom.

'I dunno,' I said, uncertain of myself, 'I just had an urge to step outside.' It was a strange sensation, as even though it was only a few seconds earlier I couldn't actually recall doing it, let alone what had persuaded me to do it.

I heard a noise to my right as I stood facing the White room. I decided to go and check it out. The others were going to try the Frank's Box, which had been a bit of a disappointment the previous evening at Dalhousie Castle Hotel, to see if they could make contact with the past residents of the White room. I had my voice recorder in one hand and my torch on my head. It was switched off as the Vaults were bright enough to move around safely with the candles Sarah had lit earlier.

I took my time and explored every single room in the Vaults slowly, methodically and silently. Using all of my senses, I was eager to get a lead, something, anything that would ensure the second hour of our investigation down here would be productive. But it was quiet, too quiet. I headed back to the White room disheartened, and worried that this just wasn't going to be our night (or, by this time, our morning).

As I neared the room, I heard the others talking over the static hiss of the white noise coming from the Frank's Box, and they sounded excited. I picked up pace, keen to see what I'd been missing.

'It said it again!' whispered Tom excitedly to Rich and John, as I slipped back into the room unnoticed, like a ninja.

'Said what?' I whispered to the others.

'F**k off!' said Rich, turning to face me.

'Alright mate, I was only asking,' I said, raising my hands in defence, although I'd no idea what I'd done to merit that kind of reaction.

'No, man,' said Rich, defusing the awkward situation like an experienced bomb disposal expert. 'Pretty much since you left we've been speaking to a man through the Frank's Box, and he's responded to every question we've asked by telling us to f**k off.'

I was speechless. I looked at John and Tom in turn. They were both grinning and nodding back at me.

'What is your name?' I asked. We waited silently, listening to the box scan through frequencies rapidly.

'F*ck off!' came the crystal clear reply. My jaw almost hit the floor. In that one offensive phrase, my Frank's Box had paid back every single penny of the £58.38 it had cost me. It was now that I also noticed the thick, oppressive atmosphere that filled the room.

'When did you die?' asked Tom. We waited, but didn't have to wait long.

'F**k you.'

'That was a new one,' said John, very matter-of-factly.

'How long has this been going on?' I said quietly.

'Since you left, around ten minutes ago.' Tom responded.

We were in uncharted waters. We'd encountered unwelcoming spirits before, but nothing like this. What's more, we weren't communicating with just any spirit here, this was undoubtedly the foul mouth of Mr Boots.

I hadn't told the others any of the history or ghost stories of the Vaults prior to our visit, so for them to experience this level of animosity with no prior knowledge was astounding.

The best known residual spirit in South Bridge Vaults is that of a man nicknamed Mr Boots for the black overcoat and large black boots he is said to wear. He is a malevolent entity, and it can't be proven historically, but psychics who have visited the Vaults claim he was once a landlord down here in the heyday of the Vaults. Eyewitnesses who've been (un)fortunate enough to encounter

him have described him as having no eyeballs in his hollow sockets, and he has a leering grin with teeth like jagged yellow tombstones. He considers the Vaults to be his place, and hates people coming down to visit, having been heard yelling 'GET OUT' and whispering obscenities in people's ears. He has pushed people down the staircase, and has scratched and bitten people. In 2011, he attacked one lady on a tour, splitting her head open so badly that the tour guide had to add an entry to the accident book. On another occasion, he was blamed for a young girl fainting on a tour, eyewitnesses claiming that a smoky presence appeared behind the girl and lunged into her body, causing her to faint and fall over. One couple alleged that the girl took on the features of a morbid, bearded man as she collapsed.

Having researched the Vaults thoroughly, I knew that this particularly nasty phantom is capable of far more than just swearing at us, so we had to difficult decision to make – stay here and attempt to provoke him into doing more than telling us to f**k off, or walk away from probably one of the most convincing paranormal experiences any of us have ever had.

It was a decision we didn't have to make. Mr Boots made it for us.

I decided to ask a few more questions and see what responses we got in return, then weight it up.

'Can you do anything else? Can you show yourself or touch one of us? If you do this, we'll leave.'

'F*ck off' came the almost immediate reply.

'We're not going anywhere,' I dared to challenge, 'we're going to stay here until you make us leave.' I said firmly.

'F**k off,' he said again.

'No, you f**k off!' I replied angrily. 'You're not capable of doing anything more than swear at us, we've had enough of it and we all know you're not powerful enough to do anything more.' Was I pushing my luck? Only one way to find out.

This time we got a different response, and I knew immediately I'd made a mistake, I'd gone too far.

'Did he just say witch?' asked Tom, confused.

'No,' I said solemnly. 'He said watch.'

'Watch, that's a bit strange,' mumbled Tom. The three of them didn't seem too concerned. I was concerned, it sounded like Mr Boots had accepted my challenge and we would have to be on guard for the next forty-five minutes until we could leave the Vaults.

'What do you mean?' Tom asked, but this time he got no response, and I didn't expect him to, as the atmosphere in the room had lifted. He tried again and again, but heard nothing in reply.

'Let's move on,' suggested John. 'Whatever was here has stopped talking to us and we've only got forty minutes left.'

We left the White room and headed left, following the main path through the Vaults, and found ourselves a few minutes later in the really damp room.

'Did you see that?' I said, stopping suddenly.

No one had seen anything.

When we entered the room, I was bringing up the rear, I was immediately drawn to my left, where I had this overwhelming feeling of being watched. I looked over to my left, to a really damp corner of the room, and saw what appeared to be a tall shadowy figure standing perfectly still. I looked towards the others to see if they'd seen it, they were still walking ahead so can't have done. When I looked back there was nothing there. Since no one else had seen anything, I had to think twice about even telling them in case they thought I was overreacting or imagining things. I've been in this game too long to be prone to flights of fancy. I told them anyway, it's what we do. If we think we've heard, seen, or felt something, no matter how outlandish it might sound, we always

speak up. They didn't ridicule me, but since no one could corroborate what I thought I had seen I'm going to assume it was my imagination.

We spent some time in this room trying to stir up some activity, but it felt flat, and our ten minutes passed by without anything of note occurring. We had a little under thirty minutes left, so we agreed to stay together and carry out one last vigil in the hope of going out of the Vaults with a bit of a bang.

We were passing through the large room with the metal gate in the corner when Rich stopped ahead of me and exclaimed 'Woah!' at the same time as Tom said, 'Did you see that?' John said he had, but I was in the dark, I had no idea what had happened.

Rich had seen an object whizz past him at speed and crash against the stone wall ahead. Tom had seen the same thing. We tried to establish if one of us could have done it by accident – there were loose stones on the ground, so I suggested I may have kicked it as I walked and it might have passed Rich and hit the wall. I tried to recreate this, but the only way I could was by having a proper swing and kick at a stone, not just walking normally.

As we discussed possibilities, there was a loud noise like a stone striking a wall hard. All four of us heard it clearly, and it made Tom jump and involuntarily swear as it hit the wall near to where he was standing. None of us were moving at the time, so there was no way one of us could have accidently kicked or knocked a stone.

Perhaps this was what Mr Boots had meant when he said 'watch', although I decided to keep this suggestion to myself. However, with stones being thrown, there was another possibility; the

Above left: None of the guys had seen the dark figure that I was convinced I'd witnessed in this room.

Above right: Our time in the Vaults had drawn to a close, but they were two unbelievable hours that none of us are likely to ever forget .

other ghost resident to the Vaults is that of a young boy named Jack. He is a mischievous, playful spirit, who has been seen in full-bodied form wearing a blue jacket. He tugs on people's hands, some people have even said they've felt him hold their hand. He throws stones around for fun. No one knows how he died, but it's believed he vanished in 1810 at the age of just six and his disappearance was never solved, causing him to remain here. He may be linked to Mr Boots, and it's been suggested that Mr Boots may have been his murderer. During one of the Vaults tours, a lady claimed that he appeared to her and said, 'Please go, he's coming back, please go'.

As we talked, we heard a shriek or laugh in the room with us, but since we were talking at the time it was difficult to establish what the sound was. Even listening back to the recording, the noise is there, but it's impossible to understand due to our chatter.

We had fifteen minutes left, and had to decide whether to stay here and see if anything else would happen, or return to the White room. We decided to stay where we were, but John and I had left our bags in the White room and I wanted my big box of tricks in case I needed to set an experiment up in a hurry. I offered to return to the White room alone, and leave the other three in this room to keep up the communication which whoever was with us.

I was back within a minute, and quickly set the Paracorder 667 up on a shelf. It would light up and make a sound should a spirit touch it, but it was also pumping out EMFs, which it is said can help to give a spirit additional energy.

We asked for anyone with us to give us a sign we weren't alone, and another stone was thrown. It whizzed past my head, literally no more than a few inches from the side of my face and clattered off the metal gate in the far corner.

'Can you do that again for us please?'

A candle in the corner of the room began to flicker wildly, then grew really large, then shrank away to almost nothing, a mere pinprick of light, before returning to normal.

'Can you throw something at us?'

Another stone hit the wall close to us.

We continued for a few more minutes, but nothing happened and our time had run out much too soon. It was time for us to bring our investigation to a close after a truly eventful two hours.

We made our way up to the office and thanked Sarah for her time. She asked how it had gone and we chatted for a few minutes. She told us they often hear footsteps down there, and they regularly have stones thrown. She added that recently a tour guide called Alex was down in the Vaults alone when he said to himself, 'I'm the only one down here' and a voice behind him said, 'I'm here.' She said she won't go down into the Vaults alone, so was glad we were there so she could go and light the candles, otherwise she would have had to wait for another member of staff to come into work and accompany her underground.

Just after midday, we emerged out into bright sunlight, which took a few moments to tolerate after being underground for the last two hours. It was a bit warmer now, and we had the remainder of the day to ourselves before our third investigation of the weekend.

CHAPTER SIX
SATURDAY NIGHT'S ALRIGHT FOR FRIGHTENING
BEDLAM THEATRE, 4 NOVEMBER 2012

After leaving South Bridge Vaults, we headed back to our plush apartment to drop off our investigation kit. Despite the late night and early start we were all feeling good, and we went straight back out to make the most of our weekend in glorious Edinburgh.

Our first port of call was the car park, so I could settle up with the parking attendant. When we arrived, the car park was really busy compared to the half dozen cars that had been parked up a few hours earlier, the small wooden hut was now open and a price board was outside. We worked out we'd need to pay for twelve hours, which would cost us £9.90. We pooled our change and I approached the hut to pay. A middle-aged lady smiled back at me through the window of the shed and came to the side door to serve me. I told her my car registration and that I'd like to pay for twelve hours, holding my hand out, which contained a fistful of change which came to exactly £9.90. She ignored my outstretched hand and looked up to the ceiling, deep in thought while stroking her chin. I wondered if she had a copy of the parking prices nailed to the ceiling of her shed.

'I can offer you a special rate for that,' she said, still staring towards the heavens. This confused me, as I didn't realise haggling, or bartering, was an option in this part of the world, so I retracted my hand and awaited her special rate. She lowered her head looked at me as she spoke again. 'I could do that for £6.60?' My response was immediate, and I counted out £6.60 quickly before she could change her mind. She gave me a receipt, which I placed on my car windscreen.

As the four of us walked towards the city centre, John asked what we planned to do. I asked what he meant, and he responded that he was planning to do his own thing. He'd decided to go and get a hog roast from Oink! then take in an open-top bus tour, maybe visit Frankenstein's, then cross the road to Nandos to get his evening meal, and off he toddled, wearing his massive black coat and holding a carrier bag that only contained a book – the same book he'd carried around the Vaults with him earlier.

Rich, Tom, and I decided to head to KFC for a snack, as we planned to have a sit-down meal this evening. We walked in the opposite direction to John, well aware we'd see him again soon enough.

When we left KFC, I realised that there'd been a drop in temperature since we emerged from the Vaults a couple of hours earlier, so we wanted to go somewhere warm and welcoming, somewhere we could sit down and chat, away from the winter chill outside. So we headed for the obvious venue: Frankenstein's.

As we entered, I spotted John sitting on his own in a booth at the back reading his book, we went to the bar and I ordered a bottle of Irn-Bru and a glass of ice and went over to join him. He didn't seem too surprised to see us, as it was a fairly safe bet that we'd have ended up in there sooner or later. He shuffled along and Rich sat next to him, as Tom sat alongside me. He told us he'd been for an Oink!, but with it being so cold had decided not to do the open top bus tour today.

Above left: We passed this quirky antiques shop en route to the car park.

Above right: The entrance to Advocate's Close.

Below: Bedlam Theatre.

We had a few drinks, a chat and a laugh. We saw dozens of people come and go, most of them carrying huge bags from toy shops, making us realise just how close Christmas actually was; a little over seven weeks away. We left around 3.00 p.m. and headed back to the apartment through the busy city centre. When we got back, John said he was going to his room to read, and Tom, Rich and I sat in the downstairs living room and chatted about our weekend so far, and the forthcoming ghost hunt much later, in the wee small hours of the morning. This time, our venue would be the never-before-investigated Bedlam Theatre.

There are many former churches across Edinburgh that have been converted for another purpose once they were no longer required as a place of religion. Some have been renovated into bars and cafés, others for accommodation, and the former church of New North Free church on the corner where Forest Road meets Bristo Place is home to the oldest student-run theatre in Britain.

The imposing Neo-Gothic New North Free church was built between 1846 and 1848 at the foot of the George IV Bridge, on the site of a former poorhouse. It was designed by Thomas Hamilton, a Scottish architect, who saw the church as key to his plan for the Southern Approach, linking Edinburgh's New Town to the Southside. It was designed to be visible when approaching from the Royal Mile.

In 1937 it was abandoned by the church, having been used as a place of worship for less than a century. It had been considered too ugly and inconvenient by the congregation.

The empty church was sold to the University of Edinburgh and it served a variety of purposes in the years that followed, including the university's chaplaincy centre, a fine art department, a furniture store, and a school for nursing. That was until the late 1970s, when work began on transforming the church into a theatre to be run by the students. The theatre was initially shared between the student-run Edinburgh University Theatre Company (EUTC) and the university's chaplaincy. The EUTC began putting on a show on Wednesday afternoons in the late 1970s, as typically there would be very few lectures at this time.

On 31 January 1980, the EUTC were given sole responsibility for the theatre's administration and production of its shows. It was renamed Bedlam Theatre, with the name being taken from the nearby site of the city's first mental hospital.

The ninety-seat theatre has grown year-on-year and now stages over forty shows a year. It is the only Edinburgh Fringe venue run entirely by students. It was recently named one of the top ten performance venues in Edinburgh by the *Guardian*. Recognisable actors who've got onto bigger and better things since cutting their teeth at the Bedlam Theatre include Elize Du Toit, who starred in *Hollyoaks* from 2000–04, she has since appeared in a variety of roles including an appearance in the James Bond movie *Skyfall*, which was showing in cinemas worldwide at the time of our investigation at Bedlam. Daisy Donovan shot to fame presenting satirical late night comedy show *The 11 O'Clock Show* in the late 1990s. Arguably the most successful former member of the EUTC is Kevin McKidd, who performed at Bedlam as part of the improvised comedy troupe the Improverts. He played Tommy in *Trainspotting* in 1996 and since then his career has gone from strength to strength, with lead movie roles including the brilliant *Dog Soldiers*, and then breaking into TV with a lead role in the joint BBC/HBO series *Rome*. He's now best known for his role in *Grey's Anatomy* as Dr Owen Hunt.

At 4.00 p.m., I went to my room to have a nap. I was flagging after our late night last night, and decided it may be prudent to try and get a couple of hours in as we had another late one ahead of us.

My alarm went off at 6.00 p.m. and I felt worse for the sleep, with my body craving more of it. I headed downstairs to find the lower floor in darkness and rhythmic snoring emanating from the

gloomy living room, lit only by distant street lights that were visible through the large window in the far wall. I fumbled for a light switch and, when I flicked it on, woke Rich up who immediately shielded his eyes from the unexpected bright light. Tom continued to sleep through it.

We'd agreed to go out at 6.00 p.m., and I went back upstairs to find John, ready to go, clutching his M&S carrier bag. Rich followed after only a few minutes. He'd put his coat on, and sorted his hair out in the mirror as John and I watched on. He turned to us and said, 'Let's go, I'm ready.'

I responded immediately, 'Mate, you've got no shoes on.' All three of us looked down at his stocking feet, then back up at his face. Without saying a word, he skulked back downstairs. He returned a couple of minutes later wearing his trainers.

Tom followed a few minutes later and the four of us left together, but as soon as we were outside we split up, with John heading towards Nandos and the three of us walking in the opposite direction towards where my car was parked. It was unbearably cold – Rich checked the weather app on his phone and it claimed it was -1° C and I could very much believe it. After around fifteen minutes, we reached my car, and we quickly climbed inside to escape the teeth of the biting wind.

I drove a short 3 miles to a pub called the Robin's Nest that Tom, John and I had eaten at back in March before our investigation at the Edinburgh Dungeon. It was surprisingly quiet for a Saturday night, so we had no problems in finding an empty table.

After our meal, we headed back to the apartment. I parked just off the Royal Mile on our return, so we only had to walk around the corner later on. John was already back and let us in. John loves Nandos, possibly even more than he loves hog roasts. He eats at Nandos at least three or four times every week, and has made it a personal goal to eat at as many different Nandos as he can across Britain. So when Rich asked, 'How was Nandos?' I didn't even listen to the reply, as I knew it would be a glowing review.

Tom turned the television on. He and Rich had been excited that *The X Factor* was on. I don't usually watch it when I'm at home, and John had never heard of it, but the four of us settled down for a couple of relaxing hours.

By 10.00 p.m. John had retreated to bed for another nap. Rich climbed into his sleeping bag and said that with all this erratic sleeping he wasn't even sure what day it was anymore. I decided to join him – not literally join him, but go off to my own bedroom and try and grab some sleep, as we'd have to leave for our investigation at around 12.30 a.m.

I fell asleep almost immediately, but was woken just minutes later as some kind of walking tour came down the close and the guide was telling a group all about its history and the people who have lived and died here. I stood and watched them out of my window, and no sooner had they left than three drunks came wandering down. They were staggering about, shouting something undecipherable. It seemed they were having a good night. However, they then reached a dead end and in their inebriated state they struggled to comprehend what was happening. They looked at each other, bewildered that they'd been stopped. Then one punched the other hard in the face. He hit the ground and the other two high-fived each other, laughing and cheering. The recipient of the punch got up, dusted himself down and joined in laughing. The three of them then starting singing *Baby Jane* by Rod Stewart and half-staggered, half-danced their way back out of the close.

No sooner had I got back into my nice warm bed than I was disturbed by more noise. It was John banging around, doing God only knows what, which continued for about ten minutes. By the time it stopped I was wide awake.

I lay awake in bed, and eventually dozed off. My alarm went off what seemed like ten minutes later, and when I sat up on the end of the bed and rubbed my eyes I was absolutely wrecked. I wish I'd sat up watching rubbish telly with Tom.

It turned out that everyone else, including Tom, had managed to get more sleep that I had, and 12.30 a.m. saw us heading out into the bitterly cold night towards Bedlam Theatre. The city was alive with the sights, sounds, and smells of a party city, lots of people having a great time, most wearing very little, especially when compared to the four of us dressed up against the elements. We were bobbing, weaving, and dodging drunken people at every turn. We passed Frankies, our usual haunt, and it appeared to be jammed to capacity with drinkers having a brilliant night. We arrived at Bedlam Theatre at 12.45 p.m., the scaffold-covered former Neo-Gothic church the picture of tranquillity, in contrast to the bustling bars and clubs all around.

Carolyn Doyle was waiting to meet us when we knocked on the door. She welcomed us warmly, and it was immediately apparent she wasn't local to Edinburgh. Her North East twang was unmistakable and she told us she was from Gateshead, just on the opposite side of the River Tyne from our native Newcastle-upon-Tyne. It's a small world.

We were joined shortly afterwards by Julien Matthews, the theatre's business manager.

It was incredibly cold in the theatre, so Rich, Tom and I all kept our coats on as Carolyn and Julien gave us a quick tour. John, however, left his big coat with his bag as he had a jumper on.

After the tour, Julien said if Carolyn wanted to get off home he was more than happy to do some paperwork while we carried out our investigation. She wished us well before leaving and said she hoped we managed to make contact with the Bedlam ghost. She explained that it's a running joke between the students whenever something strange happens or something goes missing. Julien added in all seriousness that it's a very creepy old building, and it can be very scary after dark. Carolyn left with a cheery wave and headed home, and Julien left us to go to an office to do some paperwork.

Before we began, I took some photographs from the stalls. One photograph seemed to contain a strange white light down the left of the image. I showed the others who suggested it may be my thumb, so I attempted to recreate the photograph by putting my thumb in the way, however it didn't look anything like it.

We had around two and a half hours so our investigation began. We left what we wouldn't need in the stalls. I went into my box of equipment and put my torch, voice recorder, torch, camera, Frank's Box, and Paracorder 667 into my various pockets.

We headed downstairs to the 'the Crypt', a dusty, cobweb-filled store room. The cobwebs concerned John far more than anything else we may encounter down there. We carefully passed through a bead curtain which separated two areas of the room. There were all manner of things being stored in the first room including a pushchair, an old typewriter, some crockery, a chainsaw, a reindeer's head on a stick, a skull, a creepy looking doll, toy guns, all sorts of stuff. I said a lot of the things out loud to the others, then I realised that it was starting to sound like a macabre version of *The Generation Game*.

In the room beyond the bead curtain was a desk, which looked like it had not been used in years due to the undisturbed thick layer of dust on it. The desk had two items on it, an old wrestling action figure and a roll of parcel tape. I balanced my Paracorder 667 on top of the roll of tape and flicked the switches on.

We decided to split up into two groups. John and I stood in the first room with all of the items in storage, and Rich and Tom stayed in the furthest room. We turned off all sources of light and it was absolute darkness, with the exception of the orange flashing light on my voice recorder and the red light of the Paracorder. Rich attempted to make first contact with the ghosts of Bedlam Theatre.

'If there are any spirits present here in the crypt, we come in respect, we mean you no harm. We're here to learn, we want to hear your story, and hear any messages you may have for us.'

Above: I captured this peculiar white light while taking photos of the auditorium.

Left: Rich, Tom and John in the Crypt.

'Can you move something?'

'Can you knock on something?

'Can you touch one of us?'

I could hear a constant murmuring, which I hadn't noticed until Rich began to talk. I mentioned it to the others and asked if anyone else could hear it. John confirmed that he could. I listened intently, trying to establish what the sound could be. Was it talking outside? Was it some kind of piping system? There was certainly no heating on.

Rich continued. 'If there are any spirits that wish us to leave here, give us a sign and we'll leave this room now.'

We stood in silence, the murmuring sound seemed to have stopped. The only sound was the ticking of a clock.

Ten minutes had passed with little having happened, so we agreed to move to another room. With the lights back on, I could see Rich had put his hood up on his hoodie, I asked if he was cold, but he explained he had done it in case of spiders coming down from the ceiling on their long filament of silk and landing on his head. I hadn't said anything earlier due to John's major phobia but when we'd entered the room I'd seen several spiders, and two of the large eight-legged beasts had been hanging from the ceiling. It seemed Rich had spotted them too.

I left the Paracorder 667 where it was – the alarm was very loud so we should be able to hear it should it sound when we were in the next room.

The next room was the changing room. There were a few costumes, including one very creatively put together C-3P0 torso hanging on a rail, and a long worktop almost the length of the wall with a series of mirrors on the wall in front of it. There was a hair dryer and hair products. A rail of spot lights hung above the mirrors, and to the far right was a monitor so the actors can watch for their cue.

It was bitterly cold in the room, even despite all my layers. I was hugging myself to try and warm up, and focus on the job in hand. I was distracted from my chattering teeth by Rich demonstrating some Taekwondo to us. John had picked up a toy gun from the counter and pointed it at him, so he showed us how to disarm a gunman. Then we got back to some ghost hunting.

The four of us sat in front of the wall of mirrors, looking back at our reflections. Utilising mirrors in our investigations was something we first experimented with roughly a year ago at Middlethorpe Hall Hotel in York. It was something I suggested, as some have said that it may be possible to see spirits invisible to the naked eye through a mirror. On that particular evening, Rich actually saw a dark shadow the size of a man in the mirror moving around in the room behind him – the room I then had to sleep in alone. I was hopeful that we could have a similar result tonight.

John began his attempt to reason with the spirits of the theatre.

'If there's a spirit here with us, can you give us a sign that you're here?'

'Are you able to show yourself to us, are you able to appear to us in the mirrors in the room?'

There was a loud cry of 'YES!', however it wasn't anything supernatural, it was a drunk outside. Things seemed very quiet in the room, I felt nothing.

'If you're not able to show yourself, are you able to talk to us, you could speak into the recording devices that are on the counter in front of us?' My Olympus voice recorder was on the counter, as were Rich and John's smartphones.

John continued his line of questioning for another few minutes before we suggested trying something else to stir up some activity. Rich was keen to try the Frank's Box, which had produced some jaw-dropping results at our earlier investigation at the Vaults.

I turned off the lights. The small room was filled with an electronic hiss as I switched the little black box on and set it scanning the AM frequencies.

Rich spoke this time and asked an array of questions: 'What is your name?', 'What was your job?', 'Do you like us being here?', 'Do you want us to leave?'. He then asked again, 'What is your name?'

We heard snippets of music as the box cycled through the stations, and three of the four of us heard the same response to two of Rich's questions. Tom, Rich and I had all heard 'Frank' in response both times Rich had asked for a name.

Tom said he felt icy cold, and his teeth began to chatter.

John suggested that Rich ask, 'Is your name Frank?', so that's what he did.

We huddled around the small, but loud box, and I looked at the other three, their faces eerily illuminated by the box's display. We heard nothing.

Tom said he was getting colder. John and he swapped seats to see if John was affected in the same way. He said it was definitely colder, but there seemed to be a draught coming from the window, and the windows weren't double glazed, so it seemed likely there may have been a natural explanation.

Rich asked, 'How old are you?' We all heard 'four' and then 'two', which we took to mean forty-two, but to be sure Rich asked again. We all clearly heard the response this time – 'forty-two'.

'What was the year of your birth?' asked John, a clever question, which could help us to begin to identify who Frank was. However, we didn't receive anything in response to this or any of our subsequent questions.

I switched off the noisy Frank's Box, and heard a bloodcurdling scream following by hysterical laughter. It was more drunks outside.

We'd spent around twenty-five minutes in this room, so agreed to move on, with a view to returning before the investigation came to an end.

Back in the auditorium, the seats were comfy enough; they were spacious and had arms. The temperature in here seemed even colder than it had been before. Suddenly I heard a sound, and I knew the others had heard it too as we all turned to look in the same direction at the same time. It was a cough coming from the corridor just behind the auditorium, a woman's cough. There wasn't time for us to discuss this, as straight away we heard another noise, and all four of us simultaneously looked skywards as the sound was coming from above us. It was the sound of slow footsteps circling the gallery, which overlooked the seats in which we were stood, and the stage.

They stopped, we looked at each other. No one spoke for what seemed an age, but was probably only a couple of seconds in reality. We planned to ask Julien if he'd been upstairs the next opportunity we got.

We sat down, spreading ourselves out among the ninety seats. As Rich asked for a sign, I looked up and I could see all the way up to the original church ceiling.

'Can you give us a sign that you're here with us? Why not join us? Sit in one of the seats with us?'

I looked around, hoping in vain that one of the spring-loaded seats would drop down on cue.

We were distracted by the sound of a fight outside the church, with a guy saying he was sorry and then screaming over and over. After that passed, we carried on.

Rich continued to ask, 'Can you make the lights turn on?', 'Can you touch one of us?', 'Can you affect one of us?' but we weren't getting any responses and it felt flat so it was time to move on. It felt silent and empty, the only sounds the constant road traffic passing the building, no doubt taxis taking people home after their night out.

We spent some time in among the theatre's ninety seats.

Rich said that during the initial tour he had found the upstairs to have a very strange feel, so we were full of optimism when we headed up the top of the building to the wardrobe, a room filled, as you can imagine, with costumes for the theatre's performances. The room had a really high ceiling, and we recalled that on our tour of the building earlier Carolyn had told us that some of the students had recently seen something moving around in the rafters, which they took to possibly be a bat. I looked high up in the rafters, straining to see any movement in the roof space. It was absolutely freezing, and we were all struggling to stay focussed as we battled in vain to keep warm.

Tom asked the ghosts to give us some kind of sign of their presence. He asked if they could move the clothes on the rail, make a noise, or affect us in some way.

There was a knock – it was difficult to establish where in the room it had been generated.

'Can you make that noise again?'

Nothing.

Tom continued to ask for some kind of sign that we weren't alone, however his requests were met by silence.

Now in the silence, I noticed how echoey it was due to the cavernous roof space above us.

We decided to head to the gallery, where we'd heard the footsteps, the creator of which we were yet to establish. I popped to the toilet on the way, the others continuing ahead. In the toilets, I heard a male voice say, 'Rob?'

I couldn't see anyone else in the toilets, and I could see the door from where I was stood and no one else had come in, so this took me by surprise, especially given all the cubicle doors were open and empty. I was the only person there. I was confused, but not scared, although in hindsight I had every reason to be terrified.

I joined the others in the gallery at 2.30 a.m. Tom and Rich had positioned themselves on one side of the opening that overlooked the auditorium below. John was a lone figure in the dim light on the far side; it was so gloomy that I couldn't see any of his features, and he was just a dark outline against the stacked up tables and huge blacked out windows behind him. I had to pass through

the tech box where the sound and lighting guys would sit during a show. I joined John and asked him about whether any of them had said my name in the toilets, he had no idea what I was talking about and could vouch for Tom and Rich's whereabouts too, as they'd all been up here.

It was my turn to ask for the ghosts of Bedlam to speak to us. I switched on my voice recorder as always. The lights were off, the only light coming from a couple of emergency lights, so the low lighting was perfect for us to see anything moving around with us.

'If there are any spirits with us in this old church, we've come a long way to seek evidence that you exist. We don't intend you any harm, or wish to move you on, we just want you to give us some proof that you're here with us, and that you're able to communicate with us.'

I heard a whisper which seemed to come in response to be asking for a noise, which is also clearly audible on the recording. I asked if anyone whispered or heard a whisper but no one else had heard it, I think that's because it came from just behind me.

'Could you make another noise?'

Rich said he heard two knocks from near to where he was stood, I'd heard them too. John and Tom nodded to confirm.

I asked for them to make the same sound again. There were two knocks again.

'And again,' John said, as we all heard them. They seemed to come from a corner with an emergency exit door, and an illuminated light above it next to a green fire exit sign.

We asked for the knocks again, but this time heard nothing.

John suggested that the knocks may have been from outside, but as he spoke we heard two more knocks but these were right next to Rich.

Rich in the gallery.

We listened in silence.

The only sounds we could hear were a couple of knocks every now and then. We listened, and after a few minutes we established the two knocks seemed to coincide with a car going past outside. We wondered if it could be a manhole cover, or something similar on the road that the cars are going over making this double knock noise. We continued to listen for around ten minutes and the knocks definitely did occur whenever a car went past. We'd done what every good investigation team should do. We didn't jump to any conclusions, we rationalised and we'd established this wasn't paranormal.

We asked for a sign and listened. We heard nothing. With time running out, we decided to relocate. As we walked towards the staircase, we spotted a handwritten sign above the stage, which was taken from the lyrics to the brilliant 'Hotel California' by the Eagles, and it seemed somewhat fitting: 'you can check out any time you like, but you can never leave.'

With twenty minutes left, we split up into two groups. Rich and I headed down to the crypt, taking a device called the Ghost Touch with us, to go alongside the Paracorder 667, which was already down there. Tom and John took the Frank's Box to the changing room. The Ghost Touch device was making its debut in one of our investigations, and is becoming a really popular piece of equipment for ghost hunting groups much like ours. Available from the Gizmo Guru (www.gurupaintball.com), the Ghost Touch is a really simple piece of kit, but it's proven very effective when other groups have tested it in the field. It's a grey box with two attachments, one of which is a long metal antenna that goes into the 3.5 mm socket on the top. If this metal antenna is touched, an alarm will sound and a light will become illuminated. However, it was the second attachment we were going to use, which has a wire attachment that you would plug into the same socket on the top of the device. If anyone goes near the device, they don't have to touch it, the alarm will sound and the light will come on.

We left the light on so we could see any movement, if there was any.

The Paracorder hadn't moved. The wrestling figure on the table hadn't moved either, and the thick layer of dust on the table hadn't been disturbed.

Rich explained why we were there and asked any spirits to communicate with us.

'Can you let us know of your presence now?'

'There are devices on the table in front of us here, can you touch them?'

Rich began to shiver, which was understandable, although this was the warmest room we'd been in, probably because it was underground with no windows or doors, so no draughts.

'Please feel free to use some of our energy to help you to move something or say something.'

We stood quietly and we heard some knocking, which we assumed was John and Tom. I actually had professional two-way radios in my bag of kit, but due to us only being split up for a short period of time we'd decided not to use them.

We went to join Tom and John, as the crypt felt flat and we wanted to know about the knocks.

'Coming in,' Rich announced prior to opening the changing room doors. 'Did you knock?' Rich asked. They said no.

They were sat in the dark, and said they'd been using the Frank's Box. When they asked for a name they heard 'Tom'. They asked to repeat the name 'Tom'.

My Paracorder 667 began to sound, even though I'd put it down on the counter and no one was near it. I stopped it and put it down again, it began to scream a high pitched electronic whine and the red LED illuminated the room. I stopped it and put it down again.

The four of us would spend the last ten minutes together.

We attempted to use the Frank's Box, but Rich interrupted us to say he'd seen a shadowy figure move in the corner of the room and he was sure it wasn't our shadow. We had one torch on the

counter to give us some light, and no one had moved. The windows were blacked out so it wasn't something as simple as a passing car's headlights.

We continued with the Frank's Box. There seemed to be a constant mumbling, which we couldn't quite decipher. It was much more likely that it was simply white noise and pareidolia, combined with how tired we were leading us to think there may be something paranormal going on.

We wrapped up after a great night, and went to see Julien to thank him for giving up his Saturday night to accommodate us. I mentioned the coughing in the corridor, footsteps upstairs, and someone saying my name in the toilets. He said he hadn't left the office all evening.

We left Bedlam at 3.15 a.m., exhausted but elated, and after three investigations in just over twenty-four hours we were all ready to hit the sack.

Most of the bars were closing, so there were more people out and about than there had been on our walk to the theatre. We were probably the only sober people on the streets. There were a few drunken fights, queues of people desperate to get home waiting for taxis, and little rickshaw-type cabs ferrying people to their homes.

We were glad of the warmth of the apartment, said our goodnights and went to bed straight away. At 3.35 a.m., my head hit the pillow and I was out like a light.

My alarm woke me at 9.20 a.m. and I felt better for a few hours of undisturbed sleep. The others all seemed revitalised, and we left Edinburgh after a brilliant couple of days. On the way home, we discussed how eager we were to get back for the remaining investigations, but as unlikely as it seemed at the time, for one of us the adventure was over.

Our final vigil.

CHAPTER SEVEN
THE SCIENCE OF THE LAMBS
MARY KING'S CLOSE, 23 FEBRUARY 2013

The time had finally arrived for our first investigation of a new year. Thankfully, the Mayan prophecy hadn't come to pass; the world didn't end on 21 December and 2013 was upon us.

Our year began with a bombshell, which dampened our New Year celebrations. Rich called me to say he was going to have to bow out of our Edinburgh adventure due to work commitments. I spoke to Tom and John, and although they were disappointed about Rich, we had no hesitation in carrying on as a trio. The other big talking point of 2013 so far was the weather. Last year had been the wettest since records began, where virtually every day, regardless of the season, would feel like a slap in the face by Mother Nature. January of this new year had been a whitewash, literally, as the UK was hit by a barrage of snowstorms. We had been due to be in Edinburgh the weekend of 19/20 January to carry out two investigations at some incredible venues, but that particular weekend suffered from severe snowfall and blizzards, causing huge disruptions to, well, everything. Roads were closed with cars abandoned all over the place, public transport was cancelled, and John decided he didn't want to make the trip due to the weather. Tom and I had a decision to make, and agreed to rearrange the investigations for a date when the weather would hopefully be a bit milder.

I woke up on Saturday morning at around 6.00 a.m., or rather was woken by my dogs Holly, and Indy, our new pup, a new addition to the family since the last chapter. When I sleepily made my way downstairs to let them out in the back garden, a horrific sight greeted me – snow. Lots and lots of the dreaded white stuff. We'd not had a significant snowfall since it forced us to abandon our last trip to Edinburgh, and there was no forecast for any, but here it was.

As the morning went on the snow kept falling, heaving and heavier, but there was no way we were going to be put off this time, especially considering the venue I had lined up for us to investigate tonight. It was a location we'd already investigated, but I make absolutely no excuses for returning. The opportunity presented itself and I had not hesitated in grabbing it with both hands. Yes, we'd already spent a night there, but it hadn't been our own investigation. It was led by Mysteria Paranormal Events, and although that was great from an entertainment point of view, I wanted to see what would happen this time around when we did 'our thing' with our small group.

I wrapped up against the elements a few hours before our departure to dig my car out of the fairly deep snow, and threw my stuff in the boot in readiness for our departure early in the afternoon.

I picked John up from his parents in Kingston Park at 1.15 p.m., with his Dad wishing us good luck, then we headed north and picked up Tom from his house in Newbiggin-by-the-Sea shortly afterwards.

As we drove north, the weather began to clear and by the time we passed Berwick there was very little snow.

We arrived in the centre of Edinburgh at around 4.00 p.m. I'd booked us a city centre apartment, but it was on the pedestrianised Lawnmarket so we wouldn't be able to park nearby. The apartment came with a parking space, which was roughly a ten minute walk away. It was at the top of the narrow lane of Niddry Street South, a lane just wide enough for one car, and it was this one car that was blocking the entire street as the inconsiderate driver was ferrying boxes from his car to The Caves on the corner of the street. I had to park up in a lay-by and wait for him to reappear so we could ask him if he could let us past. However, by now further up the lane was a wedding party having photographs taken. Fifteen minutes later, we were finally parked up. We grabbed our bags and headed for our apartment. It was bitterly cold, but at least it was dry with no sign whatsoever of snow.

We've spent a lot of time in Edinburgh across the last year, and generally know our way around pretty well, but we didn't know the most direct route from where we had parked to where we would be staying so we needed directions. John has a terrible sense of direction – we learned that lesson the hard way in York – but he was appointed navigator by default as he was the only one with a free hand to utilise Google Maps on his phone, as Tom and I were laden with bags and sleeping bags. We passed by the outskirts of the Grassmarket and John called 'turn right here', leading us up Victoria Street. We passed Oink! and John glanced over, hopeful of maybe picking up a hog roast en route, only to see a 'sold out' sign in the window.

'Where do you think those steps go?' he asked, nodding towards some steep stone steps just beyond his beloved sandwich shop. We'd never been up them before, so Tom and I looked at each other, then both shrugged as best we could with all the bags we had about our person. John led us up them anyway. They brought us out just next to Bedlam Theatre, and we walked around the corner onto the Lawnmarket on the Royal Mile, we'd somehow made it onto the right street but there were hundreds of properties and we needed to find a narrow alleyway leading to the apartment we'd booked.

'We're here, according to Google Maps,' John said triumphantly.

'So where exactly is our apartment from here, then?' I asked.

It was his turn to shrug.

'You should uninstall that Google Maps,' I retorted.

'Hey, it works for me!' was his immediate response.

'So do you know where we are?'

He nodded. 'Yeah, we're next to the Bedlam Theatre.'

'And do you know where we need to go?'

'No.'

Tom and I laughed and shook our heads. If you want something done properly, you have to do it yourself. I put my heavy bags down, glad to be free of the weight from my back and hands. I crossed the road and looked around, and straight away I could see where we needed to go. From where I was stood, I could see that John and Tom were actually stood about 10 metres from the iron gate leading to our home for the night. We were once again staying on the Royal Mile, the perfect central base from which to get out and about in Edinburgh, and only a five-minute walk to Mary King's Close, for our return to the world-famous haunted hotspot of this historic city.

We got inside and the welcome warmth from the central heating hit us in a similar manner to the doors opening on the airplane somewhere tropical and the hot air wafting through the aircraft.

John was going to be sleeping in the bedroom, so put his bags in there. Tom and I were on sofas, but Tom had planned ahead and brought along and inflatable bed he owns from many camping

trips. It was just before 5.00 p.m., so I dropped off my bags and nipped back out, and over the road to the House of Scotland souvenir shop directly opposite, as there was something I was going to need for our investigation later.

When I got back into the apartment, John and Tom were discussing food, as we were all hungry. Tom and I wrapped up against the cold and headed for the food court at Princes Mall, only a five minute walk away, and John headed for Nandos. Tom and I hadn't decided what we fancied but the mall was home to all the takeaways you could ever wish for so we could decide when we got there. It was getting dark by the time we walked over to the Princes Mall. Tom opted for a McDonalds and I plumped for a KFC, and we carried our takeaway back to the apartment and put the TV on while we ate and awaited John's return.

John returned before long and we kicked back for a few hours, watching episodes of *Fact or Faked: Paranormal Files* on TV.

At 8.30 p.m., we were all feeling a bit tired, so decided to try and grab a quick power nap. We had to be at Mary King's Close for 9.45 p.m., so we'd have to be ready to go around 9.30 p.m. I unpacked my sleeping bag and tried to get some sleep, but Tom's electric pump to blow up his inflatable bed made a hell of a noise. Just as I started to doze off, a fight kicked off outside our window. Tom was stood watching over the fracas from our third-floor window and giving me a running commentary.

'There's loads of them all punching and kicking each other, oh one of them just swung a traffic cone at someone else's head!'

Within only a couple of minutes, the unmistakable wail of a police siren screamed past the window as the fight had moved further down the road. I finally got to sleep and it seemed like mere seconds later when my alarm went off. I wish I'd not bothered trying to sleep, as I was more tired now than I had been beforehand.

We picked up our kit and headed out into the icy cold night air. 'Oh, there's that traffic cone!' Tom said, pointing to the middle of the road. He then had to explain the grand battle to John as we continued on towards Mary King's Close. We arrived at 9.45 p.m. precisely and we were greeted by Curtis Allan, a member of the Real Mary King's Close's staff, and were joined shortly afterwards by Mas, who also works at the popular visitor attraction.

I was chomping at the bit. I couldn't wait to get back underground and into the closes, so had no objections to the suggestion that Mas show us around the areas we would be able to access, and then we could begin our investigation. We would only have until midnight, so every minute would be precious.

It was a couple of minutes before 10.00 p.m. when we began our descent back into the most haunted place on Planet Earth. However, this time there wasn't the thirty of us there had been when we'd been here in October – there were three of us, plus two members of staff.

The tour took no more than ten minutes, we would have access to everywhere we could go on the Mysteria investigation with the exception of Chesney's House, due to the even more fragile state of the floor. The tour had ended in Annie's room, and this was perfect, as I had hatched a plan for this room.

Over the last few months, I'd read a number of reviews of *Ghosts of York* and I'm pleased to say that they'd all been really positive; in fact, I'm yet to read a bad review of the book that I'm so proud of. One particular review, however, had caught my eye. The reviewer said she settled down for a lazy weekend, curled up with her dog and read my book. She said she really enjoyed it, but she did criticise me slightly for not being more scientific in my experiments. The elaborate trap I was about to lay was my response to that criticism.

When I had popped over to the souvenir shop earlier, I'd bought the trigger object for this trap – a cuddly toy. Annie's room is full of cuddly toys left for the ghost of the young girl for whom the room is named. The toy I'd bought was a wee Scottish lambie, and I'd named him Rich after our absent teammate. I positioned this small cuddly toy on the floor away from the mountain of gifts left from all over the world. Next to Rich the lamb, I positioned my Paracorder 667 and flicked the switches on each side to the 'on' position. Off to the side of the room I positioned a motion sensor directed towards the toy. It would sound if something were to break the invisible beam that it was projecting across the room. Close to the toy, I placed a voice recorder and pressed record. Finally, I had acquired a new piece of kit called a laser grid. It works by projecting a grid of green dots, similar to a LED laser pen, but instead of one dot you get a huge blanket of them. If something moves in front of the laser grid, dots are blocked out and it makes it easier to see movement. I positioned this laser grid to cover the area around the lamb, and the whole thing was being recorded by a night vision video camera.

The trap was laid and every element of it tested we left this area, and no one else would come here until we returned.

The others left and headed to the next room, but before I caught up with them I said quietly and in what I deemed to be my friendliest voice, 'Hello Annie, I know you're here. I left you a little present, I hope you like it. It's a toy for you to play with. You can come and take it, it's for you.'

I left Annie's room and joined the others in the cowshed shortly afterwards. It had provided the backdrop for the grand finale of our investigation here with Mysteria, so we hoped it would prove interesting. Also, it was close enough to Annie's room that if one of the alarms should sound we'd be able to hear it.

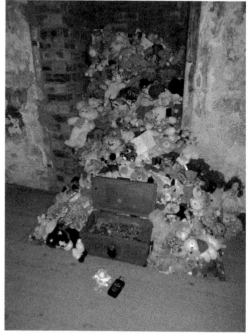

Above left: Rich the lamb, the trigger object for an elaborate experiment.

Above right: It's a trap!

We spread ourselves around the room, which seemed vast with only three of us in it. Mas and Curtis went into the adjoining Plague room, where they said they'd stay out of sight and stay silent. The lights were off and we were in total darkness.

Tom spoke and introduced the three of us, explaining who we were and why we were there. He then asked, 'Come forward and make yourselves known. Touch one of us, speak to us.'

We stood in the darkness and waited hopefully. We heard nothing, and felt nothing.

'Give us a sign that you're here. Can you copy my knocks?' He knocked twice loudly on a wooden beam. Sadly, there was no response.

'If you don't like us being here and want us to leave, give us a sign that this is the case and we'll leave.' We didn't get a sign, so we were going nowhere.

'If you're trying to communicate with us, we're not able to hear you. Can you move something so we know you're with us?'

This time, we did hear something. There was a noise that seemed to originate near to where John was stood. It was a sound which resembled a squeaky door being opened slowly. John wasn't sure what it was or where it had come from.

'If you did just make a noise there can you make another noise, and can you make it louder?'

It did make another noise, and this time it was louder, much louder. And it was right next to me. It sounded like something heavy being dropped on the ground, like the sound a brick would make if it was dropped from a great height onto a stone floor.

John checked with Curtis and Mas, but they hadn't dropped anything, and I knew they hadn't as the sound had been produced right next to me.

'Can you make a banging sound again for us?'

I couldn't see the reaction of the other guys, but I heard a bang immediately after Tom finished speaking. It wasn't next to me that time, though – it sounded like it was down near the wooden door into the room. The wooden door Tom was standing fairly close too.

Tom had heard it. It seemed strange to me that we'd had three noises in response to three requests. The first one was right next to John, the second next to me, and now one near Tom. Was someone trying to frighten us away?

The lads investigate the cowshed.

Tom politely thanked the spirits for responding, and asked if they could bang twice this time so we could be sure they wanted to communicate with us.

The room had fallen silent. We all expected a fourth successive knock but it didn't come.

Tom continued to ask questions for a further few minutes, all of which were met with silence.

However, just as we were quietly discussing trying something different, we heard a loud knock, which seemed to come from outside of the room, beyond the wooden door.

John immediately spoke in the hope of finding out who appeared to be with us. 'We mean you no harm, we know you're here and we know you've been making noises in the room with us. Can you do something to let us know beyond a shadow of a doubt that you're here with us?'

We persevered for a further five minutes, but whatever had been making those noises had decided they didn't want to speak to us, or perhaps they'd moved on to another room within the labyrinth of underground streets that make up Mary King's Close. It was 10.45 p.m., so we moved into the Plague room which is connected to the cowshed. We swapped places with Curtis and Mas.

The room hadn't changed at all since we were here four months earlier. The room had an eerie quality due to the mannequins dotted around the small room, which had been used as a family home in centuries past.

This time, John spoke, 'If there are any spirits than can hear my voice, please come to us. We come with no ill intention, we want to learn. Please tell me your story.'

He asked several questions over the next five minutes, but nothing unusual happened. The room felt flat and it seemed that we were alone. But everything changed when he said, 'We thank you if you are trying to answer these questions, however we've not heard anything. Could you communicate with us in some other way, can you show yourself?'

John and I saw and heard nothing, however Tom saw a long shadow move rapidly across a wall. The only light source was a flickering light, designed to imitate a candle, so we set about establishing where and how something would have to move in order to replicate the shadow Tom had seen. We couldn't recreate it but at the same time since Tom was the only one to see it we agreed to press ahead with our investigation and hope that it would happen again. John continued with his attempts to speak to the dead.

The Plague Room is home to some frightening mannequins.

I was suddenly overcome by dizziness. I was holding onto a wooden bed frame where the mannequin of a sick child lay at one end, and at the other end her mother, clutching a crying baby. I felt like if I let go of the bed frame I'd topple over.

I told the others, and Tom asked more of the spirits, asking them to affect me in some other way. I still felt dizzy.

After a few minutes, we agreed to move on. We'd had over an hour already and had less than an hour of our time left. I picked my steps carefully as I staggered out of the Plague room and through the cowshed. By the time I left the cowshed via the large wooden door, I felt fine and the dizziness had passed completely.

We headed back to Annie's room.

The disk in John's night vision video camera had almost run out, as we were recording in the highest quality it was capable of; if we did capture something miraculous, we wanted to make sure it was crystal clear and we could see exactly what it was. You often see low resolution fuzzy footage online, supposedly offering proof of ghosts, but typically the video is so grainy you have no idea what you're meant to be looking at.

I stood in Annie's room alone, being careful not to activate any of the sensors I'd positioned earlier. John and Tom positioned themselves in the area outside the room. I reminded them of the warnings we were offered on our last visit, to be careful as the ceiling is supported by metal supports holding it in place, and the walls are very fragile.

I spoke aloud, attempting to speak to little Annie, the young girl who it's believed died here and has remained ever since. Tom and John sat outside in silence. I was communicating one on one.

'Annie, you've not came for the little gift I left you. It's for you. Do you want me to put it with your other toys, if you do can you give me a sign so I know?'

Everything was very quiet and still.

Then I almost jumped out of my skin as there was suddenly and expectedly a series of loud bangs outside the room, in the area Tom and John were positioned.

'What the *hell* was that?' I shouted, as I frantically scrambled to my feet.

Tom and John in the area just outside of Annie's Room. The ceiling is supported by metal struts and the remaining walls are very delicate.

'Oh, I was just moving about,' said John, as if he had been moving around incredibly quietly and he couldn't understand how I'd even heard him, let alone why I was asking.

We changed tactic. John stood in the doorway, Tom stayed outside and I stayed inside.

We were trying an experiment that had been tried out by the Mysteria guys on our October ghost hunt. On that occasion, it was Tom stood in the doorway. Tom asked for any spirits with us to try and move John out of the way.

Time was against us so it was time to move on. I dismantled the trap I'd set up, hoping that when John reviewed the footage we may have captured something out of the ordinary. I then placed Rich the lamb in with the other cuddly toys for Annie. At the same time I was doing this Tom thought he'd seen something out of the corner of his eye, a short shadow crossing the wall that John and I had our backs to. I'd love to think that it Annie's way of thanking us, but we'll never know. We bid farewell to the tragic young girl and headed to Mary King's Close itself.

It still stuns me to see a street beneath the Royal Mile, the tall buildings which would have once been a thriving community, now empty and lifeless. We scattered ourselves out along the long, steep close. I sat on the steps to Chesney's House, with John a little way further up the close, and Tom further still.

John had my EMF meter, and as he spoke to the ghosts of the close he held down the button on the side. It was a steady tick-tick-tick as it sought out EMFs. The hope was that when he asked for spirits to move closer to him, the ticking would become louder as the scale would creep up beyond the '1' it read at the moment.

'If you're here with us, come to me, touch me, I'm not afraid, I want to see you.' John pleaded with the ghosts of the close. After a few minutes the electronic ticking became a loud howl as the scale jumped up to a '7'. John complained throughout that he suddenly felt really cold, with a chilly breeze moving all around him.

As the cold spot vanished, so did the noise coming from the EMF meter as the box dropped back down to '1'.

There was a loud clatter from the bottom end of the close. Tom and John turned to look at me. I knew what it was, it was an unmistakeable sound. I'd heard it a million times before on Saturday

Rich the lamb joins the hundreds of toys left for the tragic eight-year-old girl for whom the room is named.

nights up and down Britain. 'Bottle bank,' I said in answer to a question they'd not yet asked. It was a bar outside throwing their empties into the glass recycling bin.

Tom asked for a sign if they wanted us to leave. Both he and John both heard a loud bang a moment later from the top of the close. I was too far down the close to have heard it. John went to investigate but couldn't identify the source.

He stayed at the top of the close as Tom asked if the spirits could make it happen again. With only ten minutes of our investigation left we moved on.

We decided to spend our last ten minutes in a room largely overlooked by paranormal investigators: the room decorated like a typical home in the close, the first room on the tour. We set my voice recorder and John's mobile phone, which was set to record audio, on a table. The room was fairly well lit by a couple of lights that we were unable to switch off.

Tom sat in the centre of the floor as John and I stood in two corners of the room. John asked for any spirits with us to do something to let us know they were there. Unfortunately, the final ten minutes of our investigation passed by uneventfully.

We returned to the surface and into the Real Mary King's Close gift shop. It was midnight, and time for us to leave. We thanked Curtis and Mas for giving up their Saturday night to help us out, and we headed out on to the Royal Mile.

The Royal Mile was buzzing, and there were people everywhere having a great Saturday night out. The walk back to the apartment only took us a few minutes. We had a drink as we sat down to reflect on the last couple of hours. As we chatted, I checked the weather app on my iPhone and it was bad news; heavy snowfall was expected in the North East as far north as Berwick first thing in the morning. This would make our return journey treacherous. I mentioned it to the others and

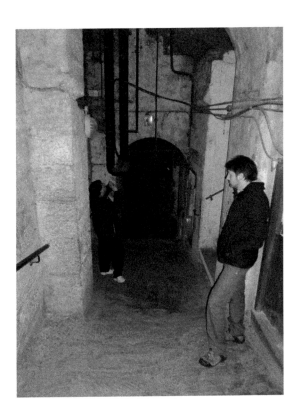

Tom in Mary King's Close.

made a suggestion. I suggested that we get a few hours' sleep and drive home from Edinburgh at 3.00 a.m., meaning we'd be safely home just before the snow began to fall. If truth be told, I was wiped out and badly needed sleep, so to me as the words left my mouth it seemed a barmy idea, although they both immediately agreed to it. We went to bed and I set my alarm for 3.00 a.m.

I praised the central location of our comfy apartment earlier, but with it being on the Royal Mile there was a lot of noise outside, people singing, shouting, more fighting, and car horns honking, so the few hours of sleep I had hoped for probably resulted in maybe an hour, ninety minutes at most.

When my alarm sounded, I fought the urge to set it again for another thirty minutes, and got up. I went to the bathroom and looked at my reflection in the mirror. I splashed some water on my face, and brushed my teeth. It seemed to do the trick and I felt a little more awake. I went and woke John up. Tom was already up and deflating his inflatable bed.

By ten past three we were leaving the apartment with all of our bags. When we got near the Grassmarket we were surrounded by drunks, we bobbed and weaved our way through them and I heard three separate people shouting, 'I want a pizza!' – they definitely need more pizza takeaways near the Grassmarket. The street my car was parked just off was closed to traffic due to there being a number of bars and clubs along it, meaning we were walking through the thick of the early morning revellers. We escaped them when we turned right up the narrow lane that my car was parked on. We were glad to finally get into the car and I followed the signs due to the traffic restrictions.

By 3.30 a.m., we were well on our way. I set the rule that since I couldn't sleep no one else could, as if I had no one to talk to there was a slim chance I might drift off as well although, if truth be told, I was feeling surprisingly awake, given it was the middle of the night and I'd had very little sleep. We chatted all the way home, driving through thick fog, then light snow, then rain, then snow again, on the eerily deserted A1.

It was 6.00 a.m. when I pulled up at Tom's front door, and there was mercifully no sign of the heavy snowfall promised.

I dropped John off at around 6.30 a.m. It was still dark, and the people of Kingston Park were all tucked up nice and warm in bed. Unfortunately, this included John's parents, and he didn't have a key to get into the house. It was starting to snow, so I asked if he wanted to get back into the car but he gestured for me to head home as he'd be fine. I felt a bit bad leaving him in the cold, but my body was crying out for sleep and all I wanted was to get home and climb into bed.

As I drove home, the snow really started to come down. It certainly looked like we'd made the right decision, even if it had deprived us of our sleep. The snow got heavier with each passing minute and the huge snowflakes kept my windscreen wipers working flat out. I had no problems though, and twenty minutes after dropping John off I was walking through my front door.

Over the next few days, I found out that all three of us spent days catching up on our sleep as none of us managed to get any sleep on the Sunday morning when we returned home. John, as I mentioned earlier was locked out in the snow, but thankfully his Dad, for whatever reason, was already up, so John could get inside but he didn't get any sleep. Tom's fiancée, Aimee, was in bed and wasn't expecting him home, so he tried (and failed) to get some sleep on the sofa. I timed my return home badly. I walked through the front door as my wife Jo was letting the dogs out in the garden. They saw dad arrive home and wanted to play, since they'd not seen me all night. So they didn't let me get any sleep.

John mentioned when I next spoke to him that he watched the footage from Annie's room and sadly she never made an appearance.

CHAPTER EIGHT
FINAL DESTINATION
CAMMO ESTATE, 27 APRIL 2013

Today was to begin as a day of surprises. Typically we're really unlucky with the weather, but it was a glorious sunny day, and there wasn't a cloud to be seen in the big blue sky above. I was even more astonished when I parked up outside my parents' house at 12.55 p.m., to pick my brother up at 1.00 p.m., and he was already there! He's never on time for anything, yet here he was actually early, and he was all set to chuck his stuff in the boot: a backpack, walking boots, sleeping bag and a pillow, and head off for what would be our last ghost hunt in Edinburgh.

By 1.15 p.m., we'd picked up John and were on the A1 for the now familiar drive north. The sun was high overhead, making my car uncomfortably warm, to the point where even John took off his enormous coat. I cranked the temperature dial as low as it would go, and flicked on the air conditioning. I pressed play on the playlist I'd put together on my iPhone – I'd tried to pick tracks that even John would know – and before long we were all singing along merrily without a care in the world.

I parked up at Drummohr Holiday Park at 3.30 p.m., as with the arrival of spring and slightly warmer nights we'd booked a bothy once again. We dropped our bags off in our huge wooden shed and took a seat on the green plastic patio furniture outside. We had a cold drink in the mid-afternoon sunshine and reflected on the last fourteen months journeying to and from Edinburgh, and some of the highs and lows. We were all feeling a little sentimental, as this would be our last investigation for a while, possibly our last ever investigation as a team. We reminisced on two and a half years in two of Britain's most historic cities, and the privilege we'd had of investigating some truly scary places, losing two team mates along the way as the five who made up our team for our first ghost hunt in York would eventually become three.

I lay my pillow and sleeping bag out on my mattress, ready to climb inside once we returned from our investigation in the early hours of the morning. I'd left my backpack and ghost hunting equipment case in the car, as I was going to need them before the day was out. Tom went to the bathroom and came out complaining there was no water. I went to investigate and found a blue stopcock behind the toilet, I turned it and hey presto! Water came gushing out of the tap, and it went everywhere.

Just before 4.00 p.m., we got back into the car and headed to the Cammo Estate for a daytime look around.

It was a fairly short drive of maybe twenty minutes and I parked up on Cammo Road, a residential street, leading down to the gated entrance at the bottom of the road, and the track beyond, lined with gnarled, twisted trees still bare of their spring leaves following the prolonged, harsh winter weather, which had only subsided in the last few weeks.

I took my camera from the boot, opting to leave my jacket behind. We closed the heavy iron gate behind us and passed the visitor centre, which was once the East Lodge, built back in 1879. It doubles as a ranger station and contains information about the history of the once grand estate, as

The gated entrance to the
Cammo Estate, with the visitor
centre to the right.

well as displays about the abundant wildlife in the grounds, and nature walks and other activities.
As the baking hot sunshine beat down upon us, we laughed and chatted as we took our first steps
on the 1½-mile walk that leads through the country park.

It felt odd to have parked up in the busy West End of the city, and mere minutes later we were
surrounded by trees and quiet woodland, silent other than the persistent chattering of the birdlife
all around us. However, this tranquillity, which gave the illusion of the countryside smack bang in
the middle in an inner-city suburb, was shattered every five minutes by the deafening roar of low
flying planes taking off, or coming in to land, at the nearby Edinburgh Airport.

Over the fields to our left, the striking Cammo Tower quickly came into view, an empty shell that
was once a water tower. It remains an impressive sight, the castellated tower visible for miles around.

We followed the tree-lined avenue, exchanging cheery pleasantries with dog walkers as they
passed, and within ten minutes we reached a clearing where the first structure of our walk came
into view – the remains of Cammo House. The estate was built around this house, and as recently
as the mid-1950s this building was a magnificent family home, but what remains today is nothing
more than a tragic husk.

We ascended the uneven stone steps and passed through the doorway into what would have
been the ground floor of the once great mansion. The three of us explored the remains, and it was
so quiet it was almost like we were the only living people for miles around. I told Tom and John of
the history, and apparent haunting, of the Cammo Estate.

The house was built in 1693 for John Menzies, a wealthy landowner. In 1710, Sir John Clerk
purchased the estate, and the following year began work on what is believed to be the Scotland's
first ever landscaped garden, a project that would last eight years and provide a beautiful design,
which includes two large wooded areas we could see to either side of Cammo House with species
of the time including sycamore and beech. The house and estate changed hands a number of
times in the years to follow, with each owner making their own mark on Cammo, including the
addition of a 140-metre-long ornamental canal, an artificial hillock constructed next to the water
tower offering lingering views over the west end of the city. In 1811, a stable block was built in a
symmetrical U-plan with a central octagonal tower. Cammo House was remodelled, and to the east
a pinetum added with exotic conifers that remain to this day including giant redwoods, douglas

We were having a great afternoon in the sunshine while exploring the once glorious estate, but we were soon to discover that after dark the Cammo Estate is a very different prospect.

firs, umbrella pines, and monkey puzzles. 1879 saw the addition of the East Lodge. Despite all of these changes, the layout of the estate still follows the basic framework of Clerk's grand design.

Towards the end of the nineteenth century, Mr and Mrs Clark bought the estate. They divorced in 1909 and Mrs Clark stayed at Cammo with one of her two sons, her other son moving to America. She adopted the surname Maitland-Tennant and, broken-hearted, dismissed all of the staff and began a life of solitude, which would lead to the Maitland-Tennants being the last owners to ever call Cammo House 'home'.

The estate, unattended and neglected became overgrown and the buildings began to rot and decay. The mother, only ever seen driving to the bank and back in a black Hudson with curtains at the windows to stop anyone seeing in, earned a reputation locally as a mysterious spinster, and the local children feared her and the inaccessible estate, talking in hushed tones about the terrifying 'Black Widow' and what went on behind the high barbed-wire-covered walls and locked gates of the Cammo Estate.

Margaret Maitland-Tennant was ninety-five years old when she passed away in 1955, and was buried in an unmarked grave in the grounds of the estate. Ownership passed into the hands of her son, Percival, who would visit his mother's grave every day without fail. He also inherited the local children's intrigue, quickly being given the cruel nickname of 'the Hermit' as he surrounded himself with over forty dogs for company. A chorus of barking could be heard every night by the locals. Adventurous children, curious to find out just what was going on, would sneak across the fields to try and gain access to the grounds, only to be greeted by the barking dogs that guarded their home and their owner.

In 1975, Percival passed away and the estate was bequeathed to the National Trust of Scotland on the condition that it would forever remain open to the people of Edinburgh as parkland and woodland. However, with the estate isolated and unsupervised, the house became a playground for the children who for so long had been desperate to get a glimpse inside the old mansion. It had been empty for a number of years, with Percival choosing to live in a farmhouse rather than in the house, which brought back so many memories of his beloved mother. The house was full of dog excrement, ruined furniture and rotting floors. The vultures swooped on the rotting carcass that was Cammo House, with locals taking 'souvenirs', and before long anything of value, including a snooker table and a harmonium, had vanished.

In 1977, the house was set alight twice by vandals. The house was deemed unsafe and reduced to its external ground-floor walls, shored up with earth to prevent the stonework collapsing further.

Cammo Estate was presented to the City of Edinburgh Council in 1980, and with its grounds and buildings having been reclaimed by nature, it was declared a Wilderness Park. The estate is now a popular public space open to everyone, no longer just the privileged; a peaceful, picturesque place to go for a leisurely stroll, walk dogs, or investigate the flora and fauna to be found in the woodland.

Or search for the ghosts of those who lived here in its heyday.

There have long been rumours of ghosts walking this once splendid estate after dark, with stories of Margaret Maitland-Tennant, said to rise from her unmarked grave every night and wander the house and grounds in death as she did in life.

This may sound like a schoolboy tale, consistent with the intrigue around the Cammo Estate for the last century. But if this is the case, what of the strange activity reported ever since the house was destroyed by fire back in 1977? Visitors to Cammo, both in daylight and after dark, have reported seeing shadowy figures moving in the woodland and the ruined buildings, most notably the ruined stable block and Cammo House itself. Often this shadowy figure is described as being that of a frail old lady, possibly that of the 'Black Widow' Margaret Maitland-Tennant herself. Other reports have been that of a male figure; it's easy to speculate on this unidentifiable spirit, but some believe it's that of Percival, others claim it's the shade of original owner John Menzies, or Sir John Clerk, the visionary behind the landscaped grounds. Whether it's any of these prominent figures from the estate's past, or perhaps someone else completely, is impossible to say.

Other phenomena take the form of phantom lights floating around near the house, and whispering coming from the woodland – upon further investigation, there's no one there. There have been reports of an overwhelming sense of being watched for no apparent reason. Some visitors who've reported this have been in large groups in the height of summer and have suddenly been overcome with fear, convinced unseen eyes are watching them.

Then there are the howling dogs. Reports of dozens of dogs howling and barking within the grounds in the dead of night, an unsettling sound that can be heard for miles around.

No sooner had I finished speaking than, as if right on cue, two big black Labradors came bounding into view through the pinetum barking and playfully fighting over a tennis ball. Their owners followed shortly afterwards, a young couple hand in hand, and they flashed us a friendly smile.

Now Tom and John knew what they were dealing with, we moved on. We headed west through the pinetum, following the path through the woodland which ran alongside the canal as Tom explained to us how best to survive a bear attack, it being something he'd seen recently on TV. I'll mention it here – as unlikely as it seems, I may well save someone's life. The common belief is that you should make yourself as big as possible and make loud, scary noises. This is apparently not the right thing to do. If you do that, a big grizzly will tear you limb from limb. You should make yourself small, don't look it in the eye, and talk calmly to the massive beast as if you were chatting to a friend. Apparently, if you do this, there's a good chance it'll not see you as a threat and leave you be. Although it still might kill you.

The walled garden then came into view. We entered through a low opening in the wall to be greeted by an intensely overgrown area, with a winding pathway through the thick vegetation to another low entranceway on the opposite wall. Despite the glorious sunshine, there seemed to be a fine mist hanging over the greenery within the garden. John spotted a squirrel on a branch next to us, and as he pointed it out, it jumped onto a neighbouring tree and scurried to a high branch where it sat and looked down at us. A sudden gust of wind rustled through the undergrowth, disturbing the blooming spring flowers and filling the air with their perfume.

Completely unmanaged these days, and totally overtaken with wild plants and flowers, the walled garden, which was once a kitchen garden, hints at the splendour of the Cammo Estate in its glory days.

We passed through the other side and followed the winding track down a slight decline, all the time Cammo Tower getting closer on the opposite side of the field to our right. We passed a ruined farm building to our right, which upon further inspection was almost completely inaccessible due to large sections of fallen stonework. We moved onto the more substantial ruin we could see on the opposite side of the track, a building I immediately recognised from photographs. The old stable block was built in 1811, and although the roof is long gone and it's scarred by graffiti, it is far better preserved that the main house and remains a testament to early nineteenth-century architecture. A quick look inside the small room within the central octagonal tower gave us a clue as to what we could possibly encounter upon our return after dark; the charred evidence of a fire, broken beer bottles, and depictions of cannabis leaves spray-painted onto the walls.

Leaving the stable block, we crossed through a bare farmer's field towards Cammo Tower. The tower has a locked gate, but this has been forced off its hinges so it is now possible to get inside, although there's little to enter for. The staircase has long since rotted away, making the upper floors only accessible to the hundreds of birds that roost there, evidenced by the incredible volume of droppings visible on the floor inside.

We climbed the small hillock next to the tower, and the open view it offers over the city was worth the short, yet steep, ascent. Being so high up left us exposed and an icy chill blew all around us, a gentle reminder that summer was still some way away. I rued my decision to leave my jacket in the car as I checked my watch. It was after 6.00 p.m., and sunset was scheduled to be only two hours away.

This brought our short visit to an end and we walked back to the car, satisfied we had a much better idea of the layout of the park, which would give us a huge advantage when we would return after dark.

We were all hungry after our long walk in the virtual countryside of the Cammo Estate, so wanted somewhere we could sit down, have a drink and a meal. We'd been to the Robin's Nest a few times before, and that wasn't too far away so that's the direction I headed. Ten minutes later, we were

The impressive remains of Cammo Tower. The ruined stable block can be seen in the background beyond the bare farmer's field.

passing through its doors to find it was full, and there wasn't an empty table in sight. We didn't have to wait long, however, and within minutes we were dashing to a table that had just been vacated.

At 9.00 p.m., after a relaxing couple of hours and a hearty meal, it was time to head back to Cammo Estate. The last signs of daylight were disappearing behind the horizon, and night had fallen on Edinburgh. We had a short drive, but it was clearly getting darker with each passing minute.

We parked up in the same spot as before, as a large group of teenagers walked out of the park. Immediately the Cammo Estate seemed a totally different proposition, the iron gates gleaming with the reflection of the phosphorous orange glow of the street lights. However, beyond the gates the tree-lined track, which looked so pleasant in the daylight, seemed dark and unsettling. This, combined with the evidence of night-time drinking and drug taking we'd seen earlier, made me begin to think that this investigation might not have been such a brilliant idea.

Nevertheless, I wasn't going to vocalise these concerns to the others, and Tom seemed preoccupied by how cold it was. He was right – it was absolutely freezing cold, and neither of us had packed warm enough clothes as we'd mistakenly been optimistic, given what a lovely day it had been. John had no such worries. He always has his huge coat on, no matter the weather. He also had a hat, gloves, scarf, and a thick woolly jumper. Tom had a lightweight jacket on, and a coat in the boot. I had a hoodie on, and put my jacket over the top. I was secretly hoping that the woodland might protect us slightly from the wind, but there was only one way to find out.

Rather than carry my heavy ghost-hunting box around, I selected the few items I thought I might need and put them in my pockets. I wanted to travel light, so took my camera, digital voice recorder, and torch.

The three of us entered the Cammo Estate. It was so dark as we walked down the dirt track that Tom almost walked straight into a young fallen tree. I pointed it out to him just him time for him to avoid it. We initially chose not to put our torches on, just in case we weren't the only people here. My biggest concern for this investigation wasn't the dead, it was very much the living. Our previous investigations had been at locations which only we had access to, however we were in the middle of nowhere, and now it was dark and the friendly dog walkers and families were ensconced in their homes – was there anyone here in the Cammo Estate other than us? We'd seen evidence of drink and drug use earlier, but just how recent was that? I guess we were going to find out.

I whispered to the others, 'We saw smashed bottles, drug-related graffiti and someone has had a fire in the stable block. We might go into one of these old ruined buildings and walk straight into a bunch of crackheads off their heads on God only knows what.'

'You're really not selling this to us,' whispered John, clearly worried.

'Why couldn't Rich have been here?' muttered Tom, his head darting from side to side as he looked all around us. 'He's the Taekwondo master!'

'We've not got time to worry about that anyway, we've got a job to do. Let's find these ghosts and go out on a real bang,' I said enthusiastically.

We walked on in silence. It had seemed such a welcoming place during the day, I'd almost wished I'd lived nearby so I could bring my dogs here for a walk every day. It was truly fantastic.

We were following the same route we'd taken on our earlier visit. Within around ten minutes, we reached the ruin of the once great Cammo House. We approached with great trepidation, as we couldn't see the inside until we climbed the steps on the small hill and entered the doorway. There was no one there.

We had a great vantage point down the southern approach, but it was too dark in every other direction with trees and woodland to see anything. We spent a few minutes listening, feeling, and hoping that the

ghosts of Cammo House would make an appearance. We felt and heard nothing. We were going to move on, as we'd already agreed during our chat in the pub that the house would be our final vigil.

We left the house and headed into the dark pinetum, the last trickle of light now almost lost to us through the thick trees with their long twisted branches, which appeared to be reaching out for us like arms.

The ground was a bit swampy underfoot, so John clicked on his torch and kept it pointed down to give us a bit of light by which to safely navigate our way past the conifers, which were indistinguishable as different species in the darkness.

We walked single file along the footpath with dense woodland both sides of us. The canal was to our right, but we couldn't see it as everything was different shades of black.

We walked in virtual silence. We were on edge, our ears straining to hear something, anything. It just seemed too quiet. We expected to hear the sounds of roosting birds, the shuffling sounds of nocturnal creatures coming out to hunt for their food, but there was nothing. John led the way with his torch, Tom followed and I was at the back. I kept checking behind me, not that I would have been able to see much. I felt like unseen eyes were watching me from within the blackness, just waiting to make their move.

We reached where we remembered the walled garden being, and John shone his torch up from the ground lighting up the area in front of him. There was a brick wall behind some trees and bushes. If we followed the footpath for another 100 metres, the entrance to the garden would be on our left.

I heard talking. It was behind us. We clicked the torch off and stood perfectly still in total silence. It was only around 10.00 p.m., so it wasn't beyond the realms of possibility that teenagers might be out and about, or even locals who know the park well taking their dog for a late-night stroll before bed. We waited for five minutes and didn't hear a thing. I was convinced I'd heard voices but it seemed I'd been mistaken.

We pressed on. We walked along the track, the noisy gravel crunching underfoot.

'Is that a torch up ahead?' said Tom, stopping.

I went and stood where Tom was, and I could see what he was looking at – a bright ball of light further up the path, way beyond the entrance to the walled garden. Whatever the light source was, it wasn't moving.

'Wait here,' I whispered to the others. 'I'll go and check it out. I'll be back in a few minutes.'

Tom wanted us all to go, but I was sure it was nothing to worry about. So I quietly walked down the path, past the entrance to the walled garden, and around a bend. I carried on for another 200 metres and then I could see where the light was coming from. There was a copse of trees and through the trees was a road. The light we had seen was a street light barely visible through the trees.

I turned to return to the others and was horrified to see two shadowy figures approaching me. I couldn't make out any features. I couldn't even tell if they were male or female. I decided to carry on walking. As I neared them the figure on the right of the pair spoke.

'What was it then?'

It was John. When I'd told them to wait where they were, they'd ignored me and followed thirty seconds behind me. Why do people never listen?

We all doubled back along the path and entered the walled garden with the entrance now on our right.

The walled garden felt really peaceful. Tom said, 'It almost feels like there should be ghosts here.' Before he could elaborate, there was a loud roar overheard. I looked up in the sky and waited for a plane to pass overheard. However, that wasn't what happened. There was an almighty gust of wind

The entrance to the overgrown walled garden.

that blew through the trees above us. The treetops clattered together loudly, then as suddenly as it had appeared it just stopped.

It was a strange coincidence, considering what Tom had said, but almost certainly nothing paranormal, just a bit spooky.

Previous owners of Cammo House would have lovingly tended to this now wildly overgrown garden, and would have loved to spend time here. It's been reported that visitors have seen indistinguishable shadowy figures moving slowly through the overrun wild undergrowth. The eye itnesses who have reported this have said at no point did they feel threatened, or scared. They felt surprisingly calm, and it was only when the figure disperses does it dawn on them that they'd just *possibly* seen a ghost.

We took our time passing through the walled garden, but other than the rogue gust of wind it was uneventful. It was reassuring to hear sounds of nature, unseen creatures disturbing the bushes around our feet as they fled from us. People passing through at night is something they're likely not used to.

We left through the exit on the opposite wall, just as we had earlier in the day, and the water tower was a true spectacle against the night sky. It looked very creepy. As soon as we reached the opening beyond the door, Tom stopped us. He'd heard a noise, which he said sounded like music. We stood still looking all around us as our ears strained to hear something, anything. We heard nothing. Tom was convinced as to what he'd heard, but if there was anyone else here, we were going to find out soon enough, as our next stop was the substantial ruin of the stable block.

As we walked as quietly as possible towards the stable block John stood on a branch, snapping it in half, and in the silence the noise sounded incredibly loud. We couldn't see any lights or hear anyone inside, so we all put our torches on at the same time and went in, ignoring the warning signs that read 'Keep Out Dangerous Building'. We tread carefully through the knee-high nettles

and weeds, and looking to avoid stepping on the fallen stone and broken bottles that littered the floor of the room in the central tower. There was no one else here – we were alone.

We were relieved that there was no one here, and without further ado we set about investigating the old stable ruin, which dates back over 200 years. There have only ever been a few investigations at the Cammo Estate, but this has proved a fairly active building so I was excited to see what it may have in store for us.

Something didn't feel quite right about it, and it definitely was no longer the nagging concern about crackheads and murderers. The atmosphere within the little ruin felt charged with energy, and I suggested we should definitely spend some time here and see if anything would happen if we did our usual thing: asking out in the hope of making contact while recording with electronic devices, taking a few photographs and keeping our eyes and ears open and alert.

We stood in the central room and turned off our torches. There was a faint burning smell – it seemed likely the charred remains of the fire in the centre of the floor had been fairly recent. John asked if the spirits who once lived or worked here could let us know if they were still here. Could they speak to us, touch one of us in some way, or show themselves in some form? I heard a strange noise outside that sounded like talking. We listened carefully and we quickly established that it was the call of a bird coming home to roost nearby.

I took some photographs and as I did, John asked if the spirits would be able to show themselves so we could capture them in my images. John explained that we weren't here with any disrespect and we weren't here to cause any further damage to their building, which they were likely proud of and attached to, gesturing to the broken glass, graffiti and the remains of the fire.

We heard noises in and around the building, but nothing conclusive, bangs outside, rustling in the grass and nettles, even knocks on the ceiling. However, since this wasn't a controlled environment, it made it an investigative nightmare, as we had to discount them all unless we got something specific.

Tom asked John and I if we had a specific area we felt more drawn to within the building. He asked this as he felt somehow drawn to the tower to the right of the central one we were stood in.

The stable block.

He couldn't explain why, but felt strongly that we should consider trying over there. Before we could even discuss this suggestion we heard a loud bang just outside, which led me to say, 'What was *that*?'

Tom said he heard it too, but it was likely just a bird or something outside, so again we dismissed it.

'If you wish us to leave please give us a sign and we will go,' I said sincerely. John suddenly screamed and jumped in the air. I jumped too as John's screaming continued, Tom was jumping around too. Neither of us knew what had happened to John. It turned out a fly had flown into his ear and buzzed, making him jump, and he started frantically poking around in his ear to get it out.

That brief scare over, we moved into the area Tom had suggested, being careful to avoid the long nettles.

'We're going to leave soon, we really would love to know you're here. Your building is beautiful and I know you'll remember the time when it was used to house your animals. We'd love to know your story, we've come a long way to see you and really wish we had some way of knowing that you're here with us.'

Tom said he felt like he'd been poked in the leg.

We were all feeling a bit nervous. I was almost expecting someone to walk through the doorway any moment. I always felt we weren't alone and that something was going to happen, however ten minutes passed by without event so we agreed to move on, going to the water tower and returning here afterwards. Little did we know we'd be back a lot sooner than that.

We left the stable block and headed over the field. We were in pitch-black and didn't want to put a torch on and draw attention to ourselves, so it was fairly treacherous underfoot. As soon as we were out in the field, we were exposed to a powerful crosswind blasting freezing cold air, which cut through the layers of clothing I had on and froze me to my core.

I had been checking behind me, as once more I was at the back. And I was shocked to see a figure walk down the hill past the stable block we'd just left. I stopped in my tracks and watched in astonishment as this man-sized figure, a black silhouette against the light stonework of the ruined building, seemed to almost glide down the gentle slope alongside the stable block. As it passed the last of the stonework, I lost sight of it. It may have continued to walk on down the hill towards the car park, alternatively it may have turned left and gone into the building we'd just vacated. The possibility that I may have just seen a ghost hadn't even entered my mind at that point.

The others had noticed I'd stopped and were watching me. We were all stood perfectly still in the middle of field like three scarecrows. With the wind being so strong, I tried to tell the others what I'd seen, but no sooner did I speak that my words were being carried away in the wind. They walked back to where I was stood and we huddled around as I spoke loudly and explained just what I'd seen. I expected them to doubt me, but a few seconds later we were returning to the stable block and we were walking at a fairly quick pace.

The pace slowed as we neared the eerily quiet building. John, by his own admission, had never been so frightened, in fact he said he was 'effing s**tting himself'. So I offered to go in alone to see whether it was still empty, or if the phantom had gone into the building. We quietly whispered the possibilities. 'If it's a bear, remember what I said earlier,' Tom joked. John and I quickly shut him up though – he perhaps didn't realise just how serious this might be if someone was in there.

If there was someone there, they wouldn't have seen us, so I decided to break cover. I switched my torch on and noisily shouted 'hello' as I walked into the building. I stopped when I heard a loud bang from the opposite end of the building. Tom came to see where I was in case I needed help. John hadn't moved from where I'd left him outside on the main track past the building. I said

'hello' and entered the central room. It was empty. I heard another loud bang, this time from just outside the room where Tom and I were stood. We were alone, or at least there was no other living person here. We shouted to John to let him know it was all clear.

We spent ten minutes there stood in silence, but it was quiet. Too quiet. Once more, we made our way through the windy field.

As we neared the tower, John stopped. 'I've just seen someone pop their head around the tower and look at us.' I suggested that I go one way around the tower and those two go the other and if there was someone we'd see them before we met up. There was no one there.

It was incredibly windy and very, very cold as we stood outside the entrance to the tower. Suddenly, a bright light shone across us like a torch beam from nearby.

We couldn't work out what it could have been. I suggested possibly a wagon or another big vehicle from the busy road we could see from our vantage point. A lot of vehicles went by, but nothing generated a light such as we'd seen.

There was a loud bang from inside the tower. We weren't sure what it was, but it was full of roosting birds so it was likely something natural. After twenty minutes at the water tower, it seemed unlikely we were going to experience anything out of the ordinary, and we were too exposed to the elements to be able to confirm that anything we may experience was definitely paranormal.

After crossing back through the field, we felt compelled to take another look around the stable block while we had the chance.

We didn't do our usual thing of asking for any ghosts with us to let us know. We simply stood still in silence in the central room. After only a few minutes we heard a voice.

'What did you say?' Tom whispered to John, convinced it was he who had spoken. But John hadn't said a word.

After a quiet fifteen minutes I was just about to suggest moving on when we heard a cow mooing. It was really loud, and most definitely the sound of a cow. However, we hadn't seen any fields with animals in at all nearby, certainly not near enough to hear it so loudly and so clearly. Given that we were stood inside a stable block, could we have just heard our first ever ghost animal?

We walked down the path from the stable block towards the car park. It was dark and cold, and we reached the car park five minutes later. It was empty.

We turned left and followed a path from the car park back to the entrance to the Cammo Estate where the visitor centre is. We were walking along a narrow path with brightly lit back streets to our right. Many bedroom lights were on, with other houses in darkness, people getting an early night oblivious to the ghost hunting going on almost literally in their own back garden. Tom kept stopping, saying he could hear an additional set of footsteps behind us, perhaps someone following us from one of the ruined buildings we'd left behind.

The path we were following split away from the back streets and took us back into the darkness of the woodland, and a few minutes later we were back at the main gate to the estate, the visitor centre directly ahead of us. I could see my car from where we were stood, through the bars of the locked gate. However we weren't returning to the car yet, we had one last ruin to investigate – Cammo House.

We turned left and followed the track towards Cammo House once again, retracing our steps along the track we'd walked along over two hours earlier. I constantly heard voices behind us as we headed down the path. But there was no one there.

Ten minutes later, we were stood in the ruins of the grand old house, and our torches had become redundant as, for the first time this evening, we were bathed in light from the full moon above us.

Cammo House was
destroyed by fire in 1977
and this is all that remains
of the once grand mansion.

An owl in a nearby tree top made a loud 'whoooowhoooo', so loud it actually made me jump. That was followed by a plane flying overhead. We all looked up as it passed directly overhead. It had blinking red and green lights on the tips of its wings.

John spoke loudly after the plane had passed. 'We have come a long way and we seek evidence that you're still here, choosing to remain in this place you loved in life. We've walked around the beautiful gardens and it's such a shame that this house is no longer standing. Is that why you remain here? Can you give us a sign?'

The owl's call seemed even louder now as we all waited for some kind of response.

'Whooooo.'

'Can you tell us your name?'

'Whoooowhoooo.'

'Please give us some kind of evidence that you're here. Use our energy, we know you're here, and we come in respect. Please communicate with us.'

After ten minutes, things remained quiet. Tom tried asking to see if this made any difference and we got an immediate result.

'Do you want us to leave? If so, give us a sign.' There was a bang on one of the walls within the house.

'Thank you. If you made that sound, if you do want us to leave give us another sign, something more definite and we'll leave.' There was another bang on the wall.

We looked at each other, I personally was unsure whether this was coincidence, but at the same time couldn't fathom how there could be banging on the almost completely ruined walls of this old house.

'Ask again!' I prompted Tom.

'If you want us to leave you're going to have to something definite, something that leaves us in no doubt that you're here with us, that you can understand us, and that you want us to leave you in peace.'

We waited, then we got another response – three knocks in rapid succession, which sounded like they were right behind us on the wall next to the doorway.

We were out in the woodland, but as we rapidly tried to get our heads around this, we rationalised in hushed tones and couldn't think of anything that could be making the noise.

'Can you knock four times?' Tom asked hopefully.

The three of us looked around expectantly, but the knocks didn't come.

Just as I opened my mouth to speak there were four, very loud, very clear, knocks on the stonework behind us.

If the ghosts of Cammo House wanted us to leave their home, who were we to overstay our welcome. We said our thanks and walked down the track one final time. We knew our Edinburgh ghost-seeking quest was at an end, and my emotions were in conflict. I was disappointed that we had no further investigations lined up, but on the other hand I was elated about the experiences we'd shared, and the memories we'd created that would last a lifetime.

It was nearing 1.00 a.m. when we got back to the warmth of my car. I cranked the heating right up to full, flicked on the air conditioning and we were on our way. The streets were deserted, and there were very few cars on the road. We were all wiped out as I drove us back to the bothy, the fresh air and miles and miles of walking had taken their toll and I was ready for my bed.

We parked up in the campsite, and it was silent as the grave as everyone was tucked up in their beds. John unlocked our bothy door and it was freezing inside. We turned the heater up and I cocooned myself in my sleeping bag to try and get warm. We chatted about the investigation we'd shared, and within mere minutes Tom started to snore.

John and I continued to quietly chat and I'm not sure who dozed off first, but the next time I woke John was creeping around putting his clothes on. I was just about to ask what he was doing when his alarm sounded for 7.45 a.m. I lay awake and could hear the sound of rain bouncing off the roof above me. I listened to it for a few minutes before anyone spoke.

'Windy night,' said John to no one in particular.

I propped myself up on my elbows. 'Was it?' I asked.

'Yeah, proper gale-force wind; I could hear it blowing through the trees and whistling through the gaps in the bothy walls.'

'You want to try sleeping mate, rather than lying awake all night so you can give us a weather update in the morning,' I muttered as I forced myself to get up and walk to the bathroom on the cold wooden floor. I tried to brush my teeth but there was no water. I tried both taps, nothing. I checked the stopcock behind the toilet and it had been turned off again. I popped my head out of the bathroom door and asked the others if they'd turned it off. They both shook their head. As I brushed my teeth I pondered the final strange happening of our Edinburgh journey.

We drove home in miserable weather – strong winds and a fine drizzly rain that threatened to turn into a downpour but it never materialised. Not that Tom or John would remember any of it, as they both slept through the whole journey.

In the days that followed, I listened back to the recordings I'd made during the investigation. During our first visit to the stable block where Tom says he's been poked in the leg, there is heavy breathing that lasts for ten minutes. The noise chilled me at first, but after listening to it several times I realised what it was – John. However, it was once I was no longer focussing on the breathing that I noticed it. I was stunned, excited, and terrified all at once. It was there clear as day, there was constant whispering all around us, not one person whispering, several people whispering, it was impossible to establish how many there were, and what they were saying but it was definitely there.

I sent the recording through to the others to get their thoughts and Rich replied, saying, 'That's a weird recording. I cranked it up really loud and it sounds like there are whispers all around you. There's definitely something other-worldly about those noises.'

CONCLUSION
IN THE END

Edinburgh was a fantastic journey of discovery; often intense, constantly frightening, but John, Tom, Rich and I loved every minute of it, and I'm sure we'll be laughing at *that* incident at the Edinburgh Dungeon for years to come. We shared in a real-life adventure, and had one hell of a time. But did we come any closer to answering the question that fuelled our quest? Do ghosts exist?

We conducted eight investigations, and we were lucky enough to be permitted access to the most amazing venues, many of which regularly make lists of the most haunted places in the UK, often the world. I made a conscious decision to go for quality over quantity when it came to the investigations we would conduct, and I feel so lucky that we were able to secure investigations at these incredibly desirable locations.

As I type this in the week following our investigation at the Cammo Estate, I've spent some considerable time reflecting on the last year, and we were blessed with some amazing happenings. We were always careful to rationalise when we experienced something that seemed out of the ordinary, and when I look at what we still can't explain, I can't help but feel that we're unquestionably closer to our own proof that ghosts may be real.

All four of us experienced some incredible phenomena, shared and individual. We also succeeded in capturing several compelling snippets of audio, and a number of convincing photographs. Standout moments were the vibrating chair and Rich's mobile phone throwing itself to the floor at Dalhousie Castle Hotel, the shadow I saw pass a window at the ghoulish Edinburgh Dungeon, the disembodied cough and footsteps at Bedlam Theatre, Rich's strange experience at the infamous Covenanters Prison, and, of course, our encounter with the foul mouthed Mr Boots and the stone throwing that followed within the subterranean hellhole that is the South Bridge Vaults.

Our time in Edinburgh may have drawn to a close, but I've fallen head over heels for the beautiful city and I know that I'll be a regular visitor for years to come. Who knows – there may even be the occasional future investigation in the historic capital?

So what does the future now hold for the North East's favourite spook-seeking quartet? Our paranormal investigations will continue, of that you can be assured. Perhaps the truth we crave can be found closer to home...